The Art of Self Invention

The Art of Self Invention

*Image and Identity in
Popular Visual Culture*

Joanne Finkelstein

I.B. TAURIS
LONDON · NEW YORK

Published in 2007 by I.B.Tauris & Co Ltd
6 Salem Road, London W2 4BU
175 Fifth Avenue, New York NY 10010
www.ibtauris.com

In the United States of America and Canada
distributed by Palgrave Macmillan, a division of St Martin's Press
175 Fifth Avenue, New York NY 10010

ISBN: 978 1 84511 395 7 (Hb)
ISBN: 978 1 84511 396 4 (Pb)

A full CIP record for this book is available from the British Library
A full CIP record is available from the Library of Congress

Library of Congress Catalog Card Number: available

Typeset in Warnock Pro by Sara Millington, Editorial and Design Services
Printed and bound in Great Britain by T.J. International Ltd, Padstow,
Cornwall

Contents

Illustrations

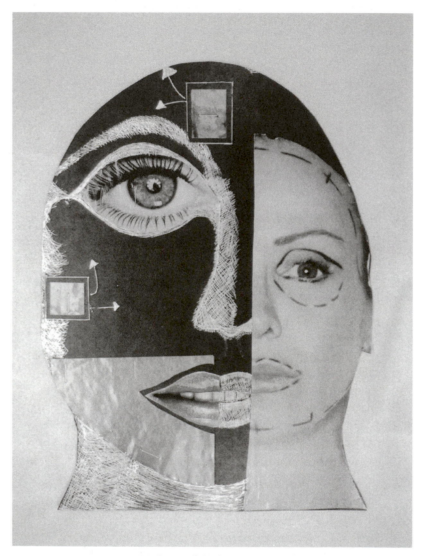

1. *Makeover* (Shirley Cass, 2005).

Introduction

It is the spectator, and not life, that art really mirrors.

Oscar Wilde, *The Picture of Dorian Gray*

Hollywood Stories

Deception and a good dramatic performance are difficult to distinguish. A deliberate lie and a practised turn of phrase can sound the same. By the same logic a fashioned appearance and self-invention are dangerously alike. The popularity of deception as a narrative device permeates the Western canon. It animates Aesop's fables (sixth century BC), Shakespeare's *A Midsummer Night's Dream* (1600) and Strauss's *Der Rosenkavalier* (1911) as well as the recent film *Mr and Mrs Smith* (2005) starring Angelina Jolie and Brad Pitt.

Hollywood has made extensive use of deception as a narrative device. Countless couples, partners and lovers remain mysterious to one another while they enjoy other lives behind a polished surface identity. In *Mr and Mrs Smith*, a bored married couple find themselves locked in mortal combat, commissioned by separate sponsors to kill each other. The film is a high-action imitation of the earlier *Prizzi's Honor* (directed

by John Huston, 1985) and it borrows from *True Lies* starring Arnold Schwarzenegger (directed by James Cameron, 1994) and Danny De-Vito's *War of the Roses* (1989). The allure of the film is that behind the apparently lacklustre surface of Mr and Mrs Smith's ordinary marriage, where the unhappy couple are resigned to a slow death from boredom and neglect, there is another seething world in which both parties are smart, savvy, athletic killers driven by high-energy desires and living by different rules.

The ubiquity of deception in popular culture is an invitation to consider the possibility that behind the surface of appearances there are other realities. In this book, I draw on this idea to argue that deception and invention frame the production of every individual's ordinary social life. We are continually introduced to situations in which lies and distortions are exercised; however, this does not lead to the conclusion that all social life is riddled with trickery and calculation. From a sociological point of view, society rests on assumptions of trust and reciprocity. We must believe that the trains will run on time, that money will hold its value, that people are not murderous and that traffic rules will be obeyed. At the same time, we know these principles are constantly violated. We live with contradiction and become alert to the existence of paradox. While we enjoy the orderliness of the surface life, we know there are irruptive tensions beneath the thin surface membrane, ready to 'flood out' the situation (Goffman, 1963). To participate in society we cultivate a public persona, a manner of being in the world that works to sustain our engagements with others. Much of the training for this dual and divided mentality is delivered through popular culture, and in the following chapters I explore how we have become attuned to the requirements of an invented self-identity that is displayed daily through ordinary activities.

The focus of this book is on the role of popular culture in the promotion of particular cultural practices that instruct us in how to pres-

ent ourselves to others and live with the paradox that we are made in the moment but also supposedly possess a fixed character. It is a study of self-invention against a background of contradictory representations of identity. By the mid-twentieth century, the idea of a fixed personality based on a stable mentality became increasingly untenable and the counter idea, of identity or subjectivity being an asset to be groomed and presented to best effect, had gained acceptance. Subsequently, the idea of identity as part of a taken-for-granted social surface existed alongside the opposite view that identity is a fixed essence, harboured at our core. *Mr and Mrs Smith, Some Like It Hot, True Lies, Pillow Talk* and hundreds of other mainstream and popular films advocate both perspectives. Identity is continuously re-styled and invented to suit the circumstances but, at the same time, it supposedly emanates from an inner quality that universalizes the human condition. Beneath the ambiguities and playfulness of the performance there is supposedly a resilient centre. The discussions in this book explore the popularity of these bifurcated ideas – that appearances are both revealing and deceiving, that identity is both apparent at the surface of social life and inaccessible to the observer, deeply concealed in the privacy of the interior. I explore these ideas by looking at the long history of theories of identity as well as the contemporary techniques that maintain the centrality of identity in everyday social practices, such as the emphasis placed on appearances by a consumer culture dominated by the fashion, cosmetic, retail and advertising industries.

The Art of Self-Invention

The growth of the entertainment industries during the twentieth century brought a new emphasis to appearance. The emerging technical capacities of the cinematic camera, such as zooming, fading, dissolving and juxtaposing images, had the effects of rearranging time and space

and blurring distinctions between the interior and exterior, the private and the public. The close-up camera shot, developed during the 1950s, coincided with a growing interest in popular psychology and the 'psy' industries. The common use of the close-up asserts the existence of a ruminative interior or self; the camera is the device giving insight into secrets. Through the close-up, thoughts are made visible. The actor's facial expressions transport the audience into the deep interior of the mind. The close-up uses the eyes as 'the windows' to the concealed personality. Suddenly the interior becomes exteriorized; certain gestures and subtle movements – a tear, quiver of the lip, a slight smile – are signs from the interior of unmediated, true emotion. These fine facial movements caught by the close-up camera shot suggest authenticity, as if the realm of meaning behind the visible social surface is indeed the real world.

Film, which works in imitation of the human eye, is a widely distributed and influential cultural form (Williams, 1983). Film has been highly successful in teaching audiences how to read signs and especially how to deduce character from physiognomy. In the film *The Talented Mr Ripley* (directed by Anthony Minghella, 1999, and adapted from the novel by Patricia Highsmith, 1955) the narrative concerns the appropriation of identity and the slow transformation of one person into another. In the novel, Highsmith describes Tom's view of his future victim Dickie: he looks into Dickie's eyes, into the shining, empty 'pieces of blue jelly with a black dot in them', and draws the conclusion that there can never be any real connection between people:

> You were supposed to see the soul through the eyes, to see love through the eyes, the one place you could look at another human being and see what really went on inside, and in Dickie's eyes Tom saw nothing more now than he would have seen if he looked at the hard, bloodless surface of a mirror. (Highsmith, 1955: 78)

Tom's inability to see into the interior of Dickie is evidence of his criminality and inhumanity. In the Ripley films, Tom's smooth social performance and innocent blank face convey to the audience that he is dangerous and not to be trusted.

The eye being a portal to other worlds is a powerful metaphor in Western culture (Jay, 1993). When the close-up camera shot entered the vernacular of the cinema it immediately heightened the significance of an actor's fine facial movements, giving multiple meanings to the squint, blink and veiled or shifty look. It also emphasized the mouth and ascribed certain meanings to pursed, open or clenched lips. The close-up revealed the character's point of view, and again this worked to reveal the interior. In Hitchcock's *Spellbound* (1945), for example, the audience is suddenly looking out from the eyes of the amnesiac (played by Gregory Peck), who is trying to control the sickening sense of vertigo produced by looking at pinstripes on a bathrobe. The film's swift optical exchange between the positions of actor and audience marks the moment when the sinister narrative begins to take shape. The use of vision and eyes, spectacles and blindness is the film's recurrent motif. The charming but mentally disturbed Dr Anthony Edwardes (Gregory Peck) is trying to see into his own mind. He stares at lines, the fine parallel lines drawn by a fork across a white tablecloth, the pinstripe on Dr Constance Petersen's (Ingrid Bergman's) robe, and we know immediately he is hiding a secret. The dream sequences in the film use surreal paintings by Salvador Dali. Giant eyes hang from the ceiling, recording the scenes of a crime but also remaining blind to it. The symbolism in the film is heavily visual. There are numerous references to eyes, vision, seeing, observation, recording, blindness and so on, with the assumption that seeing is not believing and the obvious is not always apparent being constantly restated.

The Visual World

Cinema has made both human consciousness visible and the otherwise elusive internal voice audible. It has associated gender with specific features, colours and activities. Some cars are masculine, others feminine; cigarette brands have a gender, as do shoes and hairstyles. Such coding seems conventional when, indeed, it is not. How we read the body and our physical surrounds is deeply in debt to the cultural – yet the visual, what is apparent, has seemingly become so natural as to be self-evident. This is a slippage that has profound consequences. With the late nineteenth-century development of formal psychology and the invention of technologies like the camera, the act of seeing has made visuality into its own field of enquiry. When the Lumière brothers showed their film *Arrival of a Train in the Station* to audiences in 1895 the reactions were indicative of the power of the visual. The unexpectedness of the on-rushing image was such that people fled in fright as if a real train were actually speeding towards them. So immediate were the visual impressions that it was difficult to remember the train was not present. This moment in cultural history marks the exact time and place when the perceptual skills of audiences of popular culture were irrevocably changed. It marks a moment too when it was recognized that mass hysteria could be deliberately engineered through communication technologies.

Since then the spread of visual cultures has been rapid and the prominence of the image has made the technical and aesthetic realm of art, design and representation all the more important. E.H. Gombrich's (1960) famous claim that art does not imitate nature and never did means that all cultural products have the capacity to train the eye and shape how we interpret the world. Simon Schama (2004) has made the same point. What we see is not exactly what we get. The business of the mass media is to promulgate ways of seeing and to train audiences

to read images and representations in predictable ways. In mainstream film, for example, codes are repeated to the point where they seem natural; blondes are beautiful, the young are guileless and truthful, muscular men are heroic. Slowly these associations are standardized and audiences become complicit in maintaining them.

Film works by using stereotypes. Businessmen, intellectuals, the criminal and the mentally deranged have all become recognizable through standardized insignia. A woman in neat, pale clothing represents a mother; a man in a suit, white shirt and knotted tie is a policeman or doctor; a man in a dark shirt and bowtie is suspect. The (male) intellectual has longer hair (as with Tom Hanks in *The Da Vinci Code*, directed by Ron Howard, 2006) and sometimes a beard and spectacles; the psychotic wear inappropriate clothes like the killer Norman Bates (draped in his dead mother's clothes in Alfred Hitchcock's *Psycho*, 1960) and the transvestite psychiatrist in Brian de Palma's *Dressed to Kill* (1980). Social class also has its codes. In *Legally Blonde* (Robert Luketic, 2001) Reese Witherspoon plays a rich girl who lacks good taste and dresses as if she were a shop assistant, and the same stereotyping is presented in reverse in *Erin Brockovich* (Steven Soderbergh, 2000), where Julia Robert's trashy clothes are the visual devices that propel the narrative. These associations seem too simplistic to be effective, yet it continues to be the case that identity is collapsed onto visual signs. In turn material objects like Barbie dolls, coffee machines and perfume are infused with human traits. We are asked to believe 'Cars love Shell', when we know they are unsentimental.

Faux Identity

The global reach of the mass media and Hollywood has defined much of our cultural landscape and has been instrumental in creating a virtual dimension where imaginary is accepted as real. This hyperreality

describes the mysterious world where the image bears no relation to a pre-existent reality (Eco, 1976). Film and the mass media are technologies that have transformed telltale details into forensic clues and promoted their importance. Such an approach is heavily freighted with ideology, and in this way popular culture works to designate certain objects and gestures as iconic. For instance, the driver of a VW Beetle is seen as honest, young and fresh; the owner of a shaggy dog is loving and shy; the aficionado of classical music is sinister, secretive and possibly dangerous. We have learned to see ourselves and read the scene through the visual products on the screen. This reinforces a semiotic conduit to the actual organization of society outside the film. By this process actors remain their screen characters for many of their fans, and the verisimilitude of the cinema connects closely to the everyday. Naturalism permeates the aesthetic, making a cinematic kiss seem the same as a real-world embrace, and vice versa; thus when the real-world romance fails to follow the cinematic representation, we may be disappointed.

Watching a film requires a form of voluntary immersion. This is part of the voyeuristic pleasure of the cinema. Film provides the distinct pleasure of seeing one's self, or aspects of one's self, in the glamorized portraits of the screen star. Agreeing to the codes of representation embeds us in cultural conventions. We know, for instance, that when Tony Curtis and Jack Lemmon become Josephine and Daphne in *Some Like It Hot* (Billy Wilder, 1959) they must perfect walking in high-heeled shoes in order to be convincing. Being a woman means high heels; these are part of the code system that collectively expresses the ideal of femininity. Until Josephine and Daphne 'walk the talk', they cannot pass.

Patterns of speech and the names of characters also codify identity. Richard Dyer (1993: 106–7) has described how identity is conveyed through the actor's name as well as through gestures, voice tone and

clothes. He cites the example of *Bus Stop* (directed by Joshua Logan, 1956) in which Marilyn Monroe's character has a French-inflected name, Cherie, which functions to tell the audience she has social aspirations. When her name is deliberately mispronounced as Cherry by the predatory male in the film, we know that her ambitions to better herself are a fantasy and she will never escape the bus stop café. The reverse occurred when Chance, the feral gardener in Jerzy Kosinski's allegory of modern life became the elegant Chauncey Gardiner in *Being There* (directed by Hal Ashby, 1970). His change of name pushed him up the social ladder.

The visual world, however, does not address us unambiguously. Simon Schama (2004: 17) urges us to mistrust the casual gaze: 'what you see is not what is'. The philosopher Judith Butler (2004a) supports the point; as does Susan Sontag (2004). Each have argued that the photos of war crimes from Abu Ghraib are more than a reporting of fact, they are manufacturing history – just at the rich details recorded by the Nazis of their Final Solution are more than good bookkeeping (Hilberg, 1985). We must and do resist the explicit points of view of artists and film-makers even though to do so is to step outside the cinematic narrative, which itself is contrary to practice. Films in which the characters turn and address the audience, such as in *Tristram Shandy: A Cock and Bull Story* (directed by Michael Winterbottom, 2005), have adopted this novelistic convention in order to overcome the sense of detachment an audience can have when sitting in the dark cinema. In this way, the cinema has followed contemporary advertising techniques of interpellation and thus reinforces dominant values and ways of seeing, such as using cultural codes for signalling moral character, personal values and so on, that often exist in stereotypes (Gaines and Herzog, 1990).

The contemporary social philosopher Richard Rorty (1989) associates character types with specific social locations. He believes that the category of the 'ironist' reflects the moral temper of our times. Such a

character values the idea of a 'core self' that emanates our ethical best but also understands the necessity of the opposite, namely, being able to invent an identity to suit the fluid character of cosmopolitan life. The ironist must embody an adventitious and contingent subjectivity that employs the flexibility of identity to good effect but, at the same time, the ironist laments that the 'true self' has been substituted by a repertoire of manoeuvres and calculations based on the metro scripts of urban life. Rorty's views are found in popular culture, for instance, in the knowing and ironic character of Shrek's donkey (an echo of Don Quixote's Sancho Panza) in *Shrek* (directed by Andrew Adamson and Vicky Jenson, 2001), the hard-boiled detectives of Dashiell Hammett and Sara Paretsky, the fictional celebrities in Bret Easton Ellis's books *Glamorama* (1999) and *Lunar Park* (2005), and the honourable heroes in the Stephen Frears films *My Beautiful Laundrette* (1985), *The Grifters* (1990), *Dirty Pretty Things* (2002) and *The Queen* (2006).

Traditions and conventions are constantly rewritten and invented to suit circumstances. Advertising slogans may work at one point in time, but not at another. We are told, for instance, 'Cars love Shell', 'Coke is It', 'Planet Reebok exists', and we find these assertions credible, amusing and acceptable; but only for a time. Then they date and lose their cachet. It is a process that is inevitable yet remains difficult to predict. How long will an advertisement work? How long will a cliché produce a predictable response? Producers of art forms and popular culture constantly confront such problems. While popular culture always appears self-evidential and natural (Heller, 1999; Hobsbawm and Ranger, 1983), it is also the case that its depictions of everyday reality have a short life span; they are heavily glossed by ideology, and after a time this becomes more visible and less persuasive. We grow immune to the familiar.

While our knowledge of the everyday world comes in a variety of demotic forms that makes the Zeitgeist seem natural, we are also conscious of being spectators to an external world that seems to be

passing us by. The texts of popular culture are not about natural life, even though they often seem to be so. This is the paradox of art. Reading high or low cultural forms, the classical novel or the mainstream television sitcom, embeds us in an intellectual process through which we learn, not only about the locality of cultural knowledge, but, more importantly, about the arbitrariness of the art form and its genre. Art is evidence of the freedom of the intellect; it is a sign of human invention (Eagleton, 2005). Texts in popular culture instruct us in the multiplicity of realities. We experience the thrill of seeing the gothic, romantic, nostalgic, conventional and ironic all at once, layered over the same object, rewritten and reproduced in myriad forms, simultaneously and playfully, and with this familiarity about the creation of points of view we also understand how art makes life and why reading the art form, be it Hollywood comedy, television sitcom, advertisement or painted self-portrait, is also about understanding ourselves. Art and real life are both fictional accounts of each other, and we variously play the spectator and artist with varying degrees of enjoyment.

Self-Fashioning

At the same time, it is deeply problematic to assume a neat correspondence between art forms and reality, as Platonists have argued for hundreds of years. Yet the ease with which we deduce characteristics of human nature from staged performances legitimates the aesthetic realm as a source of general social instruction. When Rock Hudson changes his character and sexual identity in order to deceive Doris Day in *Pillow Talk* (Michael Gordon, 1959), when Professor Higgins transforms Eliza Doolittle from an unconvincing street urchin into a credible and seductive figure of minor aristocracy in *My Fair Lady* (George Cukor, 1964) and when Richard Gere reinvents Julia Roberts as a jet-setting celebrity socialite in *Pretty Woman* (Garry Marshall, 1990) – making

it seem as if it were only her body (and not her innocent psyche) that had been trapped inside a sex worker – we are presented with case studies on how to invent identity. Such makeovers are not only common in modern entertainment, but provide one of its strongest appeals (Dyer, 1992). The 'before' and 'after' photos of satisfied customers who have lost weight on a new diet formula, or have been transformed with breast implants or dental surgery, are common styles of advertising that now appear regularly on television and in magazines.

Contemporary culture is a form of social instruction that can evolve beyond its original inception. The dance style of Michael Jackson, for example, through his best-selling video *Thriller*, infused itself into youth cultures across the globe, giving a common identity to hip hop, break dancers and street groups who were otherwise separated by class, nationality and language; Bob Dylan was a prophet for an entire generation from Eastern Europe to the South Pacific; Alfred Hitchcock intensified the battle of the sexes for mid-America and Western Europe; and *Seinfeld* (1990–8) invented a new urban vocabulary for the 30-somethings across the globe. These cultural forms have heightened our attention to details in a literal sense and demonstrated again how certain styles and self-fashioning in appearance, manners of speech and bodily gestures can be used to produce groups who recognize each other, who are, in effect, a community of practitioners.

Such fashions in the habits of living reinforce the playfulness of inventing our self. Popular culture thus functions as a toolkit for shaping identity. This is historically interesting as well as economically consequential as global consumer markets regulate the products we use to effect these makeovers. The daily requirement to perform an identity naturalizes this state of affairs. We accept the necessity to enact ourselves, say, at a job interview or in a business meeting, on public transport, at the tennis club or the shopping mall. If we do not act, if we are passive, blank or hesitant, we break social rules. Our compliance with

these tacit expectations builds a double consciousness and we learn to see social interactions as replete with moments when we need to conceal truths about our selves and also to exaggerate claims, such as when we are trying to impress others.

The possibility of continual self-invention introduces an element of self-conscious playfulness into all sociability. At that moment when we begin to interact with another, a series of calculated decisions are made. These calculations take place in another dimension of the social moment, a separate back area where we estimate the degrees of fictionality that the immediate situation can sustain. In that moment, and throughout the encounter, we continuously consider how earnest, bland, amusing, comedic, threatening or polite we can be. We might decide at one point to follow the conventions of the situation and display predictable forms of good manners, and at another, to resist the conventions and risk the outcome. Sometimes there is good reason to disturb the rules and accept the increased risk and, at other times, such conduct may seem to be a mistake. In these instances of self-invention we signal to the observer how we think the world at large works, and where we belong in it.

Much of popular culture reinforces the importance we place on physical appearance as indicative of identity. The Marx Brothers' comedies, which were hugely popular for the decade of the 1930s, demonstrated the ease with which identity could be switched by changing a name, hat or coat, and part of the enjoyment of doing so was to produce a sense of chaos and uncertainty. From the mid-twentieth century onwards much of the mass media around retailing and advertising has also promoted the idea of the self as a plastic commodity. Every day, in myriad ways, we are directed to think about identity and, as a result, we harbour contradictory narratives. We are coherent, self-determining beings who can make life whatever we want – and the opposite, we are deficient beings who need to compensate for a lack of character, senti-

ment and skill, which we can do with the easy purchase of a new car, cosmetic dentistry or a total makeover.

Such preoccupations with identity have been bolstered by professional studies of social character, beginning with early theorists from the mid-twentieth century (Fromm, 1956; Mills, 1946; Riesman, 1950). The general idea suggested through these early works, including Goffman's *The Presentation of Self in Everyday Life* (1959), repeats the view that societies produce the kinds of individuals they need and, in turn, individuals become capable of making the society that suits them. Individuals develop into characters who want to act in the way that they have to act in order to be successful. This does not necessarily mean we are over-socialized, that is, made into artefacts of the moment in a one-way process by forces beyond our control. Such an idea is culturally repellent, as we like to think of ourselves as the contented embodiment of economic and historical necessities, coupled with the capacity for independent thinking and the ability to shape our own values, tastes and subjectivity. Yet much of popular culture delivers a pre-defined way of thinking about identity that combines contrary and ill-fitting viewpoints. Becoming an instant celebrity overnight by winning an *Idol* contest, or the lottery jackpot, or the *Survivor* gameshow, is promoted as a dream come true, but at the same time we are subtly instructed to be ordinary, to accept circumstances and not 'rise' above ourselves (as with, for example, *Seinfeld* or *Kath and Kim*).

The Popularity of Disguise

Embedded in *Psycho* (1960), *Dressed To Kill (1980)*, *The Vanishing* (1993), *The Bourne Identity (2002)* and many other 'psychological' films are definitions of identity that complement dominant views. The self is thoroughly sentimentalized; it is variously seen as a *Doppelgänger*, interior diary, portable touchstone and inner voice that we rely on to

make sense of our circumstances. At the same time, it is a source of anxiety; after all, we know how much we style ourselves to meet the occasion, how fully we calculate the risks and view the other with an evaluative eye. Presumably, others are doing the same, and given the ubiquity of self-presentation we are often curious about whom we are actually meeting in the public arena and whom we can trust.

Shakespeare's *Twelfth Night* and *A Midsummer Night's Dream*, and old fairytales such as Little Red Riding Hood and Sleeping Beauty, are cultural antecedents that make use of disguise as a narrative device (Warner, 1994). Stephen Greenblatt (2004) explains the popularity of disguise in his novelistic reconstruction of William Shakespeare's life, *Will in the World*. He draws on the reliable pleasure that audiences have derived from *A Midsummer Night's Dream*, which hinges on the raucous humour of the troupe of artisans: Nick Bottom the weaver, Francis Flute the bellows-maker, Tom Snout the tinker, Snug the joiner, Robin Starveling the tailor and Peter Quince the carpenter. This troupe of ordinary people turned amateur actors demonstrates the pleasures of play-acting. They variously disguise themselves as beasts and gods, then fail to keep the illusion, breaking their disguises in order to speak to the audience directly, then resuming their incongruous roles. Shakespeare's comedy, with its play within the play, and unexpected confusions of identity alongside convincing illustrations of the power of illusion, succeeds in demonstrating the profound paradox of art, that it is both revealing and obvious and, at the same time, suggestive and unlimited. It unleashes the imagination by turning a bumbling joiner into a lion and a middle-aged woman with rotten teeth into a fair damsel (Dulcinea); it produces a fantasy world that far exceeds reality while also making reality easier to see. Popular entertainments encourage us to understand the instability of the social world by representing it both as a stage upon which we act and from which we want to escape. We project ourselves into amusing circumstances and, at another time,

try to evade their demands. Watching ourselves through these cultural enactments is reassuring insofar as we succeed in acting out what we think and feel, but it also illustrates the inherent difficulties of giving a good performance and of holding character.

The sitcom has been immensely popular in film and television history, continuing in the narrative tradition of Shakespeare. It engages us in the familiar and demonstrates the multiple levels of society. It shows characters going about the business of daily life but, like Snug, Snout and Bottom, they are able to step out of character (much to our delight) to resist certain imperatives of the situation. Watching the social ingenuity of characters as they manage complex and confusing moments is instructive. *Seinfeld* (1990–8), *The Osbournes* (2002–5), *Big Brother* (1999–), *Home and Away* (1988–) and dozens of other popular television programmes can be read as guides to the conventions of urban life. These are demonstrations, after all, of identity variously revealed and reinvented and we can chose to regard them as sources of authoritative reference, diversionary entertainment, substitute communities, and so on.

The organic relationship between popular culture and personal values is impossible to link causally yet equally it is impossible to deny. The prevailing features of the moment do not mechanically influence us in a one-way coercive direction but neither do they leave us untouched. In this way, popular culture is like a rapid and continual series of switching points where mass-mediated images and messages become absorbed into everyday habits and then, at other times, are displaced and sidelined. The vocabulary and fashions in popular texts are translated into everyday elements of real social life. Popular entertainments provide a backdrop that moves in and out of prominence to frame our activities and act as the foreground at certain defining moments in our lives. Films such as *Pillow Talk, Down with Love, Gone with the Wind, Pretty Woman, Legally Blonde, True Lies, Saturday Night Fever,* and so on, which have minor cinematic and aesthetic value, nonetheless

provide visual displays of everyday values that have become prominent simply because of their huge popularity. As an audience we learn to see ourselves on the screen and, in turn, the techniques of representation shape desires and pleasures and become constitutive elements in the invention and management of identity.

Mainstream cinema reinforces the view that psychology and appearance are intertwined. Characters show how they can transform themselves by donning a pair of spectacles, changing clothes, self-consciously affecting a manner of speaking and exaggerating their good manners. A transitory subject position is thus reinforced. Much of the pleasure of such texts is in their twists and surprises that keep us engaged in puzzling out 'the truth' against a backdrop where we assume everyone is trying to deliver a credible performance. Psychological thrillers, espionage stories, journeys of discovery, murder mysteries and the *noir* genre all exploit the idea that the subject is self-inventive and identity plastic.

There are no simple assertions to make about the function of popular culture, despite some obvious questions. Were the audiences for Shakespeare's plays at The Globe very different from those sitting in the contemporary cineplex watching *Love Actually*, *Clueless*, *American Beauty* or Fellini's *8½*? Are there similarities that bridge the temporal divide? To explore the nature of modern social life, over a broader time span (perhaps as long as the five centuries of the modernist project) we can see how forms of popular culture are related to the habits and patterns of everyday social life. We do not know how influential Shakespeare's plays or the early novels were in shaping individual consciousness, but we can see fashions in thinking about our selves in relation to the popularity of certain entertainments. Was the huge success of the television sitcom *Seinfeld*, for instance, involved in defining a generation of 30-somethings? If not, how do we account for the success of a television show ostensibly about nothing?

By the same token, *Pillow Talk* was the second largest-grossing film of the 1950s. It starred Doris Day as the pure American career girl working in New York City and Rock Hudson as a debonair music composer with too many girlfriends and not enough privacy. These two were joined by the unlikely situation of living next door to each other and sharing a telephone line. Brad Allen (Rock Hudson) was rarely off the phone, thereby preventing Jan Morrow (Doris Day) from conducting her freelance interior decoration business. Every time she picks up the handset she overhears snippets of his seemingly continuous telephone sex. The narrative of *Pillow Talk* hinges on the escalating feud between Jan and Brad, who unwillingly bump into each other on the phone but have not met face-to-face. Whenever Jan overhears Brad's effusive and insincere outpourings of love and desire to countless adoring women who do not know of each other's existence, she is deeply offended. His predatory masculine appetites suggest he is selfish and debauched. In contrast, Brad is offended by Jan's moral superiority and her sexual unavailability. He imagines her impervious to the pleasures of the flesh. By a series of deliberate deceptions, Brad introduces himself to Jan disguised as Rex Stetson, a mild-mannered multi-millionaire looking for an interior decorator, and he proceeds to exploit Jan's ignorance of his true identity until the whole fabric of deception is finally undone, and they fall into each other's arms, happily in love.

Love for Sale

The narrative is predictable and the ideas familiar. She will eventually fall for him even though she begins by disliking him; he will come to respect her even though he enjoys toying with her affections. The film operates from the basis that men are predators and women prey, that the love impulse begins in hostility, the battle of the sexes is without end, the bedtrick is always funny and dissemblance is not serious, indeed, it is the way of the world. These viewpoints are presented as com-

monplace and even reassuring insights into human nature. The formula of this film has been highly successful and Hollywood has made it over and again, sometimes even with the same actors – *Lover Come Back* (Delbert Mann, 1961), *That Touch of Mink* (Delbert Mann, 1962), *The Thrill of It All* (Norman Jewison, 1963), *Move Over Darling* (Michael Gordon, 1963) and *Send Me No Flowers* (Norman Jewison, 1964). In 2003, Ewan MacGregor and Renée Zellweger did it again in *Down With Love* (directed by Peyton Reed) in which MacGregor is the calculating playboy Catcher Block who disguises himself in order to deceive Barbara Novak (Zellweger), the feminist journalist whose career to date has been to expose the myth of romantic love. As the film narrative progresses, the *frisson* between the two dissolves their differences, and eventually his cynicism and her resistance convert into a happy love match. The popularity of such comedies of manners has made their formulaic narratives into seamless extensions of the real taken-for-granted world.

The easy elision of film and real life is deliberately cultivated by the Hollywood machinery, beginning with official movie star fan clubs in the 1950s that provided versions of actors' lives to a public willing to believe what they saw. It was an era when actors changed their real names to more glamorous monikers (Norma Jean to Marilyn Monroe, Archie Leach to Cary Grant, Bernie Schwartz to Tony Curtis). The line between the fabricated, fanciful and real was being blurred. Eva Illouz (1997: 33) describes the idealized Hollywood couple from the silent movie era, Mary Pickford and Douglas Fairbanks, as emissaries of the new consumer age that would soon grip America for much of the long twentieth century:

> the nascent movie industry, then, exploited the themes of love, marriage, and happiness in terms of consumption, leisure and fun, and it collaborated with the burgeoning advertising industry to make these ideas widely available to a public eager to learn and adopt new standards of romantic and sexual behavior.

Gossip magazines reported film stars falling in love on the set of their recent movie, thereby suggesting the chemistry on screen was not acting, indeed, that it was palpably real.

This was supposedly the case when the sparks ignited between Angelina Jolie and Brad Pitt on the film set of *Mr and Mrs Smith*. Soon the mass media were playfully suggesting names for their expected love child, and the couple was amalgamated into 'Brangelina', another amusing instance of merged identity following the example of Jennifer Lopez and Ben Affleck who were dubbed 'Benifer'. When Angelina Jolie had partnered Billy Bob Thornton, it was widely reported she wore a vial of his blood around her neck, as jewellery and as a sign of mergence. In these ways, the interiors of film spill off-screen and mingle with the actors' real lives, emphasizing how natural it is to invent and play with identity. Again, the on-screen chemistry of Katharine Hepburn and Spencer Tracy was portrayed by Hollywood as the real thing, while the grimness of their private 25-year relationship was concealed. Bogart and Bacall, Elizabeth Taylor and Richard Burton, John and Yoko, Emma Thompson and Kenneth Branagh are other famous couples renowned for having an underside to their lives.

Off screen, actors have very different identities; they are not their screen personas yet the continual blurring of these boundaries is to the advantage of the entertainment industries. It creates audiences prepared to believe in their products. Marlon Brando's polymorphous sexual appetites were normalized as far as they could be by the fiction of his interracial (code for mongrel or gutter) origins, and gay actor Rock Hudson who died from Aids was repeatedly accepted as a heterosexual lothario throughout his film career. Doris Day was the 'eternal virgin' yet a co-star in Doris's first film in 1948, Oscar Levant, was reputed to have said, 'I knew Doris Day before she was a virgin' (Vanneman, 1999: 1). To the knowing audience, there has always been another level of amusement in watching Rock Hudson, the gay actor playing a hetero-

sexual pretending to be gay in *Pillow Talk*. For the rest, the world on screen is an alluring suggestion of how life can be.

Mainstream and classical Hollywood films reinforced the view that psychology and visuality were closely linked. In an advertisement for *Pillow Talk* an image of two parallel bathrooms were positioned side by side. In one, Jan Morrow (Doris Day) is relaxing in a deep bubble bath while, at the same time, speaking on the phone. Her long legs are stretched out and propped up against the wall, and a thick soapy lather clings to her limbs in a suggestion of luxury and femininity. Unknown to her, in the next frame, as if next door in an adjoining apartment, Brad Allen (Rock Hudson) is also in the bath, speaking on the phone, and his legs are propped up against the wall. Without the dividing partition, their naked feet would be touching. The double domestic scene in the parallel bathrooms emphasizes the binary world of gender opposition. The juxtaposed feet signal the *frisson* of desire while the shared telephone line locks Jan and Brad into naked opposition. They might speak to one another and have plenty of daily contact but they remain disembodied. Overhearing conversations makes them intimate, but they remain invisible to each other. This advertising image of the twinned bathrooms and the almost touching feet signifies the romantic undercurrent as well as the slender divides that keep people both separate from and unknowing about each other.

As film technology improved it closed the gap between the naturalistic representations of social life found in popular culture and the real lived conditions of the contemporary world, and in this way gained status as reportage, as an authoritative source of information and insight. Thus it has successfully positioned itself to reflect on the world at large. Going to the movies therefore becomes a way of learning about other lives and, at the same time, it is a training ground for how to occupy multiple realities. If popular culture can be treated in part as a commentary on everyday life then *Pillow Talk, Mrs Doubtfire, Dressed to*

Kill, Superman, Torn Curtin, Catch Me If You Can, Little Miss Sunshine and so on, are ciphers to the mid-twentieth-century world of their audiences.

Life Imitates Art

Like any art form, film amalgamates fantasy with convincing detail and in so doing makes itself a credible reflection of its context. In this way the Hollywood product creates a Zeitgeist and positions itself as a source of insight into modern society and human psychology. The huge commercial success of *Pillow Talk*, for instance, carried its cultural assumptions about the pleasures of deception, self-invention and gender trouble to large audiences. The film advertised the value of playing with the surface. It addressed the pleasures of a good performance and the harmless consequences of dissemblance. Brad Allen's fake identity as a naive cowboy, for instance, was an invitation to a generation of film goers to consider the ease with which fabricating an identity could be a way of being in the world. John Malkovich has advanced the position more recently in *Color Me Kubrick* (Brian W. Cook, 2005) with a narrative that stretches credibility to endorse the strong appeal of pretence.

The popular television sitcom has also encouraged a playful approach to self-presentation and identity. It engages the viewer in the modest world of familiar everyday tasks, recreating the frustrations, fears and desires that presumably we all share. It engages us across a number of registers, so while the characters go about the business of daily life, they can also be seen to resist it. They complain about their friends, gossip about co-workers, get confused, make deals and break them, survive embarrassment, speak out of character by dropping their social masks, invent enemies, steal one another's lovers, reveal secrets, act in response to imagined moral imperatives and manage, when all is said and done, to exert some directorial control over their own circumstances.

Sitcoms and romantic comedies, in general, symbolically resize our circumstances, making them more manageable. *Buffy* (1997–2003), *Friends* (1994–2004), *West Wing* (1999–2006) and *Home and Away* (1988–) variously show how the boss at work can be bested, the disappointing lover reprimanded, the mocking associate sidelined. Whatever we imagine as personal weakness, imperfection, obsession or failure can be naturalized and normalized. Popular television and cinema transform dysfunctional and unreliable characters into endearing familiar friends. They depict worlds where right always triumphs and success is possible. They make the world seem easy even when it is confusing. Through much of popular culture we are exposed to the tensions between truth and trickery; appearances are simultaneously everything and nothing. They produce a reality and suggest, at the same time, its opposite. Good guys and bad guys merge and reverse positions; Luke Skywalker becomes Darth Vadar, the righteous crime-fighter (Batman, Sherlock Holmes, the Terminator) becomes an inverted neurotic who is unstable and untrustworthy.

Seinfeld, the most widely watched US sitcom in the last decade of the twentieth century, while being about nothing, was replete with lessons for life. Its core characters were constantly interfering in each other's lives, challenging one another's decisions, being derisive of one another and self-obsessed. In many ways this Manhattan-based universe resonated with Thomas Hobbes' (1588–1679) view of modern society as a war of all against all. For Hobbes, the best form of society emerged when self-interests were controlled by an over-arching *Leviathan*. Without this, life was 'nasty, short and brutish' (1947 [1660]: 64). In *Seinfeld* the emotional register between the characters was inflected with competition and self-interest; they shifted back and forwards from predator to prey, from winner to loser. There was little affection demonstrated between them yet the spectator saw them as fused together in an indissoluble knot. The sitcom manages to interpellate us by

outlining a variety of ways in which we can get what we want. We find an affinity with one or other of the characters and through an association with them we gain a sense of control that might otherwise elude us in the real chaotic social world.

Popular culture is not simply diversionary; it circulates ideas and brings complex questions to our attention. Difficult issues about the historicity and visuality of subjectivity, for instance, are blended into popular culture through entertaining films as diverse as *Tootsie* (Sydney Pollack, 1982) and *Mission Impossible* (Brian de Palma, 1996) and daytime television programmes hosted by Oprah Winfrey and Doug Parkinson. If I choose to disguise myself, if I cross-dress or wear distinctive clothes, am I as I appear on the surface or as I am behind the look? In the film *Tootsie*, is the cross-dressing male actor transformed by his experiences as a compliant female? Or if I wear a Stetson hat and pretend to be a millionaire cowboy as Brad does in *Pillow Talk*, is my identity changed? The answer may well be yes. After all, by the conclusion of *Pillow Talk*, Brad has become the type of man represented by his character Rex. After 90 minutes of the film Brad is no longer a bachelor flirt but a dedicated husband-to-be. Does this mean, by implication, that if we fake a persona or have a makeover and consciously rethink ourselves in order to appear different, do we actually encourage a new self to emerge? Who are the real *Mr and Mrs Smith*?

The debates about such matters are carried through mainstream entertainments in much the same way they have been framed by classical thinkers such as Heraclitus, Descartes, John Locke and David Hume. Discourses on the nature of identity extend from one extreme where it is regarded as unstable and fragmented, subject to impulse and contradiction (am I the same person I was yesterday?), to another position where it is seen as an obdurate core, *homo clausus*, an essence that verifies our difference from others. Lightweight and seemingly benign vehicles of popular entertainment such as *Queer Eye for the Straight*

Guy, Agony Aunt, Nip/Tuck, Extreme Makeover and the diet compe-
tition *The Biggest Loser* all address the question of identity. It can be
argued that such programmes cultivate knowledge of the techniques
for delivering a good performance and thereby make the presentation
of self a naturalized part of daily life. Yet, if the invention of identity
is part of ordinary daily life then it follows that everyone is acting;
we are all engaged in interpreting social scripts, worrying about un-
receptive audiences and how best to audition for our favourite roles.
With that realization, coupled with the emphasis given to self-presen-
tation in everyday social congress, the idea is clearly being advanced
that the self as an inherent and essential quality of human nature is
being passed over in favour of an invented, cultivated manner of being
that is tailored to every social circumstance and context. It is an idea
with a long and circuitous history; the psyche, soul, self and subject
are terms variously used to address the complex question of how we
become who we are.

Coincidental with the popularity of *Pillow Talk* and *Some Like It
Hot*, Goffman's first book, *The Presentation of Self in Everyday Life*, was
published. While it was not ostensibly a manual on how to succeed in
society, it soon became one. It was a re-working of his doctoral thesis
in anthropology that examined the social habits and practices of Shet-
land Islanders, yet it captured the popular imagination. It described
the inner workings of the social encounter and outlined the rules that
brought about social success. For a readership caught in a moment of
cultural restructuring, where opportunities for social mobility were
opening, the book became a touchstone. The American general pub-
lic responded to it as if it were a DIY guide that addressed the rising
sense of anxiety attached to metropolitan life. Goffman had detailed
communicative competence and given an account of how individuals
avoided misunderstandings and resolved conflicts between the inner
and outer life. It provided examples of identity being glossed by body

language and tone of voice, of struggles for emotional clarity being re-
solved through simple gestures such as eye contact and blushing. In
many ways the playfulness of *Pillow Talk*, which appeared in the same
year, 1959, was an echo of Goffman's systematic study of the rules and
principles governing the performance of identity and social disguise.
While Goffman had written an academic treatise on the rules of so-
ciability in a remote village community, the general reading public in
mid-twentieth-century America seemed drawn to his descriptions of
the stylishness and theatricality of interaction, and the opportunities
this afforded for dissemblance.

The Following Chapters

While the overall argument of this book is infused with Goffman's
quirky approach to social life it draws as well on historical accounts of
how identity has been displayed conventionally and how contempo-
rary popular entertainments disseminate specific assumptions about
human nature. These diverse perspectives on identity often differ from
those that commonly shadow our ordinary everyday movements, and
it is these incongruities too that are explored in the following chapters.
A common contemporary assumption, for instance, is that identity can
be changed and improved. We understand that personation requires
performance and so identity, as a result, is better considered as a public
display more than a private state of being. From various critiques of our
performances, we might be convinced that we lack certain capacities
and need to rectify this with a new wardrobe of clothes, a diet, cor-
rective surgery, transcendental meditation and alimentary irrigation.
Such is our infatuation with the importance of the self that it means we
accept the need to groom and style it. We use physical appearance and
material possessions to express identity; we accept a complementary
connection between inner character and our material circumstances,
yet, at the same time, we like to think there are more permanent quali-

ties that define us. Somehow we live with these contradictory views: we sense we are more than an expression of economic and historic events, we are more than meets the eye, we are not a mere shadow of circumstance. However, we also believe that something is held in abeyance, that there is an obdurate true core, although we are not always confident of knowing the nature of this submerged self.

Three clusters of interests around these questions of identity formation and presentation are pursued in the following chapters. The first addresses the social value accorded personal identity and the perennial interest shown in dramatic narratives of self-invention. The case studies of an impostor, Martin Guerre, a transsexual trickster named Agnes, and the aristocratic British spy Anthony Blunt are used to illustrate the enduring fascination we have with dissemblance, and the apparent ease with which some of us can control the opinions of others. The second cluster of interests addresses the diversity of cultural products such as film, television, fashion, celebrity and advertising that work as collective mechanisms sustaining the prominence of identity in everyday life. The mechanisms and techniques employed by these different texts are set aside in order to focus on their common interest in self-promotion. Finally, the visualization of identity as it is embedded in material possessions is discussed in relation to the role of status symbols in ordinary social life. Fashions and consumer interests that personalize material goods are examined for their particular influence in shaping lifestyles in a multiply divided habitus. Threading through these clustered interests are side discussions about the permeability of the linked concepts of self, psyche, subjectivity, interiority, identity and character. No attempts to define these ideas are offered, for much the same reasons that definitions of other essential ingredients of the human experience like love, desire, ambition, grief, cruelty and so on defy capture in neat definitions. Yet their daily importance and centrality to how we see ourselves remains.

The exploration of self-invention provokes questions about our relations to the material world, to consumerism, possession and the fashion ethic, and how these have influenced the semiotics of appearance. Has the emphasis on looks sustained the fashion industries, especially the cosmetic and pharmaceutical manufacturers? Has this trend, coupled with the expansion of new communication technologies, increased the power of the visual to determine what we accept as real? To explore the last question for a moment gives licence to ask how influential a romantic comedy like *Pillow Talk* can be. It is not trivial or unimportant that the film reached huge audiences in the late 1950s. Hollywood was then an unrivalled machine engaged in the manufacture of the popular imagination and it delivered to its audiences products that were, in effect, incarnations and endorsements of particular social values. This capacity of popular culture to shape everyday life produces an unsettling feeling of disproportion about the overlapping proximity of cultural representations with the real socio-political world. What are we to make of a mass media that addresses us so effectively and appears to capture our interests so accurately? Does this induce feelings of trust in the media, or nervousness and anxiety that it is remaking us in its image?

From the late nineteenth century onwards popular audiences have grown in size owing to the new technologies of mass communication. Today's audience is more diverse than Shakespeare's daily crowd of a few thousand spectators in the Globe Theatre, yet it appears to share with them, across the temporal divide, an interest in the pleasures and practices of self-invention. *Pillow Talk* (1959), *Some Like It Hot* (1959), Shakespeare's *Twelfth Night* (1623), Perrault's *Little Red Riding Hood* (1697) and *The Picture of Dorian Gray* (1890) all play with the pleasures of dressing up, putting on a disguise and faking it. In so doing, these tales (and many others) sustain a cultural reliance on spectacle as a source of insight, and at the same time they carry an embedded anxiety about the reliability of the fashioned persona.

The privileging of the visual over a long period of time (dating from the ancient Greeks in Western epistemology) has sharpened our perceptual skills. We can see in various cultural histories the techniques that have trained us in visual acuity. In the history of manners, for instance, we are being trained to observe the other, to become the audience and spectator to their performance. Similarly, in the evolution of styles in art we can see how visual history and various mannerisms such as Renaissance perspectivism, Baroque clutter, Romanticism, modernist linearity and the more recent encounter with the postmodern surface have independently trained us to read appearances and study style in order to see the image – to see it as convincing, deceptive, illusory, misleading or persuasive. There is now enough ambiguity around the interpretation of appearances to make us sceptical of what we see, and it is against such a cultural background that the consideration of styles of display of identity becomes much more interesting.

A quip from Oscar Wilde and another from author John Banville frame the argument of this book. In *The Picture of Dorian Gray*, Wilde writes, 'it is only shallow people who do not judge by appearances. The true mystery of the world is the visible, not the invisible' (1973 [1890]: 32). In *The Untouchable*, a fiction about the British spy Anthony Blunt, Banville (1997: 144) suggests the opposite, that we are always acting and cannot be sure that there is anything more: 'one has to live a life always at an angle ... to be oneself and at the same time another ... nothing, absolutely nothing, is as it seems'. Bridging these literary positions is the visual image of the *Spiral Jetty*, the colossal sculpture by Robert Smithson, built in 1976 at Rozel Point, Utah, and now submerged beneath the lake. The sculpture was constructed like a modern macadamized roadway. Heavy machinery graded earth and rock, compacted them into a hardened structure, smoothed the surface and trimmed the edges. However, instead of running in a direct line as most roads do, linking one destination to another, Smithson's spiral jetty circles

in on itself like a snail's shell and fails to function like a conventional jetty giving moorage to sea craft. Instead, it is a monument to aesthetic excess and failed functionality. In these respects it parallels the concept of self as a site of rich speculation and theoretical ingenuity that has no identifiable end point but which continues nonetheless to enrich our discourses and aesthetic works while progressing into an increasingly tight spiral.

In the following chapters, the discussion circulates around self-regard and the intense attention paid to self-fashioning. Part I contains two establishing chapters. The first presents three studies of famous deceptions and these are intended to highlight the techniques that can be mobilized to produce a convincing sense of self. These accounts are not isolated, indeed, the stories themselves are of enduring popularity and continue to provide entertainment to audiences fascinated by the types of characters represented by, say, Brad Allen, Catcher Block, Dorian Gray and Viola from Shakespeare's *Twelfth Night*, who seem confident of pretending to be someone else in order to take advantage of a situation. Permeating these narratives is a tacit belief that not only does everyone perform, it is also the case that everyone lies.

The next establishing chapter gives a history of the importance of manners. It uses the sixteenth-century commentaries of Baldassare Castiglione to demonstrate how manners address the immanence of chaos in everyday life. Displays of good manners are capable of building trust between individuals, of conveying to others that one is self-aware and controlled, willing to play by the rules; but they also remind us that such performances can collapse. Manners are an art form; they are instruments for describing position and status as well as solving the problem of the stranger. Hannibal Lector can hide himself on the streets because he is mild-mannered and well presented: so can the well-heeled spies of the Cold War, the fictional character of Patrick Bateman in *American Psycho*, Iago in *Othello*, and Dorian Gray.

Manners reflect how we think about others. They train us to be close observers of patterns and nuance, they help us to imitate one another while at the same time retaining a sense of separateness. They bridge the inside and outside but remain an unstable architecture that forces us into patterns of activity that may differ from our privately held views on the external world. How we think of identity arises in large part from observations of the body and its deportment. In the history of manners, the detailed attention given to the body by Erasmus, Castiglione, de Courtin and others was not only about changing customs around hygiene, it was about developing the capacity to see one another as constitutive elements in every social situation and to train us to craft acceptable social identities for every circumstance.

There are certain ways of using the body to influence the opinions of others. The body is often the first visible sign we draw on to make judgments of one another. Its size and shape, facial expression and hand gestures are inscriptions of culture and history made into flesh. This explains in part the endurance (despite numerous refutations) of physiognomy as a system for reading one another. We learn about our self through the reactions of others. We learn that the controlled body is a passport to sociability.

The chapter on manners and etiquette begins with a novelistic account of how a slight breach in manners can catapult the individual into unexpected territory. Drawing on Patricia Highsmith's Ripley novels, I present examples of how skills in calculation and social observation are used as foundations of sociability as well as techniques we cultivate in order to manage, dupe and deceive one another. Viewed in this way, the conventions of manners can be seen as a training ground for sharpening our powers of observation, developing social acuity and our styles of self-presentation.

While it is assumed that thinking about identity is a useful technique for shaping the world to our liking, it also makes us slightly more

vulnerable to those who would sell us back what we think we lack. Part II reviews how the purveyors of fashion commodities use them as sources of identity and we are led to believe that buying another suit of clothes, bottle of perfume, motor car or wristwatch will be good for us. Beginning with a chapter on identity and on current fears of identity loss, of being 'anonymized', we can understand how material objects and the body-as-commodity have become important sources of identity. The spurious tenets of physiognomy, a method of interpreting human nature based on physical features, are often found in the cultural stereotyping of appearances. Hollywood films use these codes for quickly conveying complex ideas about character. In Alfred Hitchcock's *Spellbound*, for instance, when Ingrid Bergman is introduced as the psychiatrist Dr Constance Petersen, she first appears wearing spectacles. This unfashionable look speaks of her remote professional stature. As the narrative progresses, Bergman's spectacles are removed, her clothes soften and her demeanour alters. She becomes more emotional and feminine. Without her spectacles she is re-coded and becomes attractively sexy. Chapter 3 reports on fashions in thinking about identity and the physiognomic emphasis given to appearance as part of the language of popular culture.

These mechanisms for reading character date back to Aristotle and then traverse centuries of thought in order to reappear in mainstream Hollywood films and contemporary pop culture. The endurance of the perspective begs the question of how this viewpoint, with its specious heritage, continues to circulate and garner credibility through centuries and across cultural forms. Why has so much value been accorded to physical appearance? One answer lies in the flexibility of the body itself: when it becomes an object and commodity, as it does in the era of modern advertising and conspicuous consumption, it is separated from any metaphysical concerns and becomes a blank slate capable of carrying any number of adornments, disguises and masks.

Chapter 4, 'Advertising', begins with the example of an advertisement for a new car that promises to deliver great sexual pleasure. The advert eroticizes the car and in so doing promulgates the view that commodities have identity. Thus, it is not a beer we reach for but a *Stella Artois*, not a cigarette but a *Peter Stuyvesant*, not a hamburger but a *McDonald's*, not a tissue but a *Kleenex*. The argument of the chapter develops around the viewpoint that objects as mundane as cars, soap and shoes could not be sold to us in such vast quantities unless they were successfully invested with attractive human qualities. We know, though, that objects are inanimate, that they do not possess personality, yet the buoyancy of a consumer society requires that we suspend disbelief.

Objects are invested with identity to make them interesting, but this is also confusing. How can both objects and people have personality? We might want a Porsche because of its supposedly masculine attributes or wear high stiletto heels because of their association with feminine qualities, but we might wonder, at the same time, how these qualities became embedded in the objects. We might find it convenient to use heavily coded objects such as shoes, jewellery, cars and clothes, to broadcast gender identity in the public domain because this makes the performance easier to effect. At the same time, these techniques make it harder to trust what we see. After all, if we learn to be adept at performing ourselves, presumably others are doing likewise. This leaves the question unanswered of who are we encountering in the public space of the social encounter.

The final chapter in Part II, 'Fashion', examines the social consequences of using material goods to display identity. Historically, possession of goods has been a reliable guide to social status. The European sumptuary laws, variously enacted between the thirteenth and eighteenth centuries, ensured that only some people could own and display goods. For instance, the opulence and extravagant patterns of

consumption associated with Italian and French court societies and the sixteenth-century church were justified by a divine claim for the superiority of these classes. Material possessions and social position overlapped, but such associations are now much harder to assert with any confidence. Modern banking systems readily advance financial credit to customers and this has provided many with the opportunity to consume and display goods they may never own. This is one way that conspicuous consumption complicates the question of identity. Examining the role of fashion teases out some of the nuances of consumption and enables us to consider how much of everyday life is shaped by social forces that we fail to recognize or else choose to ignore. Discussing the emphasis on looking good through these chapters on identity, advertising and fashions may provide an antidote to the overly groomed self that populates many routines of everyday life, and it may also militate against the pursuit of remedies designed to compensate for the inadequacies that we are urged to think are inherent in our nature.

In the summative Afterword, the fundamental issue of the relationship between the inside and outside, between how we understand ourselves and how identity is represented in the public domain, is revisited. This discussion is not a historical recapping looking at the transitions between concepts such as the ancient Greek psyche, the Christian soul, the Cartesian philosophical self and the postmodern subject. Rather it is an overview of the cultural shifts that have moved assumptions about identity away from a transcendental view of the self as a unifying concept that gives meaning to everyday experience by linking it, say, with forces that precede and endure beyond the singular lifespan of an individual, to an alternative view of the self as a necessary fiction, an unstable persona that is swiftly invented and reproduced in the moment to give a sense of stability, endurance and longevity. It is this latter process of self-invention that has underpinned the discussions in this book.

In visual terms, Rene Magritte's image of the masked identical apples encapsulates the viewpoint. In this painting, which appears as part of a fresco on the gaming room walls of a Belgian casino, we are presented with a paradox: what does the mask worn by the identical apples reveal or conceal? In everyday social interaction, we are continuously faced with the masks of others, with their cultivated personas, fashionability and social suavity, and we have learned to respond to these accordingly. We observe and calculate in rapid time how to complement or oppose the other's presented self. In ordinary social life there is a great deal of traffic around the invention of identity, and its navigation requires highly developed skills in observation, calculation and dissemblance. In this last summative chapter further instances are given of the techniques and mechanisms by which we have grasped the social implications of a normative regime in which fabrications, deceptions, disguises and inventions are accepted as elements of interpersonal currency.

We live now in a period of intense visuality and this has brought emphasis to the ambiguity and playfulness of appearances. The popularity of mainstream cinema, the effectiveness of visual advertising and the economic exuberance of the fashion industries all contribute to the dominance of a scopic regime. At the same time, the availability of abundant techniques for shaping appearances has added to the ambiguity of reading them. From Descartes' assertion that consciousness produces identity, to John Locke's questions about the seriality of identity – am I the same person in the day as the night? – to the playfulness of Brad's entrapment of Jan with his faked identity, there is a long history that records the difficulty of reading identity. These concerns have not remained within the rarefied spheres of abstract and philosophical enquiry but are commonly rehearsed in mainstream entertainments and popular culture.

In the course of this account of self-invention, we can see that there are turning points in the reliability of what we see and know. These

are often recorded in popular culture and are carried through various modes of entertainment. Within the popular imagination, many of the enduring questions about identity and human character are shaped into accessible expressive forms – for instance, Locke's complex question is re-formulated in the film *Mr and Mrs Smith*, about the couple who change their identities between day and night. Through such entertainments we are presented with the possibility that social exchanges are formulated from fictions and infused with duplicity. The question is presented to us regularly: what might it mean to live in a society where the instability of identity and the presentation of the self are commonplace? The final comments in this chapter are not focused on defining the nature of the self or subjectivity, nor on evaluating the ethical implications of a regime of dissemblance, but on examining the playfulness produced by deception and the ease with which we live with contradiction, paradox and invention in everyday social life.

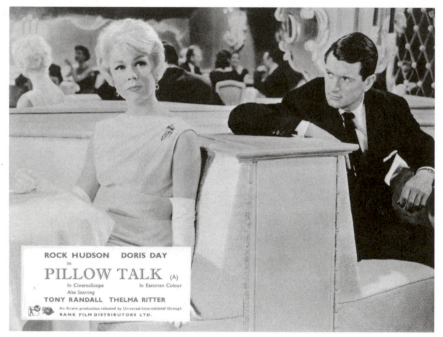

2. *Pillow Talk* (Ronald Grant Archive, 1959).

PART I
Self-Invention

3. *Mystery of Life* (Shirley Cass, 2005).

1. The Impostor, Trickster and Spy

The lie, the perfect lie, about people we know, about the relations we have with them, about our motive for some action, formulated in totally different terms, the lie as to what we are, whom we love, what we feel with regard to people who love us ... that lie is one of the few things in the world that can open windows for us on to what is new and unknown, that can awaken in us sleeping senses for the contemplation of universes that otherwise we should never have known.

Proust, *The Captive*

Martin Guerre

The strange story of Martin Guerre has been recounted many times over. It contains all the elements of an enduring moral tale – it is a family saga with episodes of ambition, scandal, adultery, sibling rivalry, embezzlement, attempted murder and deceit. It is a story that probes into the deepest inward spaces of the private self, recounting experiences of embarrassment and cunning as well as pride and desire. The specifics of the case involve the impersonation of a rich villager who had abandoned his young family, whereupon the impostor succeeded for many years in pretending to be the original Martin Guerre.

In 1548, after ten years of married life, Martin Guerre disappeared, leaving behind a wife, child and a relatively prosperous estate. A decade later a man who had persuaded Martin's wife, Bertrande de Rols, to accept him as her husband, was unmasked by the courts as Arnaud du Tilh, aka Pansette, a nickname according to Natalie Zemon Davis that meant 'a man with big appetites' (1983: 37). For a number of years, Tilh enjoyed life as Bertrande's spouse and stepfather to the original Martin's only son, Sanxi. Two further children were born during the ensuing years, and one, Bernande, survived, to become Sanxi's half-sister. As happy and congenial as the marriage between Bertrande and the new Martin Guerre seemed to be, the affair ended in two courts of law, undone by the testimony of more than 150 witnesses. The two judges, François de Ferrières and the appeal judge Jean de Coras, both decided independently that Tilh was guilty of fraud (although Coras came to the decision with strong reservations) and Bertrande de Rols was declared innocent of complicity and portrayed as the victim of a deliberate deception.

The circumstances that precipitated the first legal battle began in 1558 when, after some time as a happy family, the new Martin took an active interest in the Guerre business and wanted access to the book-keeping and accounts. When the elders in the family resisted, Martin resorted to legal intervention and brought a civil suit against his supposed uncle Pierre. From this moment on, the domestic peace of Bertrande and her new husband was over. The offended uncle became increasingly suspicious of Martin's claimed identity and proceeded to spread the word that he was a trickster. Despite the fact that the new Martin had been much more pleasant as a friend, neighbour and relative, others in the community readily adopted Pierre's position. The village shoemaker, for instance, who was called to give evidence at the trial, was convinced the new Martin was a liar – how else to explain that his feet had grown smaller over the years? Yet it was also the case

– as revealed through the investigations of the court – that the shoe-maker was an old drinking companion of Pierre and his recollections may have been muddled. Still others were divided in their opinions: 'for some, the new Martin was an upstanding householder, husband, and rural merchant, unjustly slandered by a greedy uncle; for others, he was a glib impostor robbing an established family of its reputation' (Davis, 1983: 55).

The first trial found the claimant Martin Guerre guilty, but the second appeal trial almost succeeded in overturning the first court's decision when the real, and now one-legged, Martin Guerre (which was ironic given the evidential importance placed on his feet size) returned to the scene. The judge, Jean de Coras, had interviewed large numbers of people and the majority were against the defendant, but Coras had considered the testimony of those closest to Martin, namely the sisters and parents of the immediate family, and found these to be more valuable (and they had supported the new Martin's claim). As well, Coras was persuaded by Bertrande's confidence; after all, she had lived with the man for three years, shared his bed and supported him in the face of opposition. The man calling himself Martin Guerre was charming and good-hearted, and Coras seemed secretly admiring of the as-yet-unmasked impostor.

Throughout the months of interrogation Tilh had not faltered, he had not failed to identify a witness or corroborate their stories with persuasive anecdotes of his own. He was always calm and credible. In contrast, the uncle Pierre Guerre had revealed himself to be deeply hostile to Martin, he had at one stage tried to have him murdered, and Judge Coras was increasingly unsympathetic towards him. In professional terms, Coras was responsible for establishing reliable evidence and this required him to get beneath the surface performance to uncover the legal reality of the situation. It was his role to distinguish formal truth from the lived narrative, and the institutional fundamentals

from the social and functional ones. However, from an ethical position Coras was more inclined to declare Arnaud du Tilh innocent, even if he was guilty of impersonation, as this would be better than making the mistake of condemning an innocent man. Such a conclusion had the added benefits of returning a husband to Bertrande and a father to her two children.

Such reasoning itself is revealing of a new manner of thinking about the relations between individuals and their situations. It is a manner of thinking that recognizes contingencies and the possibility of individuals being deliberately calculating and opportunistic. Coras was drawn to ignore set juridical traditions in favour of a pragmatic solution that recognized individuals as actors in a world of their own making. This evidenced a new manner of thinking about people and their identity. However, at the moment when the appeal court was about to make the final decision, a man with a wooden leg appeared on the scene and claimed to be the real Martin Guerre (Davis, 1983: 81). Coras was initially sceptical but eventually after further investigation he was obliged to accept the one-legged Martin as the rightful man. The impostor was subsequently charged with conspiracy to defraud and was dealt with harshly; indeed, he was condemned to death. Bertrande was found innocent; her crime was being a woman and thereby intellectually inferior and thus susceptible to persuasion and trickery. She was not, but could have been, considered a conspirator in the plot.

The endurance of the tale may be accounted for by the intriguing questions it poses about identity and deceit. At the most obvious, the story is a bedtrick. One woman and two husbands – one likeable the other not; a family estate; a judge who understood and admired intelligence and the capacity for self-fashioning. As Davis (1983: 103) remarked in her analysis of Jean de Coras, he was a sophisticated man of his time and thus knowledgeable about self-fashioning, 'about the moulding of speech, manners, gesture, and conversation' that could

help an individual advance to higher social positions. The remarkable performance of Arnaud du Tilh and the convincing delivery of his 'thousand necessary lies' would have appealed to an educated man like Coras, and though the deceit raised questions about personal identity and social facsimile, it was also a bravura piece worthy of applause. A century earlier, Baldessare Castiglione, the chronicler of the Italian court society, had described such social sagacity as *sprezzatura* (literally, effortless superiority) and he had upheld its importance in cultivating the best possible and most civilized society.

Other reasons for the longevity of the tale of Martin Guerre may be its historical location on the cusp of modernity. The invented marriage of the impostor Arnaud with Bertrande can be regarded as a precursor to modern relationships based on romantic love and free choice. The arranged marriages of the sixteenth century, for the upper echelons and sometimes even at the level of the landholder in society, could be conventionally burdened with commercial expectations and the ambitions of families to gain greater social influence, as was the case with the Rols–Guerre arrangement.

The notoriety around the case of Martin Guerre could also have been fuelled by desires to resist some of the changes that were insinuating themselves into society and weakening the established class arrangements. Michel de Montaigne, in his colossal enquiry into introspection and the character of the self, had taken note of the Rols–Guerre case and regarded it, in part, as a portent of future social change (Davis, 1983: 119). The story of Martin Guerre might have appealed to Montaigne as a demonstration of the art of self-fashioning as he himself placed great value on the self-made, highly observant individual (Auerbach, 1957: 307). For Montaigne, the core of the human condition was a source of continual change that could only be explored and understood through a reclusive life, spent in meditation. The business of living took place in the crowded public domain where it was impor-

tant to be amiable with others, to demonstrate an aptitude for human contact and show presence of mind. He observed that such qualities were enjoyed by the impersonator Arnaud du Tilh, who seemed adept and assured with people. Montaigne could admire such qualities but he valued privacy and introspection as more important in the cultivation of authentic selfhood.

Within the tale, there are unanswered questions as to how Tilh managed to deceive so many people for so long: how did he become so knowledgeable about the details and secrets of Martin Guerre's domestic life? How did he know about the early sexual difficulties with Bertrande, and the pressures from her family to declare the end of the marriage? Was the humiliation of the original Martin Guerre so well known throughout the village and even into the regions beyond that gossip picked up by Tilh was sufficient to school him for the impersonation? Or was there a compact of sorts between the real Martin Guerre and Tilh? Was there an intimacy between them, perhaps another layer of the bedtrick, which could account for Tilh's confidence in his recreated performance of Martin?

The various modern commentaries on the case, and the novels and films it has inspired, often reconstruct the sixteenth century through a contemporary psychological lens. For instance, a remake of the tale by the American actor Jodie Foster emphasized its elements of dramatic romance. *Sommersby* (directed by Jon Amiel, 1993) used the American Civil War as the backdrop against which Laurel Sommersby (played by Foster) struggled to maintain the farm after husband Jack had supposedly been killed. Jack (Richard Gere) then reappears and they are happily reunited but soon the doubts begin. Is Laurel fantasizing about Jack – is he real or an apparition? This Jack, like Arnaud du Tilh, is a much nicer, gentler, more appealing husband and the Hollywood retelling of the story is inflected with the modern psychological theme of transcendent true love and the psychological tricks that can follow the

trauma of deep loss. Even in Davis's (1983) professional historical account, contemporary ideas of romance and identity filter in and strike the reader as anachronistic psychological formulations. Davis, for instance, considers it possible that the original Martin suffered from the modern malaise of diasporic dislocation and she projects this idea onto the original narrative.

The Guerre family had migrated from the Basque country. As Martin was a young boy at the time and retained a local dialect and accent, he was probably singled out from others in the adopted village of Artigat. Over time, while the family established roots and become more prosperous, Martin may have felt the pressures of family expectations to build on the successes of the migrant experience. Indeed, to advance this proposition an arranged marriage was formalized between the Guerre household and the affluent local Rols family, and when this was put into effect the intended spouses, Bertrande and Martin, were still in their early teens.

However, while the marriage was a union of two families who were both interested in improving their social positions, the expectations of the arranged marriage were not fulfilled. After many years, there was pressure from Bertrande's family to declare the marriage null and void, thereby allowing them to plan for another more successful union for their beautiful daughter. Davis (1983: 20–1) considered these factors as possible contributing factors to Martin's sudden abandonment of the marriage and his disappearance from the village. He was, she opines, discontented with family life and the pressures it generated; he was known throughout the village as a failed husband. Davis considers it reasonable to conclude that Martin was suffering from the modern vagaries of depression, dislocation, anomie and even sexual nausea.

Other issues evoked by the narrative of Martin Guerre relate to the haunting effect of doubles, *Doppelgänger*, twins and mimes. For instance, the involvement of Coras in the case brought him personal fame

and notoriety. This was unanticipated and in some sense it linked him to Tilh as an intellectual double and that, in turn, adds another layer to the tale. Their celebrity is linked and amplified by the other. Visual representations of how one individual can slide into another are common enough. The somewhat mysterious photographer, Brassai – aka Gyula Halez (1899–1984), born in Brasso, Romania – has a photograph of two figures, entwined with each other, their backs to the camera. One wears the coat jacket of the suit (plus felt hat) and the other wears the trousers. Nothing else. Here are twins of a kind, mirroring each other and constituting one another. The double, *Doppelgänger* and twin are common figures in the cultural imaginary and they demonstrate the multiple facets of identity. Such representations are symbolic of a social life in which we habitually define and invent ourselves in the exigencies of the moment. The twin or double is normalized as part of the mechanics of social interaction but, at the same time, there is a haunting suggestion that the double can be a hidden or submerged self, a character from a parallel world who knows more than appearances suggest. In this way the double exceeds the limits of the immediate situation, inferring that there is another world beyond the obvious.

The twin, the impersonator and the double are remarkable for their svelte performances. The twentieth-century case of Ferdinand Waldo Demara Jr (b. 1921) was enshrined in the Hollywood movie *The Great Impostor* (directed by Robert Mulligan, 1961), with Demara played by Tony Curtis. The film reveals a lifetime of convincing performances as Demara gained positions as a university professor, surgeon, public accountant, teacher and psychologist (Schwartz, 1996: 71). He was credible, charming and successful. In 2002, Steven Spielberg made *Catch Me If You Can* starring Leonardo Di Caprio, a film about a master of disguise, based on the autobiography of Frank William Abagnale (2001).

These instances of successful deception have mass appeal and make profitable entertainment which, at face value, may seem counter-

intuitive in that their narratives recount the unreliability of appearances and the fragility of social reality. They assume a public social domain in which performances and scripts are de rigueur, in which we all expect to encounter fabrications and the deliberately misleading display. Paradoxically these work to reinforce a belief in a stable interior core over which we drape fashions in identity. The twin, then, can be seen as both a split personality and a mirror reversal. The former suggests a close intimacy while the latter has an ominous overtone. The twin, double and impersonator are repeated devices in literature and popular culture that are always suggestive of opposition, difference and possibility, even when presented in as benign a form as the mainstream Disney film *The Parent Trap* (directed by David Swift, 1961; Nancy Meyers, 1998).

The story of Martin Guerre is an encounter with a double that brings about social disarray and at the same time demonstrates there are opportunities to reinvent oneself for social advantage. Arnaud du Tilh invented a 'better' Martin Guerre and this led to the realization that a good performance can produce its own rewards. Deception multiplies possibilities and brings into existence the danger of the unexpected. *Frankenstein* (Shelley, 1831) and *Dr Jekyll and Mr Hyde* (Stevenson, 1886) use the formulation of the double. These tales suggest the second identity is a portent of unanticipated horror. The darker second self demonstrates how easily the other persona can slide into a more frightening guise. The twin and the double reinforce a belief in a deep-seated anxiety that appearances can lie, that the surface reality can fall away and reveal a more dreadful universe.

The bedtrick is another basic plot that propels much of Western high culture, and it works from the assumption that appearances can be deceiving. Shakespeare's *All's Well that Ends Well, Measure for Measure* and *A Midsummer Night's Dream*, Mozart's *The Marriage of Figaro* and *Così fan Tutte*, Strauss' *Rosenkavalier* and in popular

culture *M. Butterfly, Some Like It Hot* and *Pillow Talk* are all instances of the bedtrick. The bedtrick is not simply the discovery – sooner or later – that one's sexual partner is not who they claim to be. The bedtrick also highlights the arbitrariness of desire. One can experience a strong attraction to another and engage them sexually only to have the attraction drain away almost instantly, thereby leaving us wondering. This kind of bedtrick is about the disillusionment of the sex act:

> a man or woman goes to bed with someone s/he is crazy about and wakes up to discover the astonishing fact that the body in the bed belongs to someone entirely different, someone hated or alien or just *different*. Now, this is not just a myth. It happens to all of us, all the time, for that ol' black magic, sexual passion, is transformative … it changes our view of our partner … we go to bed blinded by desire and wake up with our eyes relatively cleared by satiation. (Doniger, 2000: 3)

In the case of Tilh pretending to be Martin Guerre, he could not know in advance the outcome of his sexual encounters with Bertrande; what would she say or do after the first sexual intimacies? The bedtrick makes us think again: can we rely on the surface performance? Does the unsaid seep beneath the surface? Is there always another layer to the appearance of things, even in the privacy of the bedroom? Is the surface always at odds with the back story? Is Proust right to say (in the epigraph opening this chapter) that unless the surface is rippled, the new and unknown will remain closed to us?

Agnes

The case of the transsexual Agnes, from the archives of twentieth-century American medicine and ethnomethodology, provides another example of the ambiguity of appearances and the difficulties of separating the various layers of social reality. Agnes's story begins in

November 1958, a few months before the publication of Goffman's *The Presentation of Self in Everyday Life* and the cinematic screening, in that same year, of *Pillow Talk* and *Some Like It Hot*. Agnes was then 19 years of age.

She maintained she had been raised as a boy even though she was a girl. In February 1958, after becoming seriously involved with a man she wanted to marry, and having some difficulties with the intimate and sexual aspects of the relationship, Agnes sought help from her hometown physician in the Midwest. She asked him to write a professional letter describing in general her physical condition and with the letter she hoped to reassure her fiancé, Bill, and dispel the problems that threatened their relationship. This tactic appeared to be effective for a short time but, in June 1958, some four months into the relationship, Agnes explained the real situation to Bill. She told him, or probably revealed to him, that she was anatomically male. The relationship continued. The following March, about nine months from this point in time, Agnes secured sex reassignment surgery.

Agnes was originally referred by her physician to Dr Robert Stoller at the Department of Psychiatry of the University of California, Los Angeles (UCLA). Stoller was working with others in the Departments of Urology and Endocrinology on inter-sexed individuals, some of whom had severe anatomical irregularities, and Agnes arrived at the clinic seeking surgical modification. Her pathway to Stoller through the normal system of medical referral for specialist assistance added credibility to her story.

Harold Garfinkel, a sociologist, and Alexander Rosen, a psychologist, also became involved in the investigation of Agnes's dysmorphia. Garfinkel (1967: 117) reported that her female measurements were 38–25–38; she was visually, on the face of it, a well-developed and conventionally shaped woman. Her facial complexion was smooth, she was narrow-waisted and seemed very feminine – except that she also had

a fully developed penis and scrotum. Agnes was seeking surgical inter-
vention to remedy this apparent quirk of nature.

 She told Garfinkel that she had been living as a woman for about
three years. She had recently become involved with Bill, and their rela-
tionship was being strained by the abnormalities of Agnes's body. Bill,
it seemed, was eager to have sexual intercourse and Agnes wanted to
oblige her future husband. After extensive interviews, Garfinkel was
convinced that Agnes was indeed a socially successful woman and her
sense of being female was entirely appropriate:

> At the time of her first appearance she was dressed in a tight sweater
> which marked off her thin shoulders, ample breasts, and narrow
> waist ... There was nothing garish or exhibitionist in her attire, nor
> was there any hint of poor taste or that she was ill at ease in her cloth-
> ing, as is seen so frequently in transvestites. (Garfinkel, 1967: 119)

With this description, Garfinkel supplied us with his own unmediated
assumptions of the feminine ideal, namely that a woman should be
demure not flagrant and aware of her physical attractiveness to men
without being sexually knowing or self-conscious. With hindsight, the
contemporary reader of Garfinkel's description would be immediate-
ly alerted to his prescriptive gaze. He saw signifiers of femininity – a
shapely figure, demure behaviour, smooth skin – and drew a conclu-
sion that would eventually be proved wrong.

 After regular consultations with various doctors at UCLA, Agnes
was diagnosed as suffering an endocrine abnormality and it was decid-
ed the best response would be a castration operation. The surgery was
performed in March 1959: the penis and testes were amputated and an
artificial vagina and labia were constructed. It took less than six months
for this process from initial consultation to final surgery; a period of
time much shorter than current practices that usually require individu-
als to live in society as a member of the desired sex for a substantial
period before the irreversible surgical procedure takes place.

Alongside the sex reassignment of Agnes are two further parallel narratives of some significance. One involves the emerging careers of the attendant researchers Garfinkel, Rosen and Stoller, who were professionally at the edge of a new and nebulous scientific inquiry into human behaviour, and the other concerns Bill and Agnes, two young lovers engaged in the early months of a presumably passionate romance.

It was important for Robert Stoller, Harold Garfinkel and the other professionals involved that before performing irreversible surgery on Agnes they were correct in their diagnosis of her condition. A great deal of conversation and formal interviewing took place in order to understand what sex meant for Agnes, what she understood about sexual identity and her future social prospects. Garfinkel (1967: 122-37) reported at length on these exploratory discussions and as a result understood her to be a genuine case of sexual abnormality. He was reassured by his observations of her sustained and hyper-vigilant approach to her own social performance as a female. In specific instances when her daily enactment of femaleness did not convince others, she reported to Garfinkel that she was deeply distressed. Thus Garfinkel accepted that Agnes lived constantly with the fear of social failure. She convinced him of her general state of anxiety, of her fear of degradation, loss of reputation and social marginalization that would result from a simple slip in her performance.

Agnes regarded sex as a discrete single category in which there could be no ambiguous membership, and she impressed Garfinkel with this strong belief. Even though she herself was an instance of this ambiguity, it was part of her campaign to secure surgical sex reassignment that she impress upon Garfinkel and his associates that having an ambiguous identity was unacceptable. Agnes was adamant that every individual had a moral right to be a member of a single sex category and, as a result, to be treated as natural and normal. She wanted that for herself. Agnes was insistent that her body was a mistake; she was

outside the norms for reasons beyond her control and it was the moral responsibility of medical science to alleviate her distress and give her a legitimate sexual status. Agnes's vociferous claim, that the world owed her an identity that she could occupy with dignity, was a view that Garfinkel found conveniently compatible with his new sociological theory of ethnomethodology.

To see the social world as a highly charged moral universe, where rules and their transgressions were obvious, and where it was recognized that they had significant social impact, lent support to Garfinkel's professional position and career ambitions. Ethnomethodology did create some celebrity for Garfinkel during the 1970s but not much beyond. His theory rested firmly on the contention that every situation was heavily rule-bound and individuals within the situation were not always capable of managing their maintenance. The methodology for uncovering the social rules that governed behaviour was simply to break them; Garfinkel suggested to students of ethnomethodology that they act in unpredictable and sometimes anti-social ways in order to break up a particular social scene and reveal its prescriptive scaffolding. As the method was clumsy and the results were difficult to codify, the future of ethnomethodology was limited. Nonetheless at the time, during the formative years, it influenced Garfinkel's reading of Agnes.

As Garfinkel delved into Agnes's personal views on sexuality and femininity, he found what he wanted, namely an evidence-based outline for ethnomethodology that emphasized situated, rule-governing behaviour. In turn, Garfinkel's professional manoeuvres suited Agnes, who was trying to convince the experts of her anomalous sexual identity and secure the much-desired surgical makeover. Thirty years later such situations are completely different; access to sex reassignment surgery is a matter of health policy, not individual opportunity. Rosen and Garfinkel would not now be able to act so independently of popular opinion and regulatory policy. In the UK, Sex Discrimination Regulations

were passed by the government in 1999, thus providing many more opportunities for individuals listed on the National Health Service (NHS) seeking sex changes. In 2004, the Gender Recognition Act was passed, enshrining the rights of individuals who had received gender reassignment. Such changes in legal and professional frameworks have meant that individuals wanting gender reassignment are no longer dependent on finding willing practitioners like Rosen or Garfinkel, who were at the margins of their professions at the time and were the only ones willing to experiment with gender identity.

Even when it was revealed years later that Agnes was a biologically born boy who did not have an endocrine imbalance but did have a personal determination to get sex reassignment, Garfinkel's interpretation of events did not alter. His *ex post facto* rationalization of the episode used Agnes's convincing performance as a woman to prove his theory of social life. Garfinkel credited Agnes with a superior knowledge of the social rules that she in turn manipulated to get what she wanted. She was able to convince the professionals that she shared their values and understandings about biological sex; she tacitly understood that she had to be what they wanted her to be, namely a quirk of nature and an instance of rare endocrine abnormality. Only with a medical problem such as a severe hormone imbalance could she gain sex reassignment surgery.

This determined performance by Agnes to invent herself impressed Garfinkel. To him, Agnes had performed as she should have done, as if she was a true female; Agnes was the coy, sexually innocent, fun-loving, passive, receptive 'young thing' that every girl should be (Garfinkel, 1967: 129–30). She favoured feminine tasks, she elicited jealousy from other girls when boys were on the scene. She was completely dismissive of her sex organs and regarded her penis as 'anaesthetized'. Agnes fervently believed the world was populated by two sexes only and this was the basis of her urgency to obtain surgery (Garfinkel, 1967: 122–3). Garfinkel was impressed by her confidence and this exerted

pressure on him and his associates to recognize the primacy of sex identity as a 'natural fact of life' (Garfinkel, 1967: 124).

In the published appendix to the case, Garfinkel acknowledged to some extent that he had been duped about Agnes's physical condition, but not about the social rules of performance that constituted his new sociological theory. As it turned out Agnes was not a true mistake of nature, she was not a biological freak, she was not a truly inter-sexed person, and she was not suffering from a rare endocrine disorder that feminized the sex organs. She was, however, knowledgeable about the rules of self-invention and was able to deliver a thoroughly convincing performance that was sustained over many months in the face of prob-ing professional examination. Indeed it appeared, with hindsight, that Agnes had deliberately misled Garfinkel and his associates in order to get what she wanted. While we cannot be sure about Agnes's motiva-tions, as she has not put her side of the story on the public record, it appears that she was a genetic male, that she had been raised a boy and she had knowingly taken female hormones in order to affect physical changes to her body. It is also reasonable to assume she was not sexu-ally innocent, that she was knowledgeable about sexual relations and capable of maintaining an active relationship (with Bill, and others) and that her performance as a female was the result of careful study and self-discipline.

Agnes knew she was not as she outwardly appeared, but she also knew that most people trusted appearances – thus all she needed was to perform successfully as a girl to become a girl. She understood this fundamental truth of sociality from her years of cross-dressing and 'passing'. She performed her identity as a social drama and manipulated the therapeutic situation with Rosen and Garfinkel to produce what she wanted – a surgical makeover. Agnes managed to shape Garfinkel's opinions in order to ease him into the decision of supporting her re-quest for sex reassignment. This was a neat double deception: Agnes

was a boy but was convinced he wanted to be girl and so he managed to convince Garfinkel and others to make him a girl.

Garfinkel's conduct in the Agnes episode is an intriguing secondary thread. After the fact, he knew Agnes was an accomplished liar yet he explained it away by suggesting everyone has to lie at some time or other because social life is riven with ambiguity. He reported that Agnes had told him 'it is necessary for me to tell little white lies a lot of the time' but neither Garfinkel nor Stoller became suspicious enough to think that Agnes could have been systematically lying to them (Garfinkel, 1967: 169). When they asked if she was taking hormones and Agnes denied it, they believed her. She lied well enough to convince them to give her corrective surgery: 'I *deserve* the status that unfortunately I find myself in the position of having to ask for' (Garfinkel, 1967: 176–7, emphasis in original). Agnes convinced them she was sincere and Garfinkel accepted she was truthful. He noted that she was an overly serious person and that she rarely laughed or played. He reported that she became impatient with him whenever he asked her to speculate or imagine how the world might be different:

> The possibility of considering the world otherwise 'just to see where it leads' – a peculiar suspension and reordering of relevances that scientific theorists habitually employ – was for Agnes a matter of inconsequential play ... the invitation amounted to a bid to engage in a threatening and repugnant exercise. (Garfinkel, 1967: 177)

It was years after the surgery before Agnes confessed to knowing more about her own performance than she indicated at the time. After the fact, Garfinkel presented himself as the successful chronicler of Agnes's exceptional abilities to create impressions. He knew she could steer conversations away from difficult areas, that she could remain charming and friendly even when feeling nervous and threatened. He recognized Agnes as a character from Goffman's world of *impression*

management insofar as she was always deliberate and calculating, always trying to anticipate what others wanted of her. As an instance of her *soignée* and ethnomethodology's analytic sensitivity, Garfinkel gave the example of Agnes's response to his request that she simply and straightforwardly present the 'facts' of her case in her own terms. She had replied to his request with a question – whose 'facts' would those be: 'what do *I* figure the facts are, or what do I think everyone else thinks the facts are?' (1967: 174–5 emphasis in original). In this response, Garfinkel felt he had captured the primary tenet of ethnomethodology – that all individuals have the capacity to manufacture the social rules they want to follow.

Robert Stoller described the moment of revelation (October 1966) when Agnes confessed to him that she was not so much his famous case of rare testicular feminization syndrome as a well-constructed drama:

> after having kept it from me for eight years, with the greatest casualness, in mid-sentence, and without giving the slightest warning it was coming, she revealed that she had never had a biological defect that had feminized her but that she had been taking estrogens since age 12.

Stoller was amazed but also amused that

> she could have pulled off this coup with such skill. (Garfinkel, 1967: 287–8).

Garfinkel was less sanguine than Stoller but nonetheless tried to use the disclosure to boost his professional career. Agnes had, after all, given a bravura performance and convinced her interlocutors that she was as she appeared. For our purposes, it is this successful performance that is important, and not the discovery of whether Agnes was a deliberate fake, a real woman imprisoned in a man's body, or 'a crazy, mixed-up kid'.

It could be argued that such a performance now would be unlikely to succeed. Too much material is readily available on the lives of individuals who have successfully 'passed' and Garfinkel, Stoller and associates would be expected to know more about the field and as a result be less vulnerable to a good performance (Garber, 1992; Morris, 1974; Smith-Rosenberg, 1985). Yet at the centre of the episode are interesting questions about the invention of sexual identity. What did it mean after all for Agnes to say she 'felt' like a woman? What did it mean that she claimed to be unproblematically heterosexual, with a new boyfriend to prove it? And what of the boyfriend? He had always stayed at the edge of the therapeutic situation, despite attempts to involve him. And as it turned out, he did not marry Agnes and shortly after her surgery he abandoned the relationship altogether.

The inside of any sexual relationship is difficult to expose. Garfinkel and Stoller appear to have failed to get inside Agnes's sense of sexual identity despite the months of interlocution. Eve Sedgwick has outlined some of the cultural mysteries of sexual identity and in particular has directly asked, what makes an act sexual and what defines it as important to an individual's sense of identity? Had her question been put to Agnes, the narrative of the case would probably be different. It is worth considering, Sedgwick suggests (and it certainly would have been useful for Garfinkel and Stoller to consider), that 'identical genital acts mean very different things to different people', that 'sexuality makes up a large share of the self-perceived identity of some people, a small share of others', and that 'some people, homo-, hetero-, and bisexual, experience their sexuality as deeply embedded in a matrix of gender meanings and gender differentials. Others of each sexuality do not' (Sedgwick, 1990: 25–6).

Contemporary analysts of transgender studies make the work of Garfinkel and Stoller seem in retrospect quaintly timid. Nonetheless, the episode is valuable for illustrating how difficult it can be to denaturalize the social world, to bring out the assumptions embedded in it, in-

deed, to accomplish the ethnomethodological aim and reveal how the social works. When Agnes refused to speculate on how the world could be different, Garfinkel interpreted her reluctance as a lack of intellectual playfulness. We know now that this was a moment of contestation. Her interests were in building a coherent surface performance and Garfinkel's were the opposite, he wanted to unlock the rules that held the surface together. She won that competition and managed to preserve the disguise that she was a woman imprisoned in a man's body.

The success of Agnes in deceiving her interlocutors for so long reinforces the viewpoint that appearances are paramount and the social realities of interpersonal exchange are merely temporal moments in which a tangle of assorted interests are held together for the duration. Judith Butler's extensive enquiries into gender and sexual identity make the same point; practices around the pursuit and achievement of our desires are flexible. Even the stability assumed to exist around the hetero-normative practices of opposite-sex desire require daily restatement; and film, television, advertising, fashions and so on are the available techniques for such reassertion. They evidence over and again the theoretical viewpoint that sexuality, like identity, needs to be continuously socially produced.

Butler points out that there is no reliable logic that links sex, gender and desire. Rather it can be the case that masculinity and femininity do not produce a sense of desire focused on the opposite gender but are indeed fluid and unstable enough to change in different contexts, at different times. Acting out desire can produce it; 'identity is performatively constituted by the very "expressions" that are said to be its results' (Butler, 1990: 25; 2004a). The case of Agnes is useful for showing how a coherent view of identity can be invented from the surface and then applied backwards to become an internal core, much like the techniques of 'method' acting. In some ways, the same process is at work with Anthony Blunt, the political spy who lived at the heart of the British Establishment he betrayed.

Anthony Blunt as Victor Maskell

The fictional account of Anthony Blunt in *The Untouchable* (1997), a novel written by John Banville, recipient of the 2005 Booker Prize, offers a dark analysis of deceit. It novelistically retells how a character like Blunt, a minor member of the British royal family, became the Queen of England's knighted Art Keeper and the last scandalously exposed Cold War spy of the twentieth century. The novel is presented in the first person, as if Blunt, in the fictional guise of 'Victor Maskell', was telling his story after being 'unmasked' at the age of 71 years. In 1964, the real Blunt confessed to the British security services of spying for the Russians but this remained a secret until Prime Minister Margaret Thatcher told the House of Commons on 19 November 1979.

Throughout the novel, we are made privy to Maskell's double consciousness. He repeatedly describes himself as having double, quadruple, multiple lives and interests: 'in my world, there are no simple questions, and precious few answers of any kind'; 'everything was itself and at the same time something else' (Banville, 1997: 28, 47). The character of Blunt seems to have accepted the necessity to remake himself whenever history changes the face of the world (Banville, 1997: 50, 56, 63, 82, 198, 325). Maskell enjoys the instability of the life of a spy because it meant he was not required to be himself. He could always be someone else and thus maintain with impunity his preferred position of detachment, of only

> observing, evaluating, remembering. This is the secret power of the spy, different from the power that orders armies into battle; it is purely personal; it is the power to be and not be, to detach oneself from oneself, to be oneself and at the same time another. (Banville, 1997: 143)

In the early pages of the book a waif-like woman writer who occasionally reminded Maskell of his wife has wheedled her way into

his house and Maskell has decided to make her his mouthpiece, even though he seriously doubts her intellectual depth and ability to understand his position. He slowly relates his story and through this literary device brings the reader into Blunt's world. Maskell considers that his espionage and betrayals of trust are entirely justifiable. He is sustained by a sense of continuity with the ancient Greek Stoics who

> denied the concept of progress. There might be a little advance here, some improvement there – cosmology in their time, dentistry in ours – but in the long run the balance of things, such as good and evil, beauty and ugliness, joy and misery, remains constant. (Banville, 1997: 24)

Such a position allowed Maskell to quarantine himself from many of the consequences of his actions. If men and women engaged in the spy game had been captured, perhaps tortured and even killed as a result of his betrayals, then these were the known hazards of the job. Fortified by the ethical convictions of the Stoics, Maskell accepted that the world could teeter this way and that, a balance could be established and then upset, but, ultimately, there was no fundamental change and certainly no progress.

By way of explaining himself to the young reporter, Miss Vandeleur, Maskell states he was a Stoic first, then a connoisseur, and afterwards a spy. He meant by this that art was his most important interest and by art he meant not just canvases and sculptured objects but also visions and ideals of how the world should be. It is at this point where politics, ethics and aesthetics fuse together. It is here that Banville makes Maskell into an ideologue. Maskell tells Miss Vandeleur that his life's ambition had been to be a painter and when he failed, like so many others before him, he turned this deficiency into a philosophy of aggression and revenge. Maskell tells the reporter, 'so you have before you, my dear ... a failed artist, like so many other egregious scoundrels:

Nero, half the Medicis, Stalin, the unspeakable Herr Schicklgruber'
(Banville, 1997: 23).

The connections to the Nazi regime continue as Maskell further
outlines his views of Stoicism. He tells the story of an exchange between
a Jewish doctor that Dr Mengele had rescued from the execution line
to assist him with his experiments at Auschwitz. During a particularly
gruesome experiment, while the two doctors were working together in
the clinic, the rescued Jew asked Mengele how long the exterminations
would go on, and Mengele's reply was that they would go on and on
and on. Maskell crisply interpreted the account by saying 'And it struck
me that Dr Mengele was also a Stoic, just like me' (Banville, 1997: 25).
Both were seekers of purity, albeit of different kinds; for Mengele this
was the extermination of Jews, for Maskell (and by implication Blunt)
it was the unequivocal support of a higher, nobler cause irrespective of
the social and ethical cost.

For the ancient Greeks, it was important that art reflect the high-
est and finest human qualities and not the most base ones. 'The Greek
revolution', as described by the art historian E.H. Gombrich, gives an
account of a fundamental contest between art that appealed to the
imagination, to what Plato described as the 'lower part of the soul', and
art that appealed to reason. Anthony Blunt mouthed the same values
about the nobility of a life shaped by reason and ideals that resisted
the earthly pleasures of fame and fortune. It was a position that some
of his contemporaries found unconvincing. The celebrated philoso-
pher Stuart Hampshire, for instance, remarked that Blunt was hugely
ambitious, which, if true, was a contravention of his Stoic claims: 'he
always tried to appear above things, that he was wholly absorbed in
thinking about Poussin or trying to be a Stoic', but he also wanted to be
the Queen's Surveyor and 'a dominant figure in the art world' (Carter,
2002: 420). After the public denouncement in 1979, Anthony Blunt was
reported to have said to his brother, 'You must admit I'm a very good

actor'. The comment may have referred to his long life within the British Establishment without arousing many suspicions, as if indeed he had been 'untouchable'. Such an achievement was hard to attribute solely to his personal skills in maintaining the subterfuge, although many of Blunt's associates remarked on 'the compartmentalization of his heart', his cleverness and delight in choreographing his multiple lives (Carter, 2002: 271–2).

In the context of the Cold War and in relation to the other members of the Cambridge group, Blunt's social longevity is part of another political narrative. Kim Philby, Donald Maclean and Guy Burgess had in the latter years of their careers become indiscreet, they had aroused suspicions and eventually been uncovered. Their exposures had taken a long time, though, and there had been many episodes where they had openly spoken of their espionage but not been taken seriously. In the privileged circles in which they moved, the idea that a well-educated and well-heeled young man would actively trade with an enemy power and sell national secrets seemed unimaginable. Even though there may have been moments when etiquette was breeched and suspicions raised, in these mannered worlds such gestures had not been read as signals of anything unusual or dangerous. The regimes of conventionality and politeness provided Blunt with excellent camouflage, just as Agnes's conventional demeanour helped maintain her secret. The political theorist, Isaiah Berlin (1990 [1959]) famously stated that to understand is to perceive patterns. In this instance, the habits and patterns of behaviour for the mannered classes helped to naturalize Blunt's performances and inadvertently sustain his intrigues.

Anthony Blunt championed the seventeenth-century painter Nicolas Poussin (1594–1665), who was at the time relatively unappreciated (Carter, 2002: 28–9). Blunt's choice has been interpreted as a narcissistic gesture toward his own personal values. Both Poussin and Blunt shared a desire to be evasive about personal qualities and deflect atten-

tion from themselves. It seems as if both invented a surface life where little was as it seemed. The self-portrait by Nicolas Poussin (displayed in the Louvre, Paris), painted in 1650 when he was aged 56 years, shows him in a stiff attitude with a rather stern visage, his body at an angle and the eyes directed toward the viewer. It is a posture that suggests a fear of disclosure, a concern with not revealing too much – which itself is odd in a self-portrait. The portrait has a certain mystery as a painting of a painter who appears to be underplaying his part. In the background, there are some canvases stacked against each other that suggest the subject's occupation. However, within the conventions of the self-portrait this painting provides an accurate likeness but not a personal revelation. Recent debates on the history of the self-portrait suggest it has the capacity to be read not only as a statement of social status but also a cipher to the personal (Bond and Woodall, 2005). In the case of Poussin's self-portrait, however, this principle is not followed.

Blunt's own intellectual position blended art with politics. He championed Poussin in order to signal his view that art was more than an aesthetic construct; it was a way of identifying the ideals of civiliza-tion. The overlaps between the seventeenth-century Poussin and the twentieth-century fictional character Victor Maskell combine to build a picture of Anthony Blunt as a detached and calculating figure. Poussin's reputation as a painter was as a chilly master of form; he was the cool chronicler of classical values that he held in defiance of the fashions of his era. Unlike many of his contemporaries, Poussin was untempted by innovation and novelty. Blunt championed Poussin, bringing him out of obscurity to become an influential force in the development of West-ern art. By joining Poussin with Blunt, as Banville does in the novel, an appeal is made to transcendental values as the guiding forces of an ethi-cal life. Blunt's passion and over-identification with Poussin suggest he was driven by principles and not circumstance, or at least, this seems to be how he wished to be represented.

With Blunt, deception had a strong personal appeal and was one of his private pleasures. This was not only evident in his social life but was also part of his professional practice as an art connoisseur. Some considered his good relations with one of the best art forgers of the twentieth century, Eric Hebborn, a dangerous liaison that could have tainted his reputation (Carter, 2002: 393). Yet Blunt's pleasure in the relationship seemed to revolve around the innuendo it created; after all, he was in a position to make and break reputations as well as determine the value and integrity of sizeable art collections. If he was seen as possibly dishonest, as a result of his association with a nefarious character like Hebborn, then he seemed to delight in brazenly accepting the risk. His biographer concluded that he 'quietly enjoyed seeing the art world bamboozled', and added that Hebborn seemed indebted to Blunt for confirming his opinion that Blunt had much in common with the sixteenth-century writer Baldassare Castiglione (Carter, 2002: 394).

Like the subjects of Castiglione's writings, Blunt was driven by self-aggrandisement, and he was familiar with and at home amongst those in the upper classes who sought power and prominence (Carter, 2002: 208). In the context of Blunt's relations with Hebborn, the reference to Castiglione can be read as a warning that Blunt was being derisively thought of as an ambitious, self-seeking performer. As a characterization, it is a view that Blunt himself may well have endorsed. As the fictional Maskell states:

> My life had become a kind of hectic play-acting in which I took all the parts. It might have been more tolerable had I been allowed to see my predicament in a tragic, or at least a serious light, if I could have been Hamlet, driven by torn loyalties to tricks and disguises and feigned madness; but no, I was more like one of the clowns, scampering in and out of the wings and desperately doing quick-changes, putting on one mask only to whip it off immediately and replace it with another, while all the time, out beyond the footlights, the phantom audience of my worst imaginings hugged itself in ghastly glee. (Banville, 1997: 315)

From Banville's novel and Carter's biography we get an impression of Anthony Blunt as an accomplished social actor. He understood the importance of public opinion and the value of a convincing performance. In the novel, Maskell's sense of himself is slightly comic. He claims his life has not been important, that his achievements in international politics have been minor, that perhaps even his role in shaping the art world had not been significant. But the admission is hard to believe because even in the confession he is acting: 'You must never stop acting, not for an instant, even when you are alone, in a locked room, with the lights off and the blankets over your head' (Banville 1997: 371). The desire to produce oneself and the necessity to control the public image are clearly underscored in these comments.

Appearances Matter

These three studies highlight how effectively deceptions can be perpetrated and how convincing some individuals can be in controlling the opinions of others. In each episode the rules of social maintenance smooth over awkward moments of embarrassment and confusion and, in so doing, nullify warnings of potential social havoc. The same point is illustrated again fictionally in *American Psycho* when Patrick Bateman confesses his murderous acts but is not taken seriously. Even when he insists, 'listen to me. Listen very, very carefully. I-killed-Paul-Owen-and-I-liked-it. I can't make myself any clearer', he is dismissed as a jokester (Ellis, 1991: 388). In the novelistic worlds of Patrick Bateman and Victor Maskell the social context framed them within naturalized, non-murderous identities from which they could not escape, even had they wanted to do so.

Stories of such deceptions and subterfuge are firmly embedded in Western culture and raise questions fundamental to the nature of social life; for instance, in situations heavily overlaid with rules and obligations, how do we know who we are talking to? Can we still operate

with confidence when we know that the rules of the game are such that everyone is inventing themselves? How do we imagine the self after we recognize the various levels of social detachment, interior fragmentation and role invention that each of us can achieve? And what do we think of the emphasis given to self-invention through the visual mass media? Does the cult of celebrity in which public personae are obviously shaped and styled make us more sceptical about the portraits of social life conveyed through popular culture?

Modern social relations emphasize the importance of appearances. In every social encounter we are directed to think about how to make a good impression and how to influence the opinion of others. We pay attention to the other, and they in turn pay attention to us. Some of the pleasures of the moment rest with seeing ourselves mirrored in the actions of others and being flattered by them. There is a sense of authority and pleasure to be extracted from such moments and it is easy to conclude from these instances that personal identity is a conceit rather than a deceit. Our training in interactional conventions and the ability to translate the cues of the situation into stylized bodily gestures, facial movements, tone of voice, eye contact, speech patterns, vocabulary and so on, provides tangible evidence of our confidence in reading the social (Goffman, 1967: 8). Occasionally we need to take corrective measures to save face, and sometimes we need to take action to protect the other person from embarrassment or loss of credibility. In all these encounters, we are concerned to avoid difficulties, to present ourselves in a flattering light and to offer a convincing performance.

Everyone Lies

The examples of Martin Guerre, Agnes and Anthony Blunt demonstrate the impact of the convincing performance. These instances are not isolated. Stories of grand deception appear regularly. In 2005, a

London court sentenced a man to jail for 'wholesale identity theft'. The man took the identity of Lord Buckingham in 1983 and continued to use the name and title for 23 years, deceiving his wife and children throughout this time. While Lord Buckingham maintained the title was inherited from his father, the Royal College of Arms stated that the last legitimate Buckingham was dated to the 1700s (see 'Bogus aristocrat gets 21 months inside', 2005: 10).

Similar conspiracy theories and spy stories are frequently in the 'soft' news. The Glen Oakley story is another example – he was a highly paid bureaucrat and influential CEO with an entirely fabricated employment history (Rintoul, 2004). He claimed three university degrees including a Harvard postgraduate diploma and high-level connections into government, NATO and the military. In fact, he had been a morgue assistant from a small country town, but for more than a decade he had convincingly reinvented himself. Being tall, handsome and well presented added to his credibility. He was competent at work and socially fluent; he did not appear anxious or self-conscious and thus did not arouse suspicion. The various psychological tests he had taken during his rise through the echelons of corporate management had not revealed him to be a fantasist or a liar. He appeared ordinary and unsuspicious.

Another example comes from the archives of the American FBI, which recently exposed Robert Hanssen as a long-time double agent. The case made its way into the soft news as a scandal with all the right ingredients – political danger, perverse sex, child abuse and unconventional religion. That the elegant fashion magazine *Marie Claire* excerpted the story adds another interesting layer. The magazine twisted the tale into one of untold secrets from the dark side of the American suburbs where nondescript families like the Hanssens lived ('Crime Report', 2003; see also *Breach*, directed by Billy Ray, 2007). According to this version, Robert Hanssen had joined the FBI in 1976 and until his

arrest in 2002 had allegedly been providing high-security material to the Russians. The American agency had become aware of the security leaks in 1986 and had appointed Hanssen, then a trusted member of the Bureau, to conduct the internal investigations.

After his exposure, he was administered psychological testing in order to find explanations for how he had managed the contradictions of his double life. Hanssen was a devout Roman Catholic, father of six children, and the child of a conservative family, but he was also a calculating undercover agent. He claimed his betrayal was for profit, but an investigative psychologist made much of Hanssen's troubled relationship with his father. His spying was then presented as a psychological failing, a result of poor parenting and a misguided form of revenge against a bullying authority figure. Explaining Hanssen's behaviour in terms of psychological twists was augmented with the release of secret videotapes of sexual relations with his wife that he had shared with his best friend for his private viewing pleasure (Wise, 2002). If Hanssen was a spy it was represented as a consequence of aberrant psychology. Hanssen was the spy without politics; his personal perversities were his more interesting crimes.

The popular media depicted both Oakley and Hanssen as psychologically scarred and outside the bounds of normalcy; the reportage emphasized personal deviances thereby making political and ideological espionage seem rare. Such representations suggest that deliberate fraud is the work of a more rational, controlled criminal perpetrator, an individual more frightening than a psychologically unbalanced suburban father such as Robert Hanssen. Such an individual is more like Anthony Blunt who represents a different order of being, a character who eludes psychological reduction. In a mainstream novel *Fraud* (1993), Anita Brookner creates a narrative in which fraud is a banality, an everyday predictable occurrence. Her lead character is a blank young woman controlled by others:

> I had become what people wanted me to be ... Fraud was what was perpetrated on me by the expectations of others. They fashioned me in their own image, according to their needs. Fraud, in that sense, is alarmingly prevalent. (Brookner, 1993: 221)

If we accept Brookner's view, we enter the analytic territory occupied by Erving Goffman, the fictional terrain of John Banville and Marcel Proust and it is the latter who provides one of the most tantalizing descriptions of deception. Fraud is the perfect lie; it is a radical view of what is obvious; we could see the world differently had we looked at it from another angle, as Vermeer's famous painting of the turbaned girl with a pearl earring supposedly infers. Her backward glance suggests there is another point of view to be considered. Proust (1982 [1922–31]) makes much the same point by asking about the legitimacy of the other's point of view: 'the lie is one of the few things in the world that can open windows for us onto what is new and unknown'. This raises the questions, is it deception if we do not see what is obvious? Is it a lie if we knowingly turn away and refuse to see a different point of view?

The realities of social life are not neatly under control. Mistakes, misinterpretations, misleading gestures and acts of deceit occur constantly, and they are unsettling. These moments are often anticipated in popular culture, which presents us with a continuous stream of the unpredictable and unconventional – men can be women (*Some Like It Hot, Tootsie*), animals can be human (*Babe, Inspector Rex*), spies can be aristocrats (*The Untouchable* (Banville, 1997)), and children can be wicked (*The Bad Seed*, the Artful Dodger in *Oliver Twist, Turn of the Screw* (James, 1922)). At the same time we are constantly reminded of the fragility of the social situation and the possibility that the people we are talking to may be fakes, poseurs, bad actors or glib performers, we are also reassured that such subterfuges are commonplace and familiar enough to find them less threatening than amusing and in some situations even reassuring. In that sense, the lie is a reliable rule of sociality.

Proust's comment at the opening of the chapter alerts us to the possi-
bilities of the lie. If we examine the lie, consider its purpose and effect,
we are drawn to see other universes, other ways of being in the world.
Thus the lie becomes a technique for penetrating the multiple layers of
social life and, in reverse, it is a constituent of those same complex lay-
ers. As effective social beings, we learn to lie and to identify the lies of
others. Indeed, in the traffic of daily life, we can count on the practice
that everyone lies.

4. *After You* (Shirley Cass, 2005).

2. Manners

... the very art that appeereth not to be art

Baldessare Castiglione, *The Book of the Courtier*

Dear Ms Manors,
A recent incident on the roads has greatly puzzled me.

I was driving alone in a large car. The electric window on the passenger side was open about half way. I pulled up at traffic lights. Another car pulled up next door. It was small, overloaded with laughing young people. Their car radio was turned up, their windows were wide open and they were smoking cigarettes. They were conspicuous and noisy and seemed to know it.

As I stopped at the traffic light, I had touched the electric button to close the passenger window. When they turned to look at me, I was looking at them but actually looking at my window. They saw an insulting gesture. I was closing them off. My rising window, it seemed, shut out their music, age, tastes, social values, indeed, their very existence. At least, that's my interpretation after what happened next.

The traffic lights changed, my more powerful car took off well ahead of them. In a matter of moments I reached a slow driving speed and eased off. From habit, I checked my rear vision mirror and there was the car with the exuberant young strangers. They were excitedly gesturing to me out of their windows, flashing their car lights and yelling. I slowed, thinking that perhaps they were warning me I had a flat tyre or a dead body was slipping out of my car trunk. They then moved to overtake, and as they did so, hurled verbal abuse and a handful of dead cigarette butts. They sped off and I slowed down even further.

It is easy to interpret the event as road rage of a kind, a prank or

*even a gesture of class hostility. However it is not that which interests
me so much as the hair trigger – the car window synchronously slid-
ing shut – that seemed to provoke the event.*

*I have wondered ever since – how little does it take, how slight a
movement does one make before raising the ire of someone else?*

Your views would be welcome,

Under Attack

The Welcome Guest

In the classic crime novel, *Ripley's Game* (1974), the author Patricia
Highsmith uses the occasion of a minor breach of good manners
to set in motion a long series of murderous and malicious events.
Tom Ripley, the main character of the novel, finds himself at an infor-
mal birthday party at which an unpleasant remark is casually made that
leaves him feeling insulted. Ripley is a nefarious character with a tainted
past. Once a rich houseguest disappeared in mysterious circumstances
and suspicion fell on him but no criminal charges were ever laid. On
another occasion, he murdered a wealthy acquaintance and concealed
the death in such a way that he became the victim's financial benefi-
ciary. As the novel opens, Tom is living quietly in the south of France
with his French wife, spending his days drawing, painting and looking
after a modest estate. He participates in village life to the extent that
he purchases his supplies from a local merchant and enjoys the kind of
social life that an American can in regional France. By chance, Tom is
invited to the party of another married couple and he attends 'think-
ing that perhaps an Englishman with a French wife might like to make
acquaintance with an American with a French wife living not far away'
(Highsmith, 1974: 10).

The meeting between the two men does not go well, at least as far as
Tom is concerned. At the introduction, his host had said, 'Oh yes, I've
heard of you', and it is this comment that ignites Tom's antagonism and
galvanizes him into vengeful action. This novelistic moment is an exam-

ple of the subtle ways in which individuals communicate their opinions to one another. Like the catalyst of the smoothly closing car window that the fictitious writer 'Under Attack' reported to Ms Manors, it is an instance of how little it takes to arouse hostility from a seemingly casual, even trite exchange. In *Ripley's Game* Tom takes umbrage against his host Jonathan Trevanny without knowing whether the remark was intended to be insulting or was merely gauche. It illustrates the hypersensitivity that loads every social exchange with potential triggers that can radically disturb the balance. In the context of Highsmith's narrative, it is sufficient cause to put both characters in harm's way.

The rules of etiquette can appear frivolous and superficial; they are, after all, not obviously related to the important activities of commerce and politics. Yet they are the medium through which everyday instrumental and pragmatic activities are expressed. Daily life may seem ad hoc but it is heavily structured by the presence of others, real and imagined, and by the weight of conventions. The basic ingredients of easy sociality are trust and predictability. Modern city dwellers are often depicted as atomized, aggressive and defensive, suffering from the stress that some mammals display when the home range becomes competitively overcrowded. Yet it is also in the city where intense sociality takes place between strangers, and where manners are essential. It is not possible to execute the most basic activities such as taking a bus, shopping, banking or walking the dog without assuming that trust exists. How we behave reflects our skills in acting, dissemblance, calculation, role-playing, sycophancy and conformity, as well as our capacity to insert ourselves into the strictures of precedents and be the obliging members of the 'wedding party', to use Erving Goffman's metonym of social life.

Manners bolster the status quo and keep social disorder at a minimum. Breaching manners can be a source of great hilarity. The early comedies of Charlie Chaplin and the Marx Brothers are pitched pre-

cisely at the point of bursting the new modes of etiquette that the rising middle classes were adopting. These comics showed 'no respect', as the bluff American comedian Rodney Dangerfield was noted for saying in the 1980s. The comedy of manners has a long history; *Candide* (1759), *School for Scandal* (1777), *Pride and Prejudice* (1813) and *The Importance of Being Earnest* (1895) each represent styles of comedy around the breach of protocols and manners.

Much of the history of manners shows them to be more significant than merely detailing the conventions of formal occasions such as weddings or official openings of buildings. Manners are about strategies of social exclusion; they define the individual's thresholds of tolerance, of what is acceptable or not. Since the fifteenth century across Europe treatises on social rules have been largely concerned with the control of natural body functions, the appetites and emotions. They have warned their readers about the likely experience of embarrassment and disgust when the controls over the natural body are transgressed. They suggest ways of avoiding such discomforts by recommending specific habits, for instance, that individuals not spit or scratch their private parts or eat noisily in public. Being well mannered and socially adept enables the individual to avoid being a joke and minimizes the risk of humiliation or *schadenfreude*.

In his sixteenth-century treatise on *The Courtier*, the Italian writer Baldessare Castiglione added a dimension to the practice of good manners that has carried forward through the centuries; he shifted the emphasis of manners away from regulating natural bodily functions to a focus on ensuring the good opinion of others. He described manners as being most effective when they were invisible, unremarkable and apparently effortless. This is different from the exercise of rituals and social protocols that tend to be highly visible and executed with flourish. In contrast, Castiglione suggested that good manners must be invisible, they are the 'very art that appeereth not to be art' (1994 [1528]: 53).

The socially adept individual must be intelligent, alert, even-tempered, educated and physically graceful. Such an individual would ideally be open but not shallow, honest without being earnest, and appear to be completely without guile, while not appearing to be naive. Of overriding importance for Castiglione was the display of nonchalance in which there could be no evidence of effort. If the individual was perceived as ambitious and striving, or nervous and anxious, then the performance was a failure. While the socially composed individual always needs to be self-conscious, they must not appear to be so. Any suggestion of this or of trying to confuse others to manipulate their opinions to gain an advantage creates distrust and undermines the social performance. Ideally, one must be ingenuous without being blunt, and completely uninterested in obfuscation, subterfuge or self-promotion.

Knowing how to behave towards others has been an articulated concern for hundreds of years and a great deal rests on possessing the correct manners. An individual's reputation and opportunities for advancement are affected by their delivery of a good public performance. Erasmus's instructional manual, *De Civilitate Morum Puerilium*, first published in Latin in the early sixteenth century and then widely translated into French, German, English and Dutch, is often cited as the primary text in the modern codification of manners. Elias (1978) regarded it as highly influential in cultivating a sense of self-consciousness and self-evaluation in the aristocracy and gentry of middle Europe. The French dominance of style that has endured into contemporary times emerged after the deliberate image-making of the Sun King, Louis XIV, in the second half of the seventeenth century. These drew on Erasmus's earlier instructions as well as a raft of new, idiosyncratic and prescriptive practices that have endured into contemporary times to underpin the current reputation of the French as inherently attuned to elegance, luxury and style.

Manners and style continue to be used to estimate class and status: a person with bad manners is said to be 'without class', without

the necessary savoir-faire. Manners announce other qualities such as whether an individual is sensitive, whether they play by the rules and should be taken seriously, and whether they are ethically minded or insincere and use manners as affectations (Martin, 1991). Manners are in large part a means of speaking about the 'science' of sociability. Their long and convoluted history is an account in part of the formation of modern practices. The best-selling, modern compendium on good manners by Judith Martin (1991), *Miss Manners' Guide to Excruciatingly Correct Behavior*, pioneered a raft of books that opined on styles of modern living with wit and humour. *Miss Manners' Guide* was in many ways a comic address to the highly successful American professional classes who were suddenly made wealthy in the 1980s and 1990s when the IT and real estate booms were gaining momentum. In some ways it paralleled the treatise by Castiglione, who also wrote for a class of individuals who were socially mobile. In both circumstances, the messages being delivered were that wealth and power alone were not sufficient attributes; being socially acceptable requires a capacity to imagine oneself to be someone else, to engage in the social contract of exchanging places in order to understand how human sociality works. The individual who is unable or unwilling to follow form, or to perform the necessary mental manoeuvres described by protocols and good manners, threatens to tear the social fabric. Such individuals break the rules and act like clowns; they are both a source of hilarity and fear depending on whether they are Kramer (from *Seinfeld*) or *The Godfather*.

From at least the fifteenth century onwards there has been an explicit connection between 'the right ordering of the self and the overall order of society' (Bryson, 1998: 70). Dror Wahrman's (2004) history of the making of the modern self examines this proposition in detail. He links manners with fashions in a historical study of the idea of identity and embeds prevailing assumptions into specific historical contexts.

He notes that industrialization and the increased access to commodities and possessions altered the ways in which individuals regarded one another; people became objects of desire, they were transposed into commodities. 'Like money, and like fashion, identity itself was in danger of coming out of the commercializing smelting kiln without real substance, referent, or real value' (Wahrman, 2004: 208). Here is a moment, Wahrman argues, when we can see the idea of identity mutating from a mysterious interior quality into a tangible asset that individuals self-consciously learn to master. That transformation, however, is not tied to an exact historical moment but emerges from a culture of practice largely shaped by trade and commodification. This is a turning point, a stage of development and an observable defining moment when individuals come to think of themselves in a new way. In current terms, individuals such as Paris Hilton, Victoria and David Beckham, Jamie Oliver, Will Self and Karl Lagerfeld are regarded as celebrities, and become familiar to mainstream audiences as advertisements for certain activities (fashion, sport, notoriety) and values.

Rules of the Game

The history of manners is closely intertwined with the rise of the commercial, consumer culture (at various locations across Europe during the late seventeenth and early eighteenth centuries) with its new emphasis on fashionability and the transformation of sociability into a transaction. In such a universe, individuals learn to think strategically, to plot and counter-plot their conduct in order to gain advantages in trade transactions. The acquisition of wealth and luxury are important to distinguish from consumerism. While the former can be observed as early as the tenth, eleventh and twelfth centuries in China and the Mediterranean, the commercialization of possessions and wealth requires a more widespread system of exchange where social practices and values support the acquisition of material goods for an ever-

increasing number of individuals. It is necessary to have classes of people being interested in acquisition and possession, and in developing practices and manners around the display of valued goods (Stearns, 2001). This is at the heart of modern commercialism, where most transactions are mediated through specific conventions and habituated rituals of exchange. Wahrman specifically associates this development with trade beginning in the eighteenth century. He quotes the historian John Pocock on the point:

> Once property [and with it everything else] was seen to have a symbolic value, expressed in coin or credit, the foundations of personality themselves appeared imaginary or at best consensual: the individual could exist, even in his own sight, only at the fluctuating value imposed upon him by his fellows. (Wahrman, 2004: 208).

Castiglione noted the same elements of social life almost five hundred years earlier. He recognized that every meeting required individuals to analyze the situation in forensic terms. He described the varying degrees of engagement and good faith that individuals displayed in their social exchanges; they could be optimistic or not, motivated by hostility and opportunism, they could have a genuine sense of affinity with others or be comprehensively contemptuous. However, whatever their particular emotional dispositions and idiosyncrasies, it was the case that the rules of engagement expressed through conventions and manners regulated the situation and ameliorated these particularities. The role of manners as an overarching structure was to displace personal expressions – be they of ineptitude, aggression, enthusiasm, indifference, anxiety and so on – in order to stabilize the social moment and make it as formulaic and predictable as possible.

Rules of conduct reveal how the unnatural is transformed into the natural, and the socially and culturally arbitrary are made to seem ordinary and uncontested. Take a contemporary example of a man opening a door for a woman. At the height of the declared battle of the sexes

in the mid-twentieth century, this particular gesture became a site of heated commentary and exchange. From one perspective, opening the door signalled a sense of superiority; it placed the man momentarily in charge of a woman's freedom of movement. It could also be interpreted as a sign of his superior physical strength, although it was merely symbolic of his more socially active status. From the opposite viewpoint, opening a door for another can be a ritual politeness, an act that simply helps one party gain ease of access.

Social habits, however, are rarely self-evident, and even when mundane as in this example, they are heavily weighted with cultural significance. Opening a door and deferring to another is after all a premeditated act. The extent of this thinking behind the gesture became obvious to Sarah Turnbull, an expatriate living in Paris, when she wrote about her slow and bumpy induction into local Parisian customs. In her popular biographical travel memoir, *Almost French: A New Life in Paris*, she describes how, for many months, her daily shopping routines and appearances on the street had gone unacknowledged by her neighbours. Turnbull found this social distance disconcerting but she could not find ways to bridge it. When she bought a dog, immediately her neighbours were talkative and accepted her as if she had always been there – as indeed she felt she had. At first she was surprised as not long before these same people had been aloof strangers. Now they were entirely relaxed about greeting her: the dog had changed her status.

Turnbull was further amazed when these same neighbours began vigorously criticizing her treatment of the dog. Some gave lengthy instructions on best dog-owner practices. Irrespective of whether they were critical or helpful, Turnbull found their proprietorial tone a remarkable change; from one day being indifferent to her and the next day feeling entitled to make judgments and comments on various trivial acts and attitudes. With the new dog her previous sense of social isolation and privacy was replaced with a sense of vexing surveillance.

An invisible wall of exclusion had been removed and Turnbull now felt vulnerable to the interference of others; her neighbours had become curious and too meddlesome (Turnbull, 2002: 206–25).

Every social gesture is potentially ambiguous. In a private home, for instance, if a tablet of soap is provided in the bathroom for use by guests, it might be left in its original wrapper to show that it is new, hygienic and provided for the guest's exclusive use. In a commercial hotel, this is precisely what the paying client expects. For guests in a home, however, presenting the soap in its original wrapper might suggest it is not for use. If the soap happens to have an exclusive fashion label on its wrapper, then the guest may consider it a status symbol and may think worse of the host who has made them feel uncomfortable by providing soap they do not know whether to look at or use. In such a circumstance, the gesture is ambiguous – is it a sign of good manners, of generosity designed to increase pleasure and comfort, or the opposite, a technique to provoke discomfort and embarrassment? Do manners evidence recognition of the other's similarities, that they are just like us and should be treated accordingly, or are they a form of entrapment where the host's presence looms over the guest?

In every unequal or instrumental exchange such as between guest and host, employee and employer, there is a great deal of mutual assessment and scrutiny taking place. Making sense of the rules of the game is not a matter of personal aptitude. Opening a door can be interpreted by one person as an act of hostility and by another as politeness; the wrapped soap can be both a status symbol and sign of hygiene. The rituals around hospitality and the exercise of manners compel us to think about one another in calculative ways; the host and the guest do not meet on equal terms yet their exchanges are supposedly complementary. Manners compel us to think about situations and to imagine the other's point of view. There is always an imbalance of power; social life is always about the negotiation of inequalities. In this way, man-

ners and social conventions train us to be observant and prepared to respond to the exigencies of various situations.

History of Manners

From the thirteenth century until the seventeenth, the guides to good behaviour such as *Zinquanta Cortesie da Tavola, Boke of Nurture, Book of Curtesye, The Book of the Courtier, On Civility, Galateo*, and *Nouveau Traité de Civilité* were written for a small class of people who lived at court. But they are also messages for posterity, giving an account of how society itself worked (Castiglione, 1994 [1528]; Rebhorn, 1978). The industry of writing about manners, civility and ethics led to the invention of a special typeface known in France as *civilité*, which was used expressly in the printing of books of manners (Bryson, 1998: 47). Norbert Elias's (1978) history of manners, written four centuries after Castiglione, rehearses many of the rules that comment on how individuals should control and regulate the body by controlling the appetites, not spitting into common bowls, and not scratching and vomiting in public.

The explicit message of manners emphasizes the need to consider others and make oneself acceptable to them. Manners function as forms of self-preservation and mechanisms that enhance the likely survival of an individual in the contested and competitive social environments of the public domain. To be conscious of etiquette and to follow the rules is to take the first step away from a life otherwise deemed by Thomas Hobbes as nasty, brutish and short. Manners mark both the recognition of the other and a respect for their difference. Manners signify a willingness to please the stranger. They curb all that is careless, excessive and passionate, and introduce efficiencies and levels of moderation. Manners refer to the nature of relations between people, to standards of bodily deportment, to ethics and the control of vice. They also refer to commonplace assumptions about dress, speech and demeanour and to a general consciousness about what it means to be

social, capable of maintaining public relations with strangers and being a virtuous, good citizen. Manners have no simple and reliable definition apart from the focus they bring to individual choice about how to conduct oneself.

Every society has rules that are in essence guides to prevailing assumptions and values. To a large extent the history of manners is about making these dominant regimes visible. Beginning with early references to the requirements of court life, the rules dictating behaviour instructed individuals that it was in their interests to be observant of others. If rustic nobility, for example, wanted to enjoy the privileges at court it would be necessary for them to know how to behave. They needed to accept different standards of dress and personal hygiene. Italian and French commentators began noting down the rules of the court in order to groom new arrivals – people who would be disparaged in the following centuries as *arrivestes*. By the thirteenth century, it was possible to consult instruction manuals that specifically indicated what one should and should not do in certain situations: one should not, for instance, remark on the food during a meal or put one's hands in one's hair or on any foul part of the body or lick one's fingers to clean them (Rebhorn, 1978: 12). The well-mannered individual should not laugh too loudly, should not scratch, or sit with the legs splayed out, neither should individuals clean their teeth with a knife, nor cough when others are speaking. At the dining table, the civilized person should not fidget or dip their bread in the common dish or throw bits of gristle under the table or feed the dog or speak with a full mouth. In the street, such an individual should not gossip about others or mention topics such as bad smells or being sick (Burke, 1995: 18).

In his quirky study of *Good Behaviour*, the Bloomsbury aristocrat Harold Nicolson summed up Erasmus's significance by noting his book had had more than 128 editions by 1780, and had achieved an enduring definition of manners: 'good manners were founded, not upon any

desire to demonstrate one's own delicacy and distinction, but solely on a desire to show consideration of others' (1955: 134). Nicolson went on to provide an idiosyncratic view that good manners cannot be rigid or highly regulative but must be innovative and responsive to situational needs. Manners were not principles in any fixed sense but were instead mechanisms by which certain valued sensibilities were fostered. He endorsed the English public school system of 'fagging', for example, as being a necessary tool in the training of the young 'both to obey and to command' (1955: 139). Such rituals supposedly produced obedient and well-mannered young men.

Thinking about society is frequently regarded as a uniquely modern interest. In 1905, Georg Simmel famously asked the question, 'How is society possible?' and in so doing seemed to mark the moment when the modern collective consciousness turned toward the business of inventing itself. However, Castiglione had already covered the territory; he had asked Simmel's question more than four hundred years earlier, albeit in a different register. His work was widely translated into Spanish, French, German, Latin and English by the middle of the sixteenth century, and was being read by diverse audiences who seemed interested in a practical handbook as well as a commentary on the 'psychology' of social life (see Castiglione, 1994 [1528]). Thus Castiglione's work was more than a compendium of social manners as it addressed concerns about the effect of political power and authority, social mobility, gender, ethics and the dispositions of the natural body. It reflected the growing interest in what we understand now as the psychological dimension of social life and it demonstrated the necessity of all individuals, in every social situation, to take account of their effect on others. This meant becoming self-reflective, and developing a visual imagination through which individuals are able to trade places with others and anticipate how specific circumstances might influence how they would think, feel and act.

Like Erasmus, Castiglione also provided myriad examples of a practical nature; for example, a younger person was told to look into the face of an older person when in conversation and not to be too talkative in reply. They should not scratch themselves, leave their spoon in the common tureen or sit down when others are standing, nor should they blow their nose on the tablecloth or spit and snuffle (Castiglione, 1994 [1528]: 367–71). Living at court brought individuals into close proximity and kept them confined in a social space where often there was little to do but talk, gossip, play games and invent amusements. The court society was a hothouse of privileges and punishments that were dispensed in an unpredictable fashion. Such an environment was heavily scrutinized as the status and reputation of individuals rose and fell according to the vagaries of monarchic grace and favour. All activities circulated around the 'prince' or 'king' and the courtier's display of good manners was all about maintaining a favourable relationship with the powerful.

Courtly society slowly spread through Europe, emerging from those feudal estates where the display of wealth was being favoured over the displays of warrior combat and brute physical force. The wealthy courts provided patronage to the arts and brought poets, artists and other talents together to provide entertainment. In such a milieu, it was the exercise of manners and not physical aggression that was valued. The successful courtier was highly aware of being attentive to others. Court life produced a calculating self-consciousness. Every gesture and habit needed to conform to the rules and sensibilities of the moment. There was a correct way to knock on a door, and being in possession of such details admitted the individual to privilege. At the court of Versailles, for example, to gain entry into a closed room the habit was to scratch using the nail of the little finger – making a louder noise was not the fashion. The professional courtier could be instantly recognized by the lengthy nail on the small finger, a sign that is just as eloquent now amongst certain groups familiar with the protocols of inhaled drugs.

Antique Cool

The decadence of the court meant that boredom and competition dominated daily life. Mme de Maintenon wrote: 'I am bored to death, we gamble, we yawn, we have nothing to do, we are jealous of each other, we tear each other to pieces' (Nicolson, 1955: 173). The preoccupations of such a life circulated around what it meant if someone sat in the wrong place, or if they were directed by the king to sit in a chair with arms. What did it mean to be asked to hold a candle while the king dressed or undressed? The closed society of the court exaggerated the significance of every gesture and directive. The manners on display were influenced by fashion and by prevailing views of what was amusing or flattering or clever. Often they were social gambits used to gain advantage or embarrass those who assiduously followed them. Their collective effect, however, was to sharpen perception, to cultivate the capacity to see the most inconspicuous gesture and to read its social relevance. Contemporary parallels to such situations have been well portrayed by the so-called 'brat pack' novelists, the nihilistic dirty realists Brett Easton Ellis (*Less Than Zero*, 1985; *Rules of Attraction*, 1987), Jay McInerney (*The Last of the Savages*, 1997) and Jeffrey Eugenides (*The Virgin Suicides*, 1994, filmed in 1999 and directed by Sofia Coppola).

Castiglione recognized that perfectly executed good manners were no guarantee of social success. Human beings could be ill-tempered, capricious and cruel. Social situations were rarely simple but always inflected with ambiguities and conflicting points of view. He understood that it was possible to behave impeccably, to respond generously to the requests of others, and be exemplary in appearance and manner and yet still fail to find favour. He described how the courtier might be 'clever and prompt to reply', he might show 'himself off well in his gestures, manners, words, and all else that is necessary', and yet find surprisingly that his 'prince' holds him in little esteem and is 'readier to treat him with disrespect'. To make matters worse, Castiglione suggests

that others will follow the caprice of the leader and further mock the good noble and in some instances even favour 'a total incompetent to whom their lord has taken a fancy' (Rebhorn, 1995: 122).

This reads like modern-day office politics: individuals in power are susceptible to flattery, and they can shift the ground rules when it suits them. Castiglione recognized that there was no natural justice in the social world; indeed, whenever human beings were together the likelihood was that caprice would rule the day. At such times (which was really all the time), the value of being well mannered was that the individual was capable of accommodating the whimsical and difficult. By detailing the functions of manners and recognizing the competitive interplay between competing social claims, Castiglione, like Simmel five hundred years later, was engaged by the contemporary question of how individuals manage to live together and produce society.

The history of manners delivers more than insights into the remote court society. It also records changing *mentalités.* For instance, the specific modern habits of calculation and speculation can be seen in rudimentary form in the early regulations controlling the body and physical appearance. These instructions give a meticulous account of what is culturally abject, and how thresholds of tolerance and repulsion are calibrated. Learning not to spit and to keep one's nose clean, like the affectation of the overgrown fingernail, indicate that the body is being used as a social instrument. In Castiglione's view the best-equipped individuals were able to invent strategies that anticipated all contingencies. He advised that civilized individuals should be socially nimble and understand that any human congress can unpredictably collapse into chaos. He emphasized the need to appear spontaneous and guileless but also alert and watchful. He used the term *sprezzatura* to refer to a sense of competence and nonchalant superiority. There could be no suggestion of artificiality or design in the exercise of good manners. *Sprezzatura* indicated a complete lack of falsity in *the art of appearing*

to be without art. Thus, the well mannered were always capable of managing any permutations in the social situation; they understood that the most regulated, scrutinized and orderly of routines could quickly dissolve into disarray. Being civilized meant understanding the immanence of chaos.

The concept of *sprezzatura* describes a way of being in the world, a nonchalance that is deeply self-conscious. The courtier who embodied *sprezzatura* demonstrated his talents across a range of activities; he should be a strong athlete, good hunter, dancer, conversationalist, card-player, singer and an elegant dresser with a trim physique and handsome face. These aggregated attributes established the courtier as civilized. Contemporary examples of *sprezzatura* are difficult to find. The same attributes do not translate easily into the value systems of the post-industrial society, yet there are attempts to approximate the concept. John Malkovich's portrayal of Tom in the film *Ripley's Game* demonstrates a civilized surface surrounded by an aura of cool cunning. His performance of Ripley emanates *sprezzatura*, which is not discordant with his own off-screen persona. The early James Bond films with Sean Connery, and the television series *The Saint* (1962–9), provide other examples of lead characters with *sprezzatura*. *The Saint* was presumably a play on the mysterious Knights Templar; it starred the debonair Simon Templar played by Roger Moore, who would also play James Bond in later films. These characters are consistently popular with audiences even though the expressions of cool differ markedly between, say, Marlon Brando in *On the Waterfront* (1954), Paul Newman in *Hud* (1963) and Johnny Depp as John Wilmot, the seventeenth-century Earl of Rochester, in *The Libertine* (2004).

Specific habits and customs transcend the moment to reveal how humans think in more general terms, and how they calculate and assess their social opportunities. This is a key idea that allows us, hundreds of years after Castiglione's account of court life, to understand that

the rules of the day are not only practical guides to social commerce, they are techniques that cultivate specific systems of values; they show the importance of calculation and observation to the presentation of personal identity. Castiglione's text goes beyond the categorization of appropriate mannerisms and roles to suggest a definition of human identity that is located in reflection, calculation and observation. These intellectual capacities thread their way from twelfth-century monastic rules about cleanliness, sobriety of dress, table rituals and conduct toward superiors, to the extended mediations of Castiglione and Montaigne in the sixteenth century and the works of Simmel, Goffman, Sennett, Elias and others, five hundred years later.

Calculation and observation are the preoccupations that underlie the 'very art that appeereth not to be art'; they are the tools for seeing 'inside' the human mind and, in turn, they are the scaffold of identity. This is evidenced in the social activities of contemporary everyday life where we follow rules and conventions without resistance or second thought. We obey road rules, act considerately on public transport, manufacture a sense of personal privacy around ourselves when dining out in restaurants, and respect others at public venues like concerts and sports events. By and large, we comply with the manners and customs of the day, and behave obediently. With such a high degree of conformity in the public domain, how do we preserve a sense of individuality?

Deception and Invention

Being in public and learning how to behave toward an audience of strangers is part of the narrative that produces a sense of self. Certain modes of popular culture function to circulate specific types of identity. The novel, for instance, has trained the individual imagination and cultivated a sense of there being an interior realm that is always separated from the interiors of others. Some forms of popular culture have directed us toward a secular voyage into the privacy of the interior,

often in search of true love, happiness, inner strength and individu-
ality. Popular culture has influenced how we think and feel, what we
see and desire. Public events and art forms entertain and engage us at
the same time that they demonstrate the attractiveness of particular
sensibilities and values. If we attend art festivals, antique markets, live
theatre, sculpture galleries and the cinema, we are employing popular
entertainments to conjure up certain inner feelings.

There is always an exchange going on between the inner and exter-
nal worlds (Burke, 1978). Every aspect of ordinary daily life engages us
in this continuous transfer and inherent tension between how we act
and what we think. Does this mean, in effect, that every action is a self-
conscious performance? And if this is so, on what basis can we trust in
the honesty of such self-consciousness? Does the apparent naturalness
of performance make it hard to know when individuals are acting with
intent to dissemble, or when they are acting de rigueur? Every audience
must think about whether the individual's performance is convincing or
not. And if it is convincing does this mean it is too controlled? Or if the
performance is obviously contrived does this mean it is a failure? Our
familiarity with theatrical performances and masquerades has the con-
sequence of making the idea of identity more confusing. Shakespeare's
comedies emphasized the tricks inherent in assuming that what we see
may not be trustworthy. When Jacques in *As You Like It* states 'all the
world's a stage' the idea is reinforced that play-acting, performance,
self-scrutiny, masking and invention are ordinary elements of daily life.
By learning to perform, the individual fabricates a life. Living by one's
wits has increasingly become a logical extension of the performative or
dramaturgical milieu (Bryson, 1998; Greenblatt, 1980). It was the very
attribute that the French judge Jean de Coras recognized and admired
in Arnaud du Tilh, the impersonator of Martin Guerre. In an era of
expanding social opportunities, the bold individual can deceive, cheat,
flout convention and fleece the gullible in order to score an advantage.

With the growth of commerce, urban populations, increased trans-
port and public entertainments, individuals enjoyed greater freedom
of movement, and a wider range of people came into contact with one
another. In particular, commerce and entertainment created situa-
tions in which individuals learned to see themselves as others might.
In these circumstances, a heightened emphasis on social observation
became normal and this performative layer of social life produced a
new understanding of privacy; people learned they were free to gaze at
others, to speculate on their identity, to watch and make judgments of
them. Castiglione understood that masking oneself in the public arena
was a necessary part of being social. At one level, everyone must play
the roles appropriate to the situation. Dress and deportment as well as
manners of speech collectively function to structure the situation. They
allow us to slip from pose to posture, attitude to affection, courtesy to
habit, as the situation demands, and this capacity to shift the register
of our actions demonstrates an expert ability to perform. Castiglione
mocked those individuals who mechanically enacted social parts and
did not understand the freedoms inherent in every performance, per-
haps as we might now be amused by officious individuals and those too
concerned about gathering to themselves honorifics, status, position
and titles. Castiglione understood the inevitability of hierarchies of sta-
tus in every society and the necessity for the individual to know how to
engage them. At the same time, he also knew that playing or masking
oneself was not an instrument of deception but a necessary talent that
supported everyday life and delivered a good social performance.

By the seventeenth century, these ideas and concerns had trans-
lated into a more widely adopted debate about the nature of human be-
ings. New theories on consciousness, memory and reliability produced
different questions about the nature of identity. For instance, was the
self a unity or a continuity? Am I what others see or as I think of myself?
If I live on an island without others, do I have an identity? Can appear-

ances be trusted? Do fashioned and stylish appearances always conceal another identity? Do they hide depths or hide the lack of depth? Is the outward persona a mask? Such questions resonate through centuries of speculation emanating from Descartes' self-conscious proof of existence, John Locke's concern that identity changes with day and night, Berkeley's assertion that we can have multiple selves and David Hume's view that we are bundled fictions. The rise of the popular novel enters into the cultural frame by providing descriptions of what human consciousness might be. Samuel Richardson's *Pamela* (1740) and *Clarissa* (1747–8), John Cleland's *Memoirs of a Woman of Pleasure* (aka *Fanny Hill*, 1748–9) and then Sterne's *Tristram Shandy* in 1759 described the workings of the human mind, showing it to be variously confusing, chaotic, irrational, disorderly, unstable, dangerous, frightening and unpredictable. Such revelations were quickly accepted by a new reading public as both entertaining and educational.

Renè Magritte's painting of two identical apples, each wearing a party mask that covers the eyes, is a succinct summary of many of the questions raised by explorations of identity. In this image, the pieces of fruit are identical (perhaps like us), even in their choice of the mask as a device for concealment. The mask itself, small, covering only the eyes, is totally inadequate as a disguise yet it usefully alludes to the confident way we employ objects to express aspects of ourselves to others in the world. The question of what is accomplished with the wearing of the mask remains – what exactly is being concealed and what is being revealed? By contemplating the mask or some other device we are drawn down the path of thinking about the traffic that surrounds the display of identity.

In the contemporary consumer age, a great deal of commercial activity is currently invested in the display of personal identity. Products are sold with the promise of being able to enhance the self and the global entertainment industries play with desires for new and better versions of our selves. In this way we become increasingly famil-

iar with the idea that identity can be materialized. Oscar Wilde's quip resonates, 'It is only shallow people who do not judge by appearances. The true mystery of the world is the visible, not the invisible' (1973: 32). It is on such a premise that the photographic imagery of artists like Cindy Sherman (b. 1954), Claude Cahun (1894–1954) and Yasumasa Morimura (b. 1951) work to amuse us. The photograph, supposedly a true image of the real world, becomes in the hands of such artists an image that plays with reality. What are we to make of the image of Yasumasa Morimura dressed as Vivien Leigh in the luxurious costume of Scarlett O'Hara, or Man Ray's photograph (1921) of Marcel Duchamp as Rrose Sélavy? The convincing appearance of each of these images makes it harder to be confident of what we are seeing.

The Modern Subject

How we understand ourselves in the social sphere, and in relation to others, is frequently through the management of our physical body. In the early moments of social exchange, it is posture, speech, eye contact and physical proximity that indicate how the exchange may proceed. These clues refer back to regimes for controlling the body that commenced centuries earlier. We take for granted certain conventions around the body as being expressive of emotions, gender, status and temperament. These indicators are deeply embedded systems of cultural knowledge that organize how we act towards others and see ourselves. The detailed attention given to the body by Erasmus, Castiglione, de Courtin and others was not only about changing customs around hygiene and improving health, it was also about developing the capacity to think about our own body as an object others encounter.

The body is the first visible sign we use to make judgments of one another. Its size and shape, smell and feel, are instructive. We make decisions about our own behaviour from the looks we receive from the other. This explains, in part, the importance of etiquette in the con-

struction of identity. Manners are about observing others and imitating them, and it is this capacity for close observation that produces self-consciousness. We learn our identity from the reactions of others. The controlled body is the passport to sociability.

Where there are lapses, the social moment is threatened. If we laugh in the wrong place, if we blush or visibly sweat, if we have a facial tic, buck teeth, a large nose, prominent ears, then the social exchange is affected. In such circumstances, seeking a physical makeover is more than a personal vanity, it is a sign of understanding how important the regulated physical body is perceived as being to the maintenance of an orderly society. The photographer Diane Arbus has shown how the excessive body breaks down the controls of the moment. She framed her subjects in such a way that they disrupted and often reversed the status quo. She demonstrated how easily the conventional could be weakened by the presence of an unusual body. For her, a stylish appearance was better seen as a successful performance, it was simply an overlay that compensated for and covered up what would always be a recalcitrant body. Arbus regarded all bodies as potentially strange. It was merely a matter of liberating the body from its context and then it could be both frightening and mysterious.

Analogies between appearance and human essence, clothing and character, survive into modern times as a semiotic discourse on identity. The American gender theorist Terry Castle (1986: 73) recognizes that such ideas are deeply embedded in our literary and visual culture; she refers to Fielding's *The Masquerade*, written in 1741, where the paradoxical wisdom is offered that to 'masque the face' was 't'unmasque the mind'. Accordingly, if we seek cosmetic surgery for drooping eyelids, a furrowed brow, protruding teeth, are we masking the face to change our sense of identity? Clothing and fashion styles signify aspects of the inner being as well as fundamental properties such as sex, rank, age and occupation. As Hollander (1980) argued, the clothed body is the more

legible body. Certain external proportions and characteristics of the body are read as pathologies. The grossly overweight, excessively hairy and over-developed, especially the muscled female body, are instances of horror and amusement. Appearances are calibrated and character is deduced in accord with the physiognomic guide to personality such as that popularized by Johann Caspar Lavater in the eighteenth century. While it seems a quaint idea at face value to read complex conditions from appearances, it is an idea with a long and robust history. At various times, people have confidently seen moral turpitude, insanity, depravity, generosity, happiness, irreverence and so on in certain body sizes and shapes (Tytler, 1982; Weschler, 1982). In the twenty-first century Paul Ekman has become a celebrity with FACS (the Facial Action Coding System), his version of physiognomy by any other name.

Interpreting appearances is unreliable yet displays of manners and a fashionable mien invite such readings. Even though there are conventions around appropriate dress that make its interpretation seem natural and reassuring, nonetheless dress is voluble and like any language can be digressive and misleading. With the example of Chance Gardiner in the novel (and later the film) *Being There*, it was his well-tailored clothes that transformed him into a member of the American political elite (Kosinski, 1970). The narrative recounts the adventures of a simple man (played by Peter Sellars in the film adaptation), dropped by chance into the complex world of a busy cosmopolitan city. After decades of a sequestered life within a walled garden of a huge city mansion, Chance is expelled onto the streets without knowing how to fend for himself. Fortunately, he encounters the fashionable, powerful and class-conscious Eve Rand who absorbs him into her 'club', and who, imperceptibly, writes her own social position onto him, making him what she wants. At first, Eve is charmed and puzzled by Chance, she unthinkingly renames him Chauncey (a classier name than his own) and sees him as a thoroughly agreeable character: 'he had not dropped

names; nor had he referred to places and events. Indeed, she could not remember encountering anyone who relied more on his own self. Gardiner's manner alone indicated social confidence and financial security' (Kosinski, 1970: 74). Yet we, the audience, know Chance did not have any of these conventional attributes. He was *tabula rasa*. He had been released into the world unprepared to function as an adult, and when Eve found him, dressed in a high-quality old-fashioned lounge suit inherited from the unnamed deceased father; this was sufficient for her to read and classify him as a member of high society, as one of her own.

The character of Chance can be read as a metaphor of the consumer age. Kosinski shapes him through a naive relationship with television. What Chance saw on the screen, he took as literally true. When he looked at the diminutive figures on the screen, he could not understand how it was that they differed in size from the real people around him. When he was invited to appear on television, his concern was that he too would be physically diminished and lose control of his body; he would become shrunken and tiny, never to return to his familiar proportions. This is also the comedic metaphor of the narrative – that appearing on television, becoming famous and part of the entertainment industries, can put the individual's stature (physical and social) at risk.

On Being Calculating

In every social encounter we are required to author or define ourselves. In the first moments of engagement, we calculate how to act within the explicit social rules of each scene. We assume that the other people we encounter will be unpredictable and capable of pushing the encounter beyond the safety of what we know. Thus we need to be always alert, constantly aware of the fragility of the moment and its incipient dissolve into disorder. On those occasions when we do succeed in controlling the moment, when, say, we have others laughing at our jokes and leaning in to hear more, then we experience a visceral sense of power,

a flash of social autarchy that is profoundly validating. Such are the pleasures of the social encounter that keep us attuned to living in the moment and seeking from others their adulation, acceptance, respect and deference.

Mannerly displays are not only about social strategies and maintaining patterns for social expedience. While they do ameliorate the consequences of bluntness, aggression and resistance, they also add to the complexities of social life. Very little is as disarming as an elaborate display of appropriate manners. To his chagrin, Fitzwilliam Darcy is drawn to Elizabeth Bennett by her social ease in Jane Austen's great romance, *Pride and Prejudice*. Manners are depicted as those subtle and stylish gestures and nuances that appeal to the cultivated, attentive mind. Manners reflect the mettle of the individual, thus it was by her fine manners that the reluctant Darcy was seduced: 'in spite of his asserting that her manners were not those of the fashionable world, he was caught by their easy playfulness' (Austen, 1962 [1813]: 55).

Goffman describes how well trained we are in calculating the social odds and how prepared we are to be deceitful or misleading whenever necessary. We are highly aware of the level of the other's social skills. We know immediately when we are in the presence of a more accomplished performer or when the encounter will be beyond our control and we will be embarrassed. Such moments are both alarming and thrilling. We might nervously wait, hoping to exit at the earliest opportunity, or else stay for the ride and hope to pick up new tricks. Social life requires us to be always poised, ready to act and minimize the inherent tensions and disarray. In this way we become highly observant and the social becomes a site of pleasure. It is from the accumulation of such calculated and performed moments that society itself becomes possible (Treviño and Lemert, 2003).

Calculation and invention are the fundamental requirements for everyday life. These skills underscore the transactional nature of

human relations and the multiple layers of consciousness that reside behind every act and gesture. It is this complexity that makes it impossible to be categorical about another's intentions – individuals are not unambiguously impostors or frauds or con artists. There are too many viewpoints and vested interests to be confident of knowing the 'truth' of a situation: the position of one individual is never the same as another's. Herein lies the possibility of always being at odds, even while occupying the same moment. It is precisely this tension that Billy Wilder reconstructs in the final scene of *Some Like It Hot*. Osgood Fielding III, the misguided millionaire, wants to marry Jack Lemmon still disguised as Daphne. He has lured Daphne onto his boat, intending to carry her away, and as he drives the speedboat through the waves, repeatedly asking her to marry him, Daphne's frustration and hysteria mount; Osgood will not take no for an answer. In desperation, Jack tears off his wig and announces he cannot marry, he is after all a man. The love-besotted Osgood is not deterred; 'No-one is perfect', he responds, and presumably Jack is trapped.

Goffman employs the terms 'face work', 'civil inattention' and 'impression management' to describe the different levels of consciousness operating within every social situation. When we overlook breaches in the rules or embarrassing moments, we are engaged in face work. When we perform in the moment and respond predictably, maintaining the rules of exchange but privately and inconspicuously occupying ourselves with other thoughts, then we are practising civil inattention. When we deliberately appeal to the audience and try to influence opinions, say at a job interview or on a date, then we are engaged in impression management. We have invented ourselves for the occasion, which means constantly thinking about how best to put our self on display and to imagine how others are seeing us. Even though these activities are the foundations of predictability in everyday life, they are also disturbing. We do not like to think of ourselves, or others, as being so

calculating. We like to think social life is spontaneous and fresh. Yet the history of manners suggests otherwise.

Goffman's *The Presentation of Self in Everyday Life* (1959) registered the mood of mid-century suburban America when he identified 'phoneyness' as the prevailing register. He asked, did we know with confidence that the person smiling at us, warmly shaking hands, telling us how clever, beautiful or impressive we are, was really being honest? Did our heightened self-consciousness and calculability mean we were cunning or untrustworthy? Was being calculative also being dishonest or being a liar? Are the displays of good manners less genuine, less acceptable because we are conscious of how best to produce them? Goffman attempted to ameliorate this level of generalized anxiety by asserting the world was a stage, and that we are all actors with roles and scripts to learn. To follow the metaphor, there is a stage front that has an audience and a backstage where we prepare ourselves to go public. Social life is a series of framed situations; we walk into these frames and try to avoid the risks they pose. Such a world requires a calculating mentality; we must constantly be thinking about what to say and how to act in order to exit the scene unscathed, but also with what we want.

Goffman (1959: 36) described the contemporary social world as being like a wedding, 'the world is, in truth, a wedding'. This draws attention to the ceremonial and structured nature of social life that has, by necessity, placed restrictions around the conduct of its members. Weddings are public displays of changed social status; they are grand performances designed to display wealth, the transfer of property and the conventionality of the participants. The contemporary doyenne of modern etiquette, Judith Martin (aka *Miss Manners*), considers the wedding overproduced and has recommended that people not make it such a theatrical and fanciful occasion (Martin, 1991: 318). Freud (1985 [1887–1904]: 266) too recognized the metaphoric richness of the wedding in a dream reported to Wilhelm Fliess.

In the dream, he is about to be married and is dressed, uncharacteristically for him, in a wedding gown as if he were the bride. The incident has been identified as a revelation of homoeroticism directed at Fleiss, the desired object (Fuss, 1995: 21). Judith Butler (1990: 31) has also made much of the wedding gown, identifying it as the means for transmitting a sense of reassurance that the status quo around gender is being maintained. She has commented that the only stable item in the marriage ritual is the bridal dress. The cultural significance placed on the wedding gown has raised it above the actual experience of the marriage. Weddings are thus seen as strategies for maintaining gender opposition. The great effort expended by the wedding ceremony is a measure of the desire to ensure the cultural separation of the sexes. The often extravagant wedding gown itself, worn only by the woman, indicates the deep investment that exists in keeping the sexes distinctive and separate from one another. Hence, Freud in a wedding dress can be interpreted as his attempt to keep himself separated from Fleiss, the troublesome object of his own desire.

There are many instances in popular culture where rules are challenged. The Elvis Presley Love Chapel in Las Vegas offers the opportunity to defy the rules and parody the wedding. The Madonna/Britney Spears kiss, that was flashed around the world, seemed to be a challenge to the hetero-normative order. Shakespeare's comedies, Virginia Woolf's *Orlando* (1928), Billy Wilder's *Some Like It Hot*, Patricia Highsmith's tales of Ripley and the Doris Day–Rock Hudson romantic comedies variously supply examples where bending the rules is possible and pushing them to their limits is a technique for uncovering their power, as Garfinkel's experiments in ethnomethodology attempted to show. He advocated breaking the patterns of social engagement in order to see which specific rules were in operation. He wanted to discover the nature of the social tie that held together the individual's sense of freedom and discipline. Under his direction, office workers acted as if

they did not know the routines of the working day and family members pretended to be strangers to their blood relatives. In these scenarios the tacit rules disappeared, leaving individuals without the conventions that normally produced trust and predictability. Within a short time, the encounter dissolved into confusion.

Everyday life is produced through regulation, it is steeped in habits that maintain patterns. Creating an audience that observes these patterns and is complicit in their maintenance is crucial. After all, there can be no performance without an audience, and there can be no social continuity without patterns. Manners are about the production of social predictability. Formal salutations, conventional modes of dress, table manners, expressions of politeness such as smiling and keeping eye contact, the use of modulated speech and the concealment of bodily functions are all instances through which patterns of behaviour are maintained. These interactional habits are taken for granted as universally necessary, even though they constantly change in different societies, within different groups and within the same society. Many women open doors for men and pay the restaurant bill, and always did. But now it is rendered more visible. It is no longer impolite to speak about sex, money and politics in public; expletives are common parts of speech for many. These modes of behaviour illustrate the historical requirement that the rules and codes of social conduct are changing and must always do so.

The Science of the Self

Awareness of others is also self-awareness. This capability was incorporated into the establishment of the human sciences in the nineteenth century through psychology, sociology, ethology, ethnology and anthropology. Commentators and thinkers were increasingly interested in questions about how society worked. Presuming societies were entities of some kind, they sought explanations in physiological reactions to the environment as well as in philosophical judgments. Herbert Spencer

(1820–1903), for instance, wrote about the psychical characteristics of an organic society that could be passed on to subsequent generations, as if these characteristics were biologically inheritable. Gustave Le Bon (1841–1931), celebrated for his study of the crowd, defined the human essence as an unconscious repository of inherited ideas, sentiments and customs. Society was like a biological entity that could absorb characteristics or behaviours in a Lamarckian fashion; these were then inherited by the next generation who would as a result be more socially successful. Wilhelm Wundt (1832–1920), the founder of modern experimental psychology, separated himself from these perspectives by depicting the psychological dimension as cultural, not biological. He argued that historical differences in language, art, religion, myth and custom impinged directly on the mind, making it an extension of society at large. The logic of the argument was that if there existed universal and large groupings of like-minded individuals then it was the result of cultural formations rather than biological inheritances. Into the twentieth century, Carl Jung carried forward some of these ideas to describe the racial unconscious as part of a collective psychological heritage.

Of significance to this discussion of manners is the variety of professional perspectives on the nature of human consciousness that have flourished since the late nineteenth century. Some of these argue for an unconscious that is biologically determined and part of human nature, others for an historical formation specific to certain situations. The concept of the unconscious has been pivotal to understanding the connections between the individual and society, biology and culture, action and history. From numerous (and some ingenious) experiments designed to reveal the properties of the psychological, a raft of new ideas emerged with the psychological era to mark a significant break with earlier pre-modern theories of society. Freud's various renderings on the multiple levels of the sub-, pre- and unconscious, along with Pierre Janet's experiments with female hysterics who demonstrated vis-

ible somatic consequences as a result of their psychic illnesses, and William James's assertion that the singular human body could be home to multiple consciousnesses and socially determined selves, all contributed to the weakening of the belief in a unifying principle of personality.

By the early twentieth century it was apparent to most people that the human self was divided, fragmented, multiple, unstable and unreliable. Freud's different levels of consciousness and William James's view of the personal self having a subject and object, and as many social selves as there are groups who recognize the individual, all contributed to new perspectives on identity. The stream of consciousness literature of the modernist writers and the philosophical works of Bergson, Schutz and Merleau-Ponty also made the idea of a fixed personality based on a stable unconscious increasingly untenable. Instead, the counter idea of identity as a contingent synthesis, influenced by circumstance, was gaining popular recognition. Anthropological material reinforced the point that specific manners and forms of etiquette were not universally known and not uniformly practised. This meant the human subject was a product of codified habits, moods and desires. The secrets of the interior were mirrored in the visible patterns of the social moment.

It became increasingly apparent that the self was a trope, a fiction, a manner of speaking, a pattern of habits that needed to be maintained and kept in the same way that the body needs to be groomed and shaped. Such re-anchoring of ideas about the self has no definitive moment of origin, although the increasingly scientific approaches to identity from William James to Erving Goffman delineate a 50-year period of intense theorizing. Now, in the early twenty-first century, the idea of the self is extensively hyphenated. We speak more readily of self-image, self-conception, self-interest, self-consciousness, self-control, and so on, thus making our approaches to identity more a manner of thinking that is part of a larger regime of popular thinking about identity, consciousness and values.

Society as Surface

Being able to judge whether strangers are dangerous or not, whether they are to be greeted or ignored, rests on rapid mental calculations that compress observations into reliable clues. From physical appearance and subtle bodily gestures, we judge whether to engage with the other person or not. We note certain physical features and turn these into calculated strategies of conduct. Such careful attention to detail expresses sensitivity to the physicality of the other as well as the importance we place on appearance. Strangers speak to one another with a glance, a suggested smile. Holding eye contact for more than a split second, stopping in the visual glide that sweeps across the backdrop of faces, is the signal that anonymity is about to disappear and the social gap is to be bridged – a conversation or gesture of address is about to take place. Reading the street or the public domain, like reading the road when driving a car, is an acquired skill and part of the modern repertoire for living in the crowded metropolis.

Erving Goffman like Baldassare Castiglione documented the precise rules governing social encounters. He observed how appearances, impressions, opinions, deceptions and embarrassments functioned to define the moment. It was the ability to construct oneself as a pure social image that ultimately brought the greatest social success. All individuals need to be able to influence opinions and shape what others see. Goffman described the social moment as a series of mistakes, some more consequential than others. We judge too soon and so misjudge, we apply stereotypes, we rely on platitudes. Social congress is a tangle of gestures and withdrawals. It survives on the basis of the questions it presents but does not answer: can we believe the polite individual is sincere? Does being well mannered mean being well trained, more observant and mindful, or being watchful, careful, suspicious and calculating? Who is the social actor after the mask has been peeled away? When we study the invented lives of individuals who have deliberately

re-made themselves, such as Arnaud du Tilh, Anthony Blunt and the transsexual Agnes, can we better understand how the idea of identity is formulated? Was it easier for Anthony Blunt to live his double existence because he belonged to a highly regulated social enclave that did not permit much doubt or ambiguity?

When Jonathan Trevanny, the reluctant murderer in *Ripley's Game*, reflects back on his uncharacteristic actions, he is surprised to sense a feeling of exhilaration for what he has done. He had not previously imagined himself as violent and yet, after he has successfully murdered two people, he is strangely fascinated by his newly discovered capacities. It is as if his morbidity were connected to an inner mechanism, part of a submerged self that he had not previously recognized. The act of murder suggested to him new aspects of being. Were those talents already in place, waiting to be discovered? Or was he driven to murder by circumstance? At the murder scene, doing what was unthinkable only a few days earlier, Trevanny realizes that he was not seized by a madness that would loosen its grip in time, but that, more seriously, he had become a new and different person. Trevanny stepped away from his familiar self, he divided himself from his previous sense of the proper and moral, and, by creating a gap, became an object of study to himself. It is this sense of distance that frees him to make himself anew, to act differently and in unexpected ways.

Creating this gap in consciousness marks a crucial stage in self-invention; it allows us to inscribe ourselves into another persona. How we behave at a wedding, at an office party, gym class, school reunion and so on arises from what we know of the rules of the situation. But how we behave at our first wedding party or school reunion, and then at the twentieth, is different. In between, we have expanded our repertoire of behaviours; we have developed opinions about such events, and about other individuals we encounter in them. We might have become more generous and worldly about such occasions, or the reverse.

As we acquire the vocabulary of different scenes, as we register differ-ent meanings and opposing views of the same situation, we transform ourselves into a surface over which circumstances glide. We position ourselves in certain situations as we might an object, thus we learn the constraints of circumstances and the versatility of our own per-formances. Society, as a result, becomes both a backdrop and a stage setting to our own desires and capacities. We realize we can be what we want.

Goffman's description of 'civil inattention' refers to the manners of distancing oneself. He describes the necessary pose that modifies any expression of hostility, callous indifference and antipathy that might be interpreted by another in a public space. Civil inattention allows us to ignore one another and be polite in doing so. The demonstration of civil inattention is a sign of recognition that others have claims to a shared space or environment. In a restaurant or shop, for instance, or on public transport, the actual conversation of another is ignored even though it can be easily overheard. But the manners of the day suggest we do not want to overhear others, we do not want to recognize their existence even though we are physically aware of them and often have to avoid literally bumping into them. The same sense of removal or in-difference allows us to conduct our own private business in the public arena. Civil inattention describes a sense of indifference to others; it is an unrehearsed ritual in which body gestures and minimal eye contact signal to strangers a sense of boundary and self-enclosure.

Commonly social regulations and rituals are already in place and we are prepared to enact them. We slide into habituated performances without feeling that this conformity or obedience is too restrictive. How we imagine ourselves on these social occasions marks the point of confluence between the regulations imposed by manners and the sense we have of a unique identity. Behind the display of courtesy there can be the angry mind plotting revenge. How we choose to behave splices

together the internal and external: it is an elusive moment to study yet it is precisely where the spark of self-invention occurs. That point of meeting – the intersection of personal estimations of who we are, coupled with the external conventions that prescribe everyday behaviour – designates the angle where the internal and external are connected.

Popular conceptions of the self often give it a developmental history as if it evolved like the physical body. Certain types of individuals are thought to appear in history to match the circumstances in which they live. Thus the pre-modern 'savage mind' emerges from tribal taboos and customs and frames a collective consciousness from which all individuals find an identity. By the same token, the modern psyche is supposedly shaped by a bureaucratic world of rules and regulations, and by the influences of industrialization with its mighty workforce that makes us all cogs in the wheels of progress. The 'spirit of capitalism' has been famously depicted as an elective affinity between religion and psychology (Weber, 1930). Under the current influences of psychobiology and psychoanalysis, we do not like to think of ourselves as such direct products of the times.

This makes identity contingent and too much a matter of chance, of where we were born and to whom. We might acknowledge that we can change with history and that the specific attributes of a person are acquired through experiences but, if history and circumstances are so influential, can we really speak of a human character that persists through time? While our past influences behaviour, and childhood experiences have long-term effects, it is also the case that we can choose how to act in certain ways. How those decisions are made and enacted brings attention to the significance of the audience, of who is looking. Every action is formulated within the gap, between the social distances separating us from the observer. It is here that the self is invented, for the moment, to suit the circumstance, to supply us with a sense of identity.

In the compacted, contemporary city, we constantly brush up against strangers, literally and symbolically, whenever we go about our business in the public domain. These encounters, by necessity, involve mental calculations about the maintenance of poise, the avoidance of embarrassment, the allocation of spatial position, register of speech, and so on. This constant vigilance over the social involves being aware of what is said, how it is said, and how we act and appear to others. The necessity for this vigilance is often thought of as a form of restraint over our real natures. Manners then seem to be conventions that prevent a more brutish nature from slipping out from hiding and disclosing cruder emotions and desires. Such a way of thinking leaves civility as a mere veneer masking self-serving impulses. Yet there is more to the display of a mannered surface.

The modern individual must display a willingness to be self-controlled, which in turn signals to others that s/he is practised with the requirements of social life and can be trusted. When the control is broken, when the demands for body maintenance break down, when competence is weakened or disturbed by inadvertent lapses, say, when we blush, are clumsy, forget a name, make a *faux pas*, then we can become rattled. Freud thought of the slip of the tongue, the lapse of concentration, as revealing. Goffman too has referred to this as 'flooding out', and the metaphor is suggestive of the body being merely a bag that breaks and splits open, disgorging an unformulated essence that is the real human being, set free from the rigidities of culture.

The idea of the self as a social tool and the question of character as inherent or cultivated have long histories in Western culture. We now live in a world where references abound to notions of free choice, selfhood and individuality. What we own and our social practices speak to others of our tastes and status. But what exactly is this centrifugal concept that draws into itself all the taken-for-granted habits of the everyday and claims these as part of an identity which is, at the same

time, regarded as unique and different from all others, and which separates and keeps us apart from one another? What is self-identity? Is it a psycho-biological feature of all human beings? Is it a product of the social and historical? Is it a phenomenological entity? Is it a social force, an elemental spark that keeps us going just like cellular oxidation maintains the body? Such questions resonate through various displays of identity in popular culture and function to reposition the self as central to everyday life. Yet this gesture does not bring greater clarity to the question of identity, but largely only confirms a preoccupation with self-invention and the availability of accoutrements that emphasize its importance – for instance, fashionable clothes, stylish possessions and a valued lifestyle.

Manners equip us with the necessities to participate in society. They link behaviour with ethics and other more abstract cultural features of a specific community; they absorb ideals of human conduct into their practice and prescribe patterns of living. Manners refer to the nature of relations between people, to standards of bodily deportment, to ethics and the control of vice and brutishness, and to how we imagine ourselves. As well, they refer to commonplace assumptions that prescribe dress, speech and demeanour and to a general consciousness about what it means to be social, to be capable of maintaining public relations with strangers, and being a virtuous, good citizen. Manners are not necessarily didactic: good manners, civility, courtesy, politeness, a sense of decency and so on are loose terms with slippery usage. Indeed, the term has no simple and reliable definition, but it does have the important function of bringing focus to how we conduct ourselves in the public domain and how we pursue pleasures and cultivate tastes.

So pervasive is this sense of being self-conscious that even when we are alone, we are haunted by the social. Historians of privacy such as Elias, Braudel and Duby advise that the loss of a sense of being alone

is a sign of social integration and complexity. In the modern era, with increased daily contact with a variety of strangers, the capacity to separate oneself, to be ultimately alone, becomes much more difficult. Carrie, the character from *Sex in the City*, and Jerry, in *Seinfeld*, have television episodes in which their private actions are imagined being overseen by others. This realization that one is never alone, as well as the fear of public scrutiny, is part of being sociable; as Goffman would say, it is the social condition.

Playing the Game

Twentieth-century cubist painters painted what was not there – they painted movement that we the audience knew existed but did not visually register as such. Braque's still life paintings are representations of movement. They depict energetic action that make the objects appear to be without boundaries. These ideas map onto contemporary social theories that argue the orderliness of social life is a scrim behind which lurks constant movement and activity.

Playing with perceptions in this way is not a deceit. Shakespeare's comedies illustrate the naturalness of deception. In *Twelfth Night* no single individual conspires to deceive another, rather the social universe is brimming with surprises, reversals, mistaken ideas and failures. In this particular romantic comedy, identity (both social and sexual) is confounded by a series of unexpected disasters as well as deliberate disguises invented on the spur of the moment to manage the strange circumstances. After Viola is separated from her twin brother Sebastian during a shipwreck, she is washed up on a strange coast (Illyria) and decides to disguise herself as a boy for her own protection. When rescued, and in disguise as Cesario, she is employed by her rescuer Count Orsino as a page who is then assigned the task of wooing Olivia on Orsino's behalf. The plot becomes more complicated when Viola falls in love with Orsino and Olivia in turn becomes infatuated with Viola in

disguise as Orsino's emissary Cesario. These mistakes and deceptions are sources of playful amusement ('how quickly the wrong side may be turned outward', quips the clown (III.i.10–12)) rather than the result of any secretive human manipulation as arguably the case could be made with regard to *Othello*.

In *Twelfth Night* the various deceptions make sense; the daughter and son of a nobleman are not in their rightful place in the world. They are forced by the shipwreck to re-invent themselves – with some loss of social standing. Viola becomes a servant to Cesario and Sebastian wanders about in a daze. The shadow side of the play comments on pretence, greed and the dangers of aspiring to higher rewards – be they social status, wealth, political ideals or even the illusion of truth. The character Malvolio is the vehicle for these messages; he imagines himself better than he is, he feigns social importance but is depicted as suffering from narcissism. In this new world, 'social' laws are suspended in favour of 'natural' ones; the 'natural' rule of emotion challenges the social order. The rules defining gender identity are suspended, reversed, manipulated, dissolved and then restored. At the end of the play, the natural attractions and emotional impulses of the characters are fitted into the social conventions and a series of proper marriages re-establishes the hetero-normative order replete with happy arrangements of love and romance.

Irrespective of these conveniences, the Shakespearean comedy illustrates the inescapability of deception as part of everyday life and presents it as neither corrosive nor intentionally manipulative. Just as Anita Brookner suggested in her twentieth-century novel, *Fraud*, the search for identity and its enactment is a constant challenge to the good actor. Again and again in everyday life there are unexpected events, even catastrophes that suddenly make the predictable world seem chaotic and alarming. These reversals and losses are both material and existential. After the rupture (whatever that is), normalcy (whatever that

is) must be restored and the conventions that frame the everyday must be deliberately re-established. Such are the requirements of social invention and in turn self-invention. Derek Jarman's 77-minute film *Blue* (1993) illustrates the point: this static film of Yves Klein blue glow is offered to the audience as a blank slate. Obligingly, we make something of it; we can be irritated and numbed by the seemingly unchanging visual screen or we can find allusions to interesting issues – say, to blindness, death, life, hope, human ingenuity and so on. We make sense of what is in front of us, we resolve the perceptual chaos and push against the threat of formlessness.

Deception is the mirror of performance. Every social moment is always on the edge of collapse into chaos and disorder, we must always be poised to spring to its resuscitation and reinvention. The well-ordered situation is an illusion, a matter of perspective. Misrepresentations and illusions are fused together as reflections of one another. Truth and deception cannot be easily separated. Nature may not be natural, the obvious may not appear to be the case. Shakespeare has Orsino state this position succinctly in the last act of *Twelfth Night* when he sees the twins Viola and Sebastian together for the first time, and quips, 'a natural perspective, that is and is not' (V.i.209–10).

The contemporary theorist Stephen Greenblatt (2004) makes the argument that Shakespeare became Shakespeare because he was a professional actor. Acting is about inventing a narrative and making it real for the other person, out there looking on. It is about learning tricks of persuasion to convince the viewer to see what is not there, to conjure up the world, just as did the cubist painters. All literary and visual forms – the novel, painting, photograph, Hollywood film, advertisement – have the capacity to activate the imagination. With the most rudimentary training in theories of representation we can see human movement in the multiple edges of Braque's cubist portrait; we can see huge landscapes in the minimalist canvases of the Australian painter

Fred Williams. Such interpretive skills allow us to produce a sensible social environment.

In this light, identity is a shifting category. It can be thought of as a residue, 'an image pieced together' from ongoing events, a manner of acting in situations in which we know we are being judged and classified (Goffman, 1967: 31). It can be a belief, an almost universal acceptance of a real, tangible, verifiable substance as well as an apparition, an effect of the morally charged environments in which we always expect others to judge us. Self-identity is a discourse embedded in cultural conventions. Its nature, substance, durability and origins are of less interest than the habits of social engagement that sustain it. We enter every moment with assumptions that seem natural and self-evident. We adroitly assume a role, pick up a script, find a place in the continuous babble of the moment. Even in circumstances where information seems obscure, when we are in a foreign country or contemplating a work of art or discovering the rules of a new computer game, still we are practised at closing the gap between what we perceive and what makes sense.

The industrial age ramped up the circulation of ideas about personal identity as the 'science' of retail became a preoccupation of the new economy. Emile Zola's novel of the new department store, *Au Bonheur des Dames* (1883), describes how goods shaped our readings of the social surface and invented modern identity. By looking at the world of retail, advertising and fashion, we can see how identity has been styled into a commodity that is bought and sold in the thriving marketplace of the globalized and cosmopolitan society. We have learned to act in ways that infer we have a sense of self that transcends the moment. This is the convention: to act as if personal identity existed. At the same time, the supposed hidden self is understood as the repository of all that is reliable, honest and authentic. Looking closely at the mechanisms and devices such as advertising, fashions and conspicuous consumption

that are engaged in sustaining these contradictory and unstable ideas about human identity reveals many of the strategies that sustain the art of self-invention.

5. *Down with Love* (Ronald Grant Archive, 2003).

PART II
Looking Good

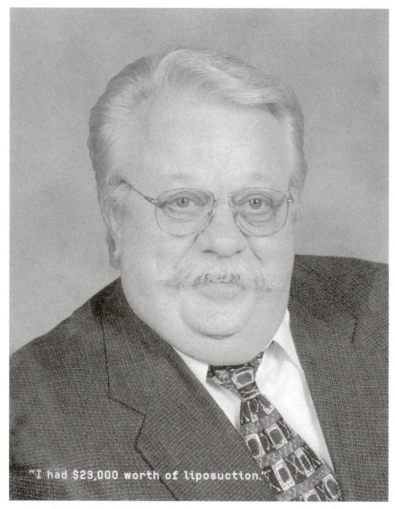

6. *I had $23,000 Worth of Liposuction* (advertisement placed by Citibank in the *New Yorker*, 15 December 2003).

3. Identity

One has to live a life always at an angle ... to be oneself and at the same time another ... nothing, absolutely nothing, is as it seems.

John Banville, *The Untouchable*

Status Symbols

Claiming an identity is an ordinary occurrence. The passport, bank account, credit card, tax history and driver's licence all confirm who we are. With these credentials we are able to purchase goods and services, travel and enjoy civil rights. Having an identity is a tangible asset. An advertising campaign by a major global bank uses the fear of identity loss to promote its insurance and credit facilities. The advertising campaign displays a series of full-face photographs overlaid with a contrary text message. One image is of a corpulent man with the caption 'I had $23,000 worth of liposuction', another is of a conservative middle-aged woman wearing pearl earrings and matching necklace, with the caption 'I spent $2,342 on violent and suggestive video games'. Another shows a young woman with a fresh, open face, smiling and relaxed, with the message 'There are 3 warrants for my arrest. One of them involves smuggling' (*New Yorker*, 15 December 2003).

Why do these advertisements work? Their effectiveness rests on the incongruity between the stereotyped image of the person and the printed text. Each image looks directly out to the reader. The background is plain and undistracting, there is no trick lighting. They are a true study of the straightforward and uncomplicated. Yet there is a sense of menace and anxiety as if this very ordinariness was in jeopardy. The impact of the images rests on the shock of the crimes wrongly attributed to upstanding citizens.

We are in an era where impressions matter, and where reputation is both an asset and a liability. Part of our daily maintenance now is to secure personal details and prevent becoming 'anonymized' or invisible. We have learned to value privacy and avoid joining a global data bank to become the target of a telemarketer or computer hacker. At the same time, we are increasingly self-conscious and alert to how others are looking at us. Indeed, thinking about how others see us is an engrossing preoccupation. Pop psychology has made 'people-watching' and the search for 'motives' into respectable pastimes. In everyday parlance it is common to speak of the forces driving us as if they were observable and factual, and as if they could explain why people act as they do: 'he cut me off in the traffic because his boss is a woman'; 'she is always gossiping because no one takes her seriously'. This level of interest in the self has been commercialized; personal therapy and meditation classes can be purchased to help improve and realize our potential. We can learn to sleep differently, change our eating practices and sexual desires in order to understand and perfect the mechanism that holds body and mind together. This heightened level of attention encourages an overvaluation of self-presentation.

Looking Good

Philosophi Phisnomia is attributed to Aristotle and is one of the earliest works addressing issues of identity. It argues that there are strong con-

nections between temperament, health and appearance. This apparently simple idea has been reworked over the millennium and gives rise to physiognomic theories about the connections of particular body parts with specific emotions. Over the centuries links have been asserted between the shape of the head, or eyebrows, lips, ears and fingers, and the counterpart characteristics of intelligence, character, moral rectitude, perversity and criminality. Some have argued that the shape of the nose signifies levels of cruelty, pugnacity and kindness, or that the ears demonstrate impulsiveness and the capacity for memory. In the seventeenth century, the logic of physiognomy connected thick lips with the level of heat retained in the body, which in turn had the effect of dulling the senses (Turner, 1641: 114–20). As quaint as these theories may sound hundreds of years on, the fundamental idea that appearance and character are linked has remained influential into contemporary times, often sustaining the kind of uninterrogated stereotypes such as those used in the bank advertising campaign warning of identity fraud.

A recent example of physiognomy made popular again has been produced by a California-based psychologist, Paul Ekman. He has developed an analytic framework for reading the human face that he calls FACS (the Facial Action Coding System), as mentioned in Chapter 2. Ekman believes in the reliability of non-verbal communication. FACS is a catalogue of more than three thousand different faces. The face has 43 possible groupings of muscular movements that shape its mien and by looking at a combination of two muscle movements and then three, four and five such movements, Ekman has built up a list of over ten thousand facial configurations that represent emotional states such as honesty, anger, fear, modesty and so on. Ekman maintains that these voluntary and involuntary expressions are universal and can be reliably read irrespective of the cultural setting. He confidently asserts that FACS overrides many differences produced by circumstances or particular social and local practices (Ekman and Friesen, 1975).

Ekman has designated the AU (Action Unit) as his principal diagnostic tool. An AU refers to a specific arrangement of the facial muscles. Ekman has numbered and classified every muscular twitch and related it to a corresponding meaning. An AU may be the raising or lowering of the eyebrow, a stretch of the lips, a jaw drop, a forehead furrow, a widening of the eyes, a protruding lip and so on. Ekman has mapped these movements onto the physiology of the facial musculature, identifying how each movement contributes to a specific expression; there are, he maintains, critical differences between infraorbital and nasolabial furrows.

In Ekman's elaborate system, AU 17 refers to a slightly raised chin, AU 24 refers to the rolling of the eyes and AU 9 is disgust – which involves the wrinkling of the nose (*levator labii superioris, alaeque nasi*). He uses the proper terms for these muscles to add 'scientific' credibility to his system. The more complicated the emotion, the more facial movements are involved and the list of AUs gets longer. The gestures around sexual flirting, for example, involve a series of actions in various sequences – eye contact, a small smile then a glance away and an averted gaze. A reprimand with an apologetic gloss involves an abrupt smile, a nod and then a tilt of the head sideways. The list of AUs involved might read 1, 2, 4, 20, 26 and so on. A genuine smile involves the *zygomatic major*, the *orbicularis oculi* and the *pars lateralis*, whilst a fake smile does not involve the latter muscle groups.

A long article in the popular *New Yorker* magazine by Malcolm Gladwell, author of the best-seller *The Tipping Point*, describes an exercise in applying FACS to the celebrated murder trial of O.J. Simpson. An important witness supporting Simpson was being questioned by one of the prosecutors, Marcia Clark. The witness, Kato Kaelin, appeared to have a rather blank, expressionless face. However, Ekman shows on the slow motion videotape of the proceedings how Kaelin's apparently blank face registered his actual feelings of hostility and aggression that he quickly and almost imperceptibly managed to control:

on the screen, Kaelin moved forward to answer the question, and in that fraction of a second his face was utterly transformed. His nose wrinkled, as he flexed his *levator labii superioris, alaeque nasi*. His teeth were bared, his brows lowered. 'It was almost totally AU 9', Ekman said. 'It's disgust, with anger there as well, and the clue to that is that when your eyebrows go down, typically your eyes are not as open as they are here. The raised upper eyelid is a component of anger, not disgust. It's very quick ... he looks like a snarling dog.' (Gladwell, 2002: 46)

Ekman uses other celebrated events to support the veracity of his FACS. In a press conference with Kim Philby, taped in 1955 before Philby had been disclosed as the third Soviet spy, Ekman identifies the signs of guilt conveyed by his facial expressions. He points to the smirk that plays over Philby's face when he denies the suggestion that he is the third man. It is an expression so quick and subtle that without the slow motion replay of the tape, it would be impossible to see. Similarly Ekman points out, in another moment in the same interview, that a slightly raised eyebrow indicates that Philby is unhappy with the questions being put to him. The tape has to be slowed down to quarter speed before this slight gesture can be seen. Ekman treats it as reliable and argues, on its basis, that Philby felt guilty in that moment about his earlier betrayal of Burgess and Maclean.

Any critic of FACS would say such reactions by Philby are to be expected and hardly need the science of FACS to establish their existence. FACS, like other physiognomic systems, is self-referential and as such has a dubious claim to providing scientific evidence, yet its popular appeal cannot be dismissed. Ekman believes that it is possible to teach FACS and use its techniques to see discrepancies between what is explicitly and implicitly signalled. He argues that unconsciously we already rely on information gathered through registering the subliminal micro-expressions from those with which we speak daily.

Relying on the visible surface of the body to reveal identity is indicative of a profound cultural investment in psychology. When then US

Secretary of Defense Donald Rumsfeld was pictured rubbing both his eyes in public, the interpretation was made that he was blind, he could not see, and in political terms it meant Rumsfeld was not astute. Those aspects of self-experience that are not visible such as dreams, moods, anxieties, phobias and obsessions may be concealed but can, with the right training, be made visible. For Ekman, it is logical to think that there is a two-way current running between the inner and the outer; thus the interior emotions become visible through muscular movements, and in turn involuntary muscular movements speak of an undisclosed self. This concealed or repressed self is made visible to observers who themselves are trained to respond to details in presentation. Ekman's FACS allows us to draw such conclusions (Braiker, 2004).

At minimum the self is bifurcated, it has a double; there is the conscious and unconscious, private and public, civilized and base, good and bad, and we can create ourselves as well-rounded beings from the management of these seemingly opposed elements. Thus we are shaped by the circumstances of birth and have no control over our parentage, but we can, if we desire, make ourselves in our own image by employing the wide range of products and services designed for self-enhancement that are available in the consumer marketplace.

Coded Identity

The foundation for Ekman's FACS is also the basis of the systemization of physiognomy produced by Johann Caspar Lavater in the mid-eighteenth century. His theories were so popular that parlour games were based on their principles and miniaturized versions of his schema were printed on playing cards that could be carried about and consulted whenever a new person was encountered. The social historian Richard Sennett has described the importance the emerging middle classes in France and England, in particular in the late eighteenth century, attached to demeanour and the body:

> people took each other's appearances in the street immensely seri-
> ously; they believed they could fathom the character of those they
> saw ... Finding out about a person from how he or she looked be-
> came, therefore, a matter of looking for clues in the details of his
> costume. (Sennett, 1976: 161)

The number of buttons on a shirt, the fabric of a dress and the cleanli-
ness of one's gloves were all clues that corresponded to the individual's
psychology and personal values.

Similar ideas still circulate: we attribute to the wearer of the be-
spoke lounge suit a different temperament from that of the Sears Roe-
buck off-the-rack, and we might presume to deduce a woman's sexual
preferences from her choice of high heels instead of flat, sensible shoes.
So precise and detailed are some of these expositions on self-fashion-
ing that we learn from them which items of clothing, mannerisms of
speech and hand gestures mobilize specific social messages. An erect
posture, a smile and steadiness of gaze have precise social meanings
that speak of particular personal characteristics – as do a hat, wig, ear-
rings, a necktie or a fur coat. Attached to our bodily deportment and
accessories are highly detailed codes that suggest specific social im-
pressions.

Some kinds of dress and body decoration make the identity of the
individual highly visible, while others disguise it. A sinister example
was imposed (not for the first time) on Jews during the 1930s, who
were made to wear the *Magen David* to signal who they were in the
'civilized' heart of Europe. The effort to sift through these insignia of
identity in the context of the social encounter has occasionally led to
laws and regulations forcing people to display identifying signs. Sump-
tuary laws of early modern Europe were attempts to systematize the
visual emblems of social rank and identity. They controlled who could
own material goods, dress in particular styles and have access to the
distinct privileges of social position.

On the basis of physical appearance it could be safely assumed, between the seventeenth and eighteenth centuries, that an individual with an elaborate wig, silk clothing and a painted face was an aristocrat (Greenblatt, 2004). An individual with the ribbons and buttons of a trade guild was of a lower rank, permitted to own only certain kinds of goods (Jardine, 1996). At the other end of the spectrum, the peasant and slave wore rags held together with toggles of leather, straw rope and skewers. Peasants did not own buckles or belts (Engels, 1952 [1891]). Clothing has long emphasized distinctions between men (trousers) and women (skirts).

The opportunity to play with these visual distinctions (for example, allowing women to wear trousers) is a feature of social freedom in egalitarian societies where appearances are much less constrained by rules and ironically, as a result, appearances become much more ambiguous. When Marlene Dietrich appeared in full male evening dress in *The Blue Angel* (directed by Josef von Sternberg, 1930) the transgression of the gender boundary created a frisson that surrounded her on and off stage for years. In the following decade, the 1940s, Hollywood films were influential in changing the clothing styles of women. Katharine Hepburn was often shown wearing slacks both on and off screen, thereby making the more casual, masculine attire popular with women. Underscoring this association of identity with appearance is a cultural anxiety about knowing who it is we are encountering. Using coded items of clothing to make such categorizations more visible also makes them a site for playful resistance.

In the film *Victor Victoria* (1982) directed by Blake Edwards and starring his actual wife Julie Andrews, there is a scene where she and her male counterpart, James Garner, are dressed identically in full evening attire. Both are in white tie and black tails, both have a white camellia in the buttonhole, both wear heavy cufflinks and smoke large cigars. The film is a comedy set in the 1930s about cabaret, opera, high

culture and low life. In order to survive in such a world, Julie Andrews must disguise herself as a man, a Shakespearean twist often used to ensure a woman's safety in a foreign land. Yet even in disguise, dressed in identical evening wear, Julie is still coded as a female. James Garner wears a moustache, Julie Andrews does not. She wears lipstick and he does not. His gaze is direct and hers is averted demurely downward. He smiles, confident in his reading of the situation; she is expressionless, anxious about how the moment will play out. The signs of gender difference are apparent despite the characters wearing the same dress.

Spectatorship cultivated through cinema, art, theatre and fashion has conventionalized the visual representation of identity. This emphasis on appearances provides a ready means for fabricating and popularizing certain aspects of identity. Sennett noted of eighteenth-century street life, 'whether people were in fact what they wore was less important than their desire to wear something recognizable in order to be someone on the street'. He depicted the bustling city centres of Europe as platforms or stages upon which individuals continuously practised being 'somebody'. He recorded how Londoners and Parisians believed they could distinguish anyone's social standing simply by examining the details of their dress (Sennett, 1976: 66–7). Those with a more sober and uniform appearance were the middle ranks, the accountants and lawyers, and those with painted faces touched around the nose, forehead and chin with odd patches of red or black pigment were members of the upper ranks who transformed their bodies into amusing toys with which they played out frivolous fantasies.

The idea that character and personality are both immanent in appearance still exerts a strong influence even though it is riddled with ambiguities. We are familiar with the idea in Westernized societies that appearances can be fashioned and that we can choose to dress or behave in a particular manner in order to convey a certain impression. We also know that such makeovers and masquerades are commonplace,

that everyone is doing the same. A stylish appearance may liberate us from the strictures of conventional roles, or in reverse – if we play by the rules – a conventional appearance can conceal what we do not want to reveal. The dual image of *Victor Victoria* is a reminder of the value of reading the obvious in order to see what is there, in this case, a male and female. It also alerts us to look for what is concealed beneath the obvious. The paradox of fashioning ourselves is that it reveals by concealing. Thus the art of deception carries the surprising truth of Oscar Wilde's quip that appearances are important, that the 'true mystery of the world is the visible, not the invisible' (1973 [1890]: 25).

Finding the Subject

It has been common to argue for a linear history in the emergence of the modern self. Thus identity in the *ancien régime* evolved into a different concept in the scientific age under the influence of physiology and biology. The historical trajectory from the village character to the mass-produced self of the post-industrial society has a convincing force. Yet cutting across the easy logic of this linear approach is a persistent concern with self-invention that has circulated throughout fifteenth-century Italy, sixteenth-century France, nineteenth-century Britain, twentieth-century America and so on. Porter (1997: 17) rightly warns against a history of the self that parallels a history of Western industrialism. There is another kind of self that emerges from a history of manners that locates the invention of the self in various forms of cosmopolitanism: 'in the centres of European commerce, outward displays of wealth were now widely accepted as an index of one's identity' and 'individuals were required to adopt highly stylized public personae when they regularly confronted virtual strangers whose approval and esteem they sought'.

In pre-bureaucratic communities, attention to personal identity was a matter that arose from legal conflicts and not from a daily con-

cern with public display and presentation. This is an important reason that accounts for the enduring interest in the story of Martin Guerre. At one level this story is a classic bedtrick, of one person pretending to be another and the 'victim' of the deception agreeing to it. All bedtricks involve a degree of self-deception; thus we go to bed with one person only to discover afterwards they are someone else. Bedtricks work on the assumption that 'all cats are grey', that every body is like every other body. So the questions that make Martin Guerre of enduring interest, five hundred years on, include those about Bertrande's role: did she know the new Martin (du Tilh) was not her husband? Did the intimacies of the sexual encounter reveal or conceal Martin's identity? Were the sexual exchanges with the two different men much the same? Was the masquerade convincing enough to sustain the illusion even in the bedroom?

Thinking about identity in institutional terms as reputation or as legal status – as suggested by both the case of Martin Guerre and the *New Yorker* advertisements for credit card security – is now an ordinary habit of mind. Reaching this point, though, entails reviewing the endurance of the idea of the self through Western thought. The meditations of René Descartes elaborate a paradox of thinking about the self that resonates back to even earlier interests pursued by the ancient Greeks. The Cartesian self separated the material world (*res extensa*) from the world inside (*res cogitans*) and in so doing made the life of the mind, feelings, impressions and sensibilities into an unreliable and imperfect reflection of the world outside. Descartes' famous *cogito ergo sum*, I am thinking therefore I am, has been the site of strenuous scholarly investigation for centuries as well as relentless satire, as Lord Shaftesbury commented in 1711: 'What is, is – Miraculously argu'd! If I am; I am' (Porter, 1997: 133). Shaftesbury (1671–1713) was a popular philosopher and advocate of the Whigs; he regarded his fellow humans with affection and opposed the view of Thomas Hobbes that life was

nasty, brutish and short, taking a commonsensical approach that disregarded the subtlety of Descartes' anxiety about the interior realm.

The history of the self is a persistent theme in the rise of the middle classes. The desire to be self-made, to have control over one's life and be free are not vanities of will but the everyday expectations of the modern, new individual. The quest for adventure through travel and trade, and the desire for autonomy achieved through democratization and social mobility, are predicated on the existence of a striving, centred, coherent self. Such a self is presumed to be the engine of society. The classical anthropologist Marcel Mauss (1928) argued for the universalism of the self on the basis that every human society, no matter how different and exotic, evidenced such a belief. He saw the play of the self in the capacity to think about change, death and the passage of time, and the possibility of a better future. New knowledge of the world gained through scientific experimentation, travel, war and technological invention also brings new awareness of individual difference and this, Mauss suggested, marked the proper process by which we become a person. Every human being is aware of his or her body, yet every society with its distinctive laws, religion, customs and social structures produces a sense of typicality, of being like this group of people and not another. Mauss saw the self anthropologically, as a cultural mask, a performance and social role that every human irrespective of cultural background strived to control. This was the universal self; it might have different appearances in various societies but it emerged from the universal desire to master consciousness and project a social presence (Mauss, 1985 [1928]: 20).

Norbert Elias (1978) produced a theory of identity linked to the historical development of the nation state and the growth of complex economies. He begins by questioning the sense of uniqueness that every individual supposedly experiences and wonders about the nature of a core being. He referred to this view as *homo clausus:* it was 'the image

of the individual as an entirely free, independent being, a "closed personality" who is "inwardly" quite self-sufficient and separate from all other people, [and] has behind it a long tradition in the development of European societies' (Elias, 1978: 222). The inner core appears to remain insulated within an interior vacuum. Elias questioned this view by asking about the process of exchange between the internal and external worlds, between psychology and history: how could the individual be enclosed and self-sufficient when he or she was also an actor in the world? Elias was intrigued by the paradox of the inner and outer. European societies since the Renaissance had consolidated the idea that humans are isolated from one another by an impenetrable inner life and this, in turn, creates a basic separation, a binary view of the world – us and them, inner and outer. But what was the value of thinking in such a manner, Elias asked, and what kinds of societies thrive on these beliefs?

A persistent puzzle in the study of human identity is that of embodiment. While we are all flesh and blood, and share the ambiguity of body language, it is the case that the visible body marks a limit. Twinned with the body is an invisible interior that makes us amalgams of the outer and inner, the visible and invisible, the heart and the head. The embodied self never lets the mind forget the presence of the body. The sensation of pain or pleasure cannot be removed from the mind, nor the tone of voice separated from the facial look. This fusion makes sense, but the connection between them does not – what holds together the inner and outer?

There are no definitive answers to such questions. Variations in societies suggest a plastic human nature and not a universal one. The cultural habits of the West, of grooming and cultivating the self, appear to contradict the idea of a stable interiority that is embedded in the ideology of identity. Playing with appearances and emphasizing certain qualities in the production of a public identity emphasize the influence

of circumstance, yet at the same time the contrary claim of a fixed self endures. The stable core of human experience resonates across the centuries in the face of challenging evidence. Even the claims of biological enthusiasts – that with technical data from the genome project we can genetically isolate characteristic behaviours like musicality, sexuality, intelligence and athleticism – still do not constitute evidence from which to assert there is a stable human nature.

We have imagined the self along a spectrum – it is at once a specific cultural form emanating from our living habits, and an expression of enduring universals and timeless principles such as those embedded in Western humanism. The self is the repository of fundamental truths held in perpetuity and expressed through canonic texts and figures – Medea (Euripides), Narcissus (Ovid), Sisyphus (Homer), Lear and Hamlet (Shakespeare). Like these archetypes we all experience and suffer more or less the same ethical, emotional, existential and philosophical conflicts and concerns, and these are repeated through changing cultural forms whose study and contemplation makes us human and civilized. This is the strong humanist tradition in Western culture that has placed the individual at the centre of science, history and the arts, and made the world into a creation of mind, a place we feel competent to shape.

Much of this manner of thinking emerged from eighteenth-century concepts of the mind that imagined identity as a by-product of the examined life, and society as a vehicle to ever-improve the human condition. Consciousness, memory, sentiment and human will were thus the robust ingredients that always brought together the fate of society with that of singular individuals. Against this dramatic view of the self is another slightly more sanguine view, that identity is a social device; it records a series of ever-erupting selves or performances. And these are of no consequence. Thus identity can be safely ignored, or lost in the rush of social life. A new self emerges, a new social opportunity

appears; the self then is thought of as a series of manoeuvres. It is not a fixed element within human nature, but a habit of mind, a way of thinking about ourselves.

In contrast, the desire to believe in a fixed human nature has been associated with the process of embourgeoisement, with secularization and the loss of divine authority located in the church and monarchy. With the growth of trade, wealth and social mobility an extended cultural horizon has developed. Technological innovation has secured a sense of mastery over the physical environment but, as well, this freedom to produce brings a fear of unfettered possibilities. Historians of the middle classes have suggested that with this new freedom comes a need to identify basic human capacities that provide a sense of stability. With a fixed self, the bourgeoisie could feel that their rewards were earned, that they were entitled to their new achieved status, that they were who they wanted to be and that this was not the result of accident or circumstance: 'only the insecure bourgeoisie had the need for something so prosaically reassuring as that insurance policy, continuity of personhood' (Porter, 1997: 135).

Self as Surplus

The idea of the self as a convenience has strong appeal. It encourages a secular exploration of everyday life in which patterns of behaviour and conventions can be recognized more justifiably as products of circumstances than simply being part of a well-rehearsed, lubricated and habituated regime. The emergence of the novel as an art form dedicated to explicating the human interior supports this view and explains in part its increasing popularity over the past two centuries. Laurence Sterne's *Tristram Shandy* (1759) is now thought of as a daring exploration of interiority; its 'novelization of life' brings the mysteries of consciousness to the foreground. The authorial voice mixed with the expressions of the novel's characters creates a sense of disorientation within the

reader who is then drawn into the narrative as part of a working consciousness. Thus the idea of personal identity becomes synonymous with the art of thinking about oneself in the social world.

From this viewpoint, society is not an expression of inherent human drives or remote external forces. Society comes into existence because we will it; sociability emerges from our consciousness and actions, it is manufactured from sustained attention to the fulfilment of duty, obligation, the pursuit of pleasures and a sense of reciprocity. To be cultivated and practised in the conventions of the everyday is to be sociable. The inscription over the door of Shakespeare's Globe Theatre, *Totus mundus agit histroniem* (the whole world plays the actor), might be interpreted as a summary of the viewpoint (Greenblatt, 2004: 292). Social life is built on an ability to act, to play with others and carve out sustainable patterns of action and thinking about oneself as a social actor who understands the value of strategic reasoning.

Presumably the thousand-strong audiences who regularly attended the theatre –the Globe Theatre could hold three thousand people (Greenblatt, 2004: 292) – and watched the actors manipulate situations in which identities were often mistaken, lovers impersonated, social positions reversed and ridiculed and the customs of the day constantly breached, also learned that identity both on and off stage was a fabrication. Such ideas were probably circulating through the France of Martin Guerre and it is possible that they informed the quiet admiration that the judge of the case, Jean de Coras, held for Arnaud du Tilh.

The popular theatre showed its audience that acting and pretending were both amusing and advantageous. There were benefits to being self-conscious, inscrutable and in control of what others saw. Learning to act as if the world were a stage meant that the self was not a mysterious core like a soul waiting to be understood, but the opposite, an ephemeral quality, an idea that had no material presence and could

only be thought of as a residue, memory or inflection that might be discerned (with careful scrutiny) from everyday performances. To accept the notion that poise and self-possession are necessary elements of everyday life is to accept tacitly that there is no need for a permanent sense of identity. The self can be better thought of as a fusion of unrelated emotions and sensations of daily life that inexplicably manages the various pleasures and anxieties of the day. Identity then is a concept with which to think about self-invention and the pleasures of the fabricated life; it is a vehicle for seeing oneself as a performer both on and off the stage and as such it can provide an exciting manner of thinking of oneself as an actor or agent in the world.

The many discourses on identity found in the cultural histories of the West emphasize its enduring allure. Identity is variously described as a measurable psychological state, an existential *tabula rasa*, a mechanism of mind, a quality of curiosity, doubt and ambiguity, a privileging of introspection, a fiction, an ideological device and so on. It is whatever we are capable of imagining. It can incorporate the future and the virtual, it can slide easily into facticity and organize our various mundane activities. The idea of a self endorses the reality of an inner coherence as if it were the driving force behind our achievements. At the same time, it can be the opposite – a divided, fragile, addicted and chaotic set of habits. It can be a manner of speaking that allows us to recognize we are deluded and fragmented at the same time that we imagine we are in control of our destiny and capable of robust happiness. It is a trope through which we can register cultural fatigue and dissipation. It is a device for acknowledging the existence of submerged desires, mysterious pleasures and ungovernable thoughts that fill the interior world with dreams, nightmares, calculations and visions. It is an invention that enables us to understand the other person. It is a way of differentiating ourselves in order to be separate from them, and a way of making ourselves like them.

Thus the self is a storage and retrieval system, a repository of the roles we have in the world as, say, the perfect mother, ardent lover, reliable bureaucrat, brilliant doctor and so on. The self is the powerhouse behind our desires; it authors the gestures that hinge us to conventions. It provides a way of building consensus with others as we seek to belong to circles of like-minded people with whom we live and work. We share overlapping, if not identical, perspectives on objects of our fancy; we develop a language that enables us to make sense of Helen Frankenthaler's paintings, Antonio Gaudi's architecture, and films of distorted and lost memory such as *Memento* (directed by Christopher Nolan, 2000). Our self-consciousness becomes a mental tool from which the social and cultural rules of the moment surface at appropriate times to organize our performances. Thinking about identity and asking the question 'What is the self?' focuses attention on abstract notions of power and autonomy, the interplay between what we know and do, what is acceptable and not, what is deemed normal or odd. This manner of thinking has the effect of keeping the category of the self uppermost in everyday activities.

The Irresistible Allure of Identity

Roland Barthes refers to how we live in the world as the process that encourages 'the cunning advent of myself as other' (1981: 15). He is defining the self as an invention. If we think of ourselves as a device then we understand we are hinged to circumstance. This means we can accept the idea of a self as already apprehended, as if it had been assembled a priori from layers of cultural sedimentation. It follows that the techniques of its invention, presentation, delivery and performance propagate the reassuring belief that it exists and can be accessed from beneath layers of scripts and conventions that we daily execute. As reassuring as this manner of thinking may be, it is itself a function of historical circumstance as popular culture so effectively demonstrates.

In a context of contemporary confusion between the real and the illusory, the pursuit of self-knowledge becomes a complex activity. Drawing from Machiavelli's (1469–1527) fundamental assertion that all human affairs develop from the capacity of individuals to dissemble, there have been numerous reworkings through George Herbert Mead (1863–1931), Georg Simmel (1858–1918), Erving Goffman (1931–82) and others that all social life involves a struggle to control the opinions of others and determine whose narrative or point of view will prevail. Machiavelli's contemporary, Baldassare Castiglione (1478–1529), wrote about self-invention as a sign of social competence. If an individual could invent himself it was a clear sign that s/he understood the prevailing conventions of the situation. Castiglione's sixteenth-century treatise on how to be socially successful was pointing out that social rules pre-exist the individual and it was a serious mistake for an individual to step outside convention. The contemporary consumer ethic lends itself to much the same position. Buy a branded object and join the Stüssy crowd, the McDonald's family, the Star Alliance. Now it is being suggested in the marketplace that the search for identity and community can be pursued through conspicuous consumption and self-fashioning.

Understanding this relationship between the public display of identity and self-identity has a long history. Michel de Montaigne (1533–92) argued for an important distinction between reflection and self-consciousness (Burke, 1981: 42). Montaigne was interested in the nature of the emotions, dreams and their interpretations, and argued that there were reliable links between the somatic body and consciousness. He imagined these causal relations well before Sigmund Freud's nineteenth-century interpretation of dreams. He emphasized that in the modern world the successful individual would need to be highly accomplished in anticipating the reactions of others, and this level of social competence was gained through rumination. He imagined self-

knowledge was both the means for cultivating good social relations and the consequence of enjoying them. These views marked a break in the manner of thinking about identity as they emphasized the fluid and situational contexts in which such knowledge of the self developed. For Montaigne, writing five hundred years before Goffman, it was necessary for individuals to be effortless in their social dealings, to be capable of self-control and self-invention. Only with such skills could the individual be 'cool' and behave appropriately in public.

The concerns of Machiavelli, Montaigne and Castiglione have travelled across the centuries. We are still engaged by questions of character and identity, of how to be cool in public, and whether we are formed by historical and cultural influences or an innate psychobiology. Societies supposedly produce individuals with specific social values. The sixteenth-century European courtier, the dandies and *flâneurs* of the eighteenth and nineteenth centuries, the other-directed and inner-directed men and women of the mid-twentieth century and the cool hybrid performers of the twenty-first century are all recognizable characters or stereotypes of specific historical settings.

In his monumental study of the rise of the middle classes, Peter Gay (2001) refers to an exchange between Freud and his fiancée Martha Bernays that expresses this point of view. Freud explains to Martha how each social class has a different emotional and intellectual tone. Freud states there is a psychology of the 'rabble' that is entirely separate from the middle classes. Those lower on the social hierarchy are more impetuous and direct; the bourgeois are more controlled:

> 'Why don't we bourgeois get drunk?', he asked rhetorically. 'Because the discredit and discomfort of a hangover give us more pain than drinking gives us pleasure. Why don't we fall in love with someone new every month? Because every breakup tears away a piece of our heart.' (Gay, 2001: 26)

The views Freud expressed show how sentiments identify us, as if certain emotions are more appropriate for some and not others. The variations of emotions within families or groups and across gender categories strongly suggest that types of individuals experience the world differently, that men and women, children and adults, the wealthy and indigent, live in different worlds and have emotional responses that are non-transferable.

Montaigne's sixteenth-century ruminations on human consciousness portray individuals as repositories of concealed layers. His metaphor of identity as a 'room behind the shop' (*une arrière boutique toute nostre*) has found its way through four hundred years to be variously restated in the twenty-first century. It can be interpreted to mean that the true individual is found off-stage, in the back room, away from the mêlèe of social life. Thus to retire from society, to remove oneself from the scrutinizing gaze of others, to live without having to wear a mask, is the only way to achieve self-awareness. Individuals who enter public life in order to find themselves through reputation and celebrity status are deeply misguided according to Montaigne. It is only in the quiet of one's own company that reliable insights into the human condition can be trusted. The public domain is for the pursuit of ambition and avarice, reputation and glory. Living in public requires the individual to be always anxious about the opinions of others, hence one is always having to act. However, this, importantly, is not how the self can be understood.

Montaigne was not arguing for the abandonment of society on the basis that it made us too vulnerable to the opinions of others. He was pointing out that what happens in public and private are deeply different experiences. Public life is enhanced when individuals are well mannered and rigorously self-examining. Such individuals are adept at making others feel comfortable, at their ease, and in so doing society as a whole is made possible and more civil. Such good behaviour main-

tains the orderliness of society and preserves conventions and privileges. It does not, however, produce an identity.

Goffman, writing about social life four hundred years later, assumes a position like Montaigne's insofar as both are concerned with public performance and how we manage a sense of ourselves both on and off stage, away from and in front of another's presence. Both these thinkers regard the social domain as a contested site where conflicts over ethics and competing values contribute to a persistent sense of instability and doubt. Both thinkers played with the idea that the desire for community, for advancing the collectivity, for establishing a common good, was not the explicit interest of the majority of individuals. Both regarded the social encounter as the site where capacities were revealed in both their ethical glory and moral paucity.

Goffman differs from Montaigne in his emphasis on anxiety as a prime constituent of identity. In the opening pages of *The Presentation of Self in Everyday Life* (1959) Goffman describes a fictional Englishman making his debut on the summer beaches in Spain. The portrait is of a buffoon who suns himself, parades on the sand, swims in the water and reads a book as if he were being closely scrutinized by an attentive audience. Preedy behaves as he thinks a happy tourist should. Goffman's point is that this level of self-consciousness is both ordinary and counterproductive. The self-conscious performance is rarely convincing because we cannot manipulate or deliberately control how the anonymous other sees us. Goffman demonstrates time and time again the plausibility of this view, that others will see us as they will, irrespective of what we want and almost certainly in defiance or ignorance of our wishes. Even though we cannot know how the other sees us, nonetheless, we are consumed with trying to control it. This is a point also made by Jean-Paul Sartre (1905–80) in the mid-twentieth century through his existentialist philosophy, which permeated the interests of the middle classes of the affluent West.

Goffman amplifies the pathos of Preedy's plight in subsequent works. In *Stigma: Notes on the Management of Spoiled Identity* (1963), he opens with a letter to the 'Miss Lonelyhearts' newspaper column extracted from a fiction of the same name by Nathanael West (1933). The letter asks for advice from a 16-year-old girl born without a nose. She describes herself as a good dancer, with a shapely body and plenty of pretty clothes. Her parents love her and she feels well adjusted and happy, except now when she has become interested in boys, she is realizing how impossible it is for them to ignore the big hole in the middle of her face. It is the source of all her misery. After explaining herself to 'Miss Lonelyhearts' in plangent terms that convey to the reader her appealing 'personality', the girl concludes her letter by asking whether she should commit suicide.

Goffman draws this episode into his account of modern social life. He documents in fine detail the manner in which we assess each other. We observe that the other's fingernails are too long or too short; their clothing too stylish or too casual; their manner of speaking appealing or not. The other person 'gives off' an impression that we pick up and trust, or not. Every new social encounter is filled with the exchange of these 'first impressions' and the subtle cues that cannot be easily enumerated, yet which shape opinion. The significance we attribute to this mêlée of reactions leads Goffman to a Kafkaesque view that society is mysterious and difficult which in turn explains our enthrallment with the invention and performance of the self. Careful rituals and the constant fear of embarrassment are the foundations of society; we perform on the assumption that others will do likewise. We try to prevent others making mistakes in the hope that they will reciprocate and help us when the time comes.

From this brief discussion of identity it is clear that a unified theory or approach to the topic is neither possible nor interesting. It is equally obvious that ideas about the self have been sustained across different

cultures and time frames for a variety of purposes. From one point, say, Shakespeare's comedies, we encounter an emphasis on the unreliability of character and the entertaining consequences that follow from giving it too much importance; from another perspective, say, Banville's and Goffman's, we are engaged by the plasticity of the idea and how much more confusing social life is as a result. Across the range of views on questions surrounding the definition of character, how the self is produced and whether identity has inherent cohesion we are constantly reacquainted with the possibilities of making ourselves: such is the art of self-invention.

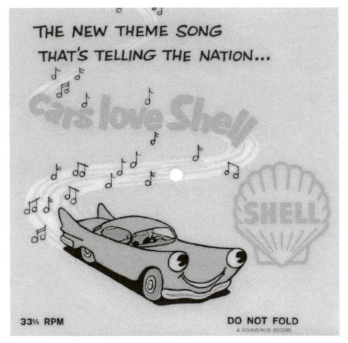

7. *Cars Love Shell* (Shell advertisement, *c.*1955).

4. Advertising

Champagne from my slipper?
He begs for it.
The pearls I admired in Cartier on the Rue de la Paix?
Mine without a murmur.
But when he is driving that Citroën
suddenly I am nothing.
How can a car mean so much to a man when it cannot even kiss?

Citroën car advertisement, *c.* 1963

The Advertising Industry

Advertising is one of the most dynamic industries of the past hundred years. It has global reach, and it commands vast amounts of money. At its most literal, advertising is a source of information, it informs us about the availability and cost of specific items. Early advertisements were announcements posted in public places, for example that a shipment of tea had docked or that new silks and timber had arrived, which was a way of urging people to purchase them. Styles in advertising have changed dramatically. Now a range of subtle techniques makes advertising the vehicle of mass persuasion and subtextual engagement.

Advertisements have to be arresting. If they address us in embracing terms then we are drawn into their universe. The Citroën advertise-

ment (*c.* 1963) has packed into its tight text a profusion of suggestions about fetish, sadomasochistic sex, power and money. Some of these ideas are eternal and haunting: can beauty be possessed as easily as the pearls from Cartier? Can desires be satisfied? Or should they only be pursued and never met? Are the pleasures of the car the same as the pleasures of the kiss?

'Cars Love Shell', men love cars, women love men who love cars, and so it goes. Advertising is about purchasing. In industrial economies advertising seems to ensure the high circulation of goods and the maintenance of the consumer ethic. However, advertising is not only about retail sales. It is a form of communication that reaches millions of people and promulgates shared values. Advertisements create communities of like-minded individuals. Some advertisements admit to this: they offer membership – become part of the McDonald's family, join the Stüssy tribe, be part of Qantas world and so on. As such they provide a reassuring identity. Goods and services become expressions of personal tastes. The question of how tastes and desires take material form, of how R.M. Williams boots, Kelly handbags and Suzuki, Citroën or Honda motor cars (that cannot even kiss) become symbols of personal identity, takes us to the heart of our relations with the material world and further into the art of self-invention.

The Unnatural World

Every advertisement is a mystery. Raymond Williams (1983) characterized the advertising industry as magical in that it makes something from nothing, it transforms rhetoric and image into objects and facts. Before Williams, Daniel Boorstin had made the same observation. He lamented the prevalence of advertising in a book entitled *The Image: A Guide to Pseudo-Events in America*; 'what happens on television will overshadow what happens off television' (1961: 39). Boorstin was concerned about the effects of the mass media from its earliest days.

He rightly identified both the content of the mass media as well as the technology of the media – its distribution, ease of access and availability – as two influential forces that would directly shape social life. He characterized this moment in history as the 'age of contrivance' to draw attention to the prevalence of staged, scripted and fabricated communications manufactured for the mass media.

More than 40 years after this warning, Boorstin can be read as alarmist; he viewed popular culture as a 'menace of unreality' and a deliberately wielded political tool that vulgarized high culture in order to pacify the masses. The reach of the media has expanded since the publication of *The Image* and many would argue it has been responsible for increased democratization rather than the degradation of society as Boorstin warned. Yet his book was presciently published before the Nixon–Kennedy presidential television debates that have been subsequently identified as a watershed that marked the deep incursion of the modern media into everyday life.

Boorstin's concerns have been ameliorated in the intervening decades by the increasingly ironic and parodic qualities of much broadcast media. In some ways the media world now resembles the romantic comedy *The Truman Show* (directed by Peter Weir, 1998) more than it does the sinister world of Boorstin's *Image*. *The Truman Show*, subtitled *The Story of a Lifetime*, re-creates an entire town on a gigantic television stage studio and the lives of the inhabitants are broadcast regularly to a mass audience. The weather of the town is created by special effects; the town's commerce, industry and social rhythms are controlled by the professional writers generating daily scripts. The seamlessness of the staged world is accidentally interrupted when a huge arc light (suspended high above the streets of 'small-town America') falls to the ground giving the lead character, Truman Burbank, the first clue that he is trapped in a stage set – presumably located in the suburb of Burbank where the film industry is located in Los Angeles.

The film expresses a conspiratorial view of society in which the media has the power to control our thoughts and actions. When Truman Burbank realizes he is an engineered product made for television, he has the ideologically appropriate response – he revolts. The film depicts a gentle form of social refusal: Truman wants freedom so he can be himself. He does not attempt to change the system. He does not pursue the narrative logic of the plot to ask where he and his friends came from – were they produced in a biogenetic laboratory, for instance, or stolen from a marginalized ethnic subgroup and sold into media slavery? Is the show peopled with organically grown specimens much like the society of Aldous Huxley's *Brave New World*?

The question of the influence of the mass media was at the heart of Theodor Adorno's (1991) concerns about the culture industries and has remained central to all debates about the mass circulation of information. In every aspect of ordinary life there is evidence of the controlling capacity of remote economic and political interests. The themed and engineered environments of shopping malls and chain restaurants and the proliferation of brand-name consumer goods are instances where commercial and political interests form a subtext of social values. The question is whether these managed environments pose a real threat to personal freedom. At Disneyland, where the costumed cartoon characters function both as security guards and crowd controllers and where surveillance exists alongside social order, the question springs to mind, is this a threat to individual dignity or a reassurance? If we think after 9/11 that being in crowded public spaces amongst strangers is now dangerous, then we might be reassured by the presence of a life-sized Mickey Mouse who is also a benevolent surveillance officer. To think otherwise is to see the engineered, themed environment – of the shopping mall, restaurant and leisure park – as a form of hyperreality produced to bolster remote interests not necessarily our own.

Commercial entertainments and modern advertising have constructed a globalized communication system crossing linguistic, political, economic and cultural barriers. An international community of like-minded individuals thus comes into existence. Some products aspire to this – 'Planet Reebok', 'Pepsi Generation'. Along with the products, they offer membership in a select community. There is an emotional promise in the advertisement that addresses the consumer's desire to belong. Along with this, a number of globally recognized signs and symbols have become absorbed into the vernacular. This visual language of brand logos, familiar shapes and colours (such as the golden arches of McDonald's, the Nike swoosh, the red can of Cola-Cola and the signature fliptop box of Marlboro) provide points of recognition, even familiarity. The success of these globally recognized signs has produced an audience of literate individuals trained in the art of visual semiotics. Alongside this ability to read the sign is also the capacity to search within the sign for the elusive promises of cultural ideals. Every advertiser hopes to capture these ideals and embed them in the product. While it is relatively easy to interpret many of the qualities associated with a promoted object, what is not easy to understand is the promise itself, that in the possession of these goods there will be even greater pleasures. This is the allure of the hyperreal.

Like all languages advertising is polysemic, it can express multiple levels and registers of meaning. At this point art and advertising overlap in the capacity to interpellate diverse audiences. Andy Warhol's paintings of the Campbell's soup can are an acknowledgment of the similarities between the visual sophistication of the new advertising of the twentieth century and the social function of art. When exhibited, Warhol's soup can was controversial: could this be a proper object for art? Could the photorealistic style be a legitimate form of art? Such questions continue to reverberate as art historians unravel the crafty

tricks of the trade of such great classicists as Rembrandt, Vermeer and van Eyck who strived to produce art that lacked a visible technique (Schama, 2004).

Art materializes the imagination; it turns objects into surfaces that can be overwritten by the imagination. Advertising achieves the same. The repeated sign of the soup can and Warhol's grids of the famous – Elvis Presley, Mona Lisa – evidence the complex relationship between the object and audience. What is achieved by the multiplication of the image? If the art object is not singular and unique like the Mona Lisa (which, ironically, has been widely reproduced on coffee mugs, tea-towels, mouse-mats and so on), but is common and imitable like the Campbell's soup can, is it still art? The repetition of the sign may evacuate it of meaning, making it background wallpaper and part of the vernacular. At this point it achieves the very ambition of the global advertiser, to make the sign of the product so familiar that it becomes part of an interior language. In this way the beer = Stella and lunch = McDonald's. Repetition embeds the received meaning into everyday use. The repeated sign is part of everyday consciousness.

This achievement of advertising brings into focus the question of how influential the visual landscape is in describing the everyday. The easily recognized logo or soup can functions in much the same way as, say, the religious icon. Representational and figurative art do not capture reality but replace it. Schama describes the value of art as being its expression of artifice and its capacity to undercut the natural with an alternative version: 'art's allure is the alternative version of existence with which it teases us: a fictitious world in which the sprawling tangle of existence has been tidied, its chaos drilled into shape; its patches of raw ugliness edited'. To confuse representation with reality is the danger art presents to the viewer. To absorb this instruction, to understand that representations of nature are unnatural, is the function of art: 'A Campbell's soup can is not a soup can, Magritte's pipe

is emphatically not a pipe.' Schama makes the point that 'art, when it works most powerfully, is a prescription for unease...' (2004: 11–13). Art alerts us to the various reasons why we might try to represent reality visually, whereas the advertiser wants to make the image stand in place of reality. How important is it for us to distinguish between them? Does the artist reliably unscramble the difference between looking and imagining? Does the advertiser always try for the opposite, to scramble appearances so reality is written over by the imagination? Does the divide between art and advertising rest only with the intentions of the producer?

Part of Theodor Adorno's mordant conclusion about twentieth-century consumer culture is that it changed human nature. We no longer have a reliable sense of our self and thus find it difficult to separate ourselves from our material circumstances. Adorno was concerned that we do not fully understand how different we are to the objects we love – the Porsche, Calvin Kleins, Cartier pearls. Adorno required us to have a sceptical intelligence, to recognize there was no need to enhance ourselves with luxurious possessions. If we think of ourselves otherwise, then we have produced a form of subjectivity that is an object and consequently requires display and affirmation. We have become the opposite of what is intrinsically valuable about being human:

> absolute subjectivity is also subjectless ... pure subjectivity, being of necessity estranged from itself as well and having become a thing, assumes the dimensions of objectivity which expresses itself through its own estrangement. The boundary between what is human and the world of things becomes blurred. (Adorno, 1981: 262)

Adorno is currently unfashionable. He is regarded by many as too extreme and puritanical, yet elements of his lament are enunciated by the popular Naomi Klein (2000). When she argues that advertising is not only about selling goods but is more ambitiously about prescribing ways of living, she echoes Adorno. Advertisements promote spe-

cific values such as success and happiness; they are in the business of dispensing instructions about how to invent and present ourselves. This is how advertisers of global products have inserted the desire for their products into everyday life, by making it seem as if the values promoted with the products are the same values we should embrace for ourselves. Whenever we use fashion goods we are tacitly buying into a system through which we make ourselves intelligible and recognizable to others through the borrowed ideas and values embedded in advertisements. Benetton used this style of advertising to good effect by repositioning itself as the conscience of a generation. Its advertisements did not display procurable items like shirts and shoes but delivered commentaries on world events – the incidence of Aids, oil slicks from industrial accidents that polluted natural waterways, migration and people-smuggling. Benetton's product was respectable opinion; it positioned itself as informed and ethically savvy. Naomi Klein recognizes in this process the insertion of global commercial interests into our daily social activities.

Calvin Klein, like Benetton before it, produces advertisements where the product is not obviously on display. In a typical ad for jeans, a young man is standing under a running shower gripping wet jeans to himself in an act of modesty. His finely sculptured body is on display; the narrative asks, what is going on here? How did this situation come about? What circumstances brought him into the shower with jeans in hand? We are drawn into the narrative, we are receptive to the message that exciting and unusual events can happen when wearing Calvin Kleins. Our receptiveness to the ad does not mean we are gullible, that we believe what we see, only that we are good at reading signs, of picking up the thread of a narrative. The advertisement suggests an interesting story and we are prepared to listen to the language of Calvin Klein, Tommy Hilfiger or Von Dutch, and in many instances even to buy the products.

The Afterglow of Advertising

Advertising is calculated to influence the consumer and as a result of global marketing there is a vast audience that recognizes the same symbols – Prada, Marlboro, YSL, Rolex, Levi Strauss, RR. Has the absorption of these messages been successful because we are passive by nature? Do marketers have a positivistic view of us, that we do as we are told like the people in Milgram's troubling experiments reported in *Obedience to Authority* (1974)? One response points to the large numbers of failed products in the marketplace that we have refused to buy, and these are used to prove our independence. Those failed products are presumably what we do not want. According to this logic we have not been passive and manipulated, we have expressed ourselves. By the same token, what is available in the marketplace is presumably what we do want.

Such thinking is inadequate for explaining the complex relationships that connect products and desires. The availability of goods is not a direct measure of taste and sentiment. There are heavily engineered environments designed to create interest in particular objects. Restaurants, shopping malls and supermarkets are instances of such persuasive environments, and they are deliberately over-stimulating and confusing. Are we then more manipulated than we like to think? The Hollywood film, *Wag the Dog* (directed by Barry Levinson, 1997), written by Hilary Henkin and David Mamet, addresses this concern in comedic and entertaining terms. It illustrates how circumstances that manipulate the public can be manufactured but, within the film, the issue is addressed and depicted as not a matter for alarm because the production of these circumstances is so transparent it all appears benign and unthreatening.

The narrative recounts how a potential political scandal that threatens to topple a government is contained and the politician at the centre

of the story is, against the odds, returned to office. In the film a mysterious fixer, a spin doctor who has the uncanny ability to manipulate politics, the press and the American public, is called to the White House. The fixer is a Hollywood producer who proceeds to stage a diversion to get the President's sex scandal off the front page of the daily newspapers. He creates a war, although in actuality this is only a ploy, a believable illusion. Nonetheless war is declared, troops go to the field, a body count begins. The fixer employs the techniques of the film industry to create the illusion. Daily bulletins of the war predictably receive instantly high ratings in the media and overshadow the lesser issue of the sex scandal. *Wag the Dog*, made in 1997, preceded the events surrounding the US President Bill Clinton and Monica Lewinsky, and it suggests again that art does not mirror but instead produces life.

Wag the Dog is a gentle illustration of the power of the media. When Orson Welles tested the same premise with his radio programme *War of the Worlds*, broadcast on the day before Halloween, 30 October 1938, the result was completely different. Welles' broadcast was a simulation of a disaster. During the radio show several fake 'breaking news stories' interrupted the broadcast, creating a sense of urgency and immediacy; reports were of huge flaming objects in the sky, then the arrival of spacecraft and finally the emergence from them of black, gleaming serpent-like creatures. There was large-scale panic as members of the listening audience accepted the fiction as fact. The implications of Welles' broadcast have reverberated for decades. At the time Dorothy Thompson, a columnist with the *New York Tribune*, foresaw the episode as a dire warning of how politicians (amongst others) might use the power of mass communications to manipulate the public:

> All unwittingly, Mr. Orson Welles and the Mercury Theater of the Air have made one of the most fascinating and important demonstrations of all time. They have proved that a few effective voices, accompanied by sound effects, can convince masses of people of

a totally unreasonable, completely fantastic proposition as to cre-
ate a nation-wide panic. They have demonstrated more potently
than any argument, demonstrated beyond a question of a doubt,
the appalling dangers and enormous effectiveness of popular and
theatrical demagoguery ... Hitler managed to scare all of Europe to
its knees a month ago, but he at least had an army and an air force
to back up his shrieking words. But Mr. Welles scared thousands
into demoralization with nothing at all. (*www.transparencynow.
com/welles.htm*)

We live in a society where deceptive simulations are commonplace,
although their effect may be less dramatic than that produced by Or-
son Welles. We accept the prevalence of fakes and imitations and of-
ten applaud them. We understand there are secrets and conspiracies,
that governments, public relations companies and advertisers have an
arsenal of misinformation and use various techniques to delude us. It
has created a new dimension to social life – the simulated or hyperreal
world, which is a residue from the effective visual language of global
marketing. Hyperreality is a consequence of the expansion of techno-
logical communication systems that enable us to be globally connected.
Hyperreality is the world of novelty made familiar, it is the world of
imagined texts made real (Eco, 1976). The Marlboro Man, Ronald Mc-
Donald, Mickey Mouse, Max Headroom, Bart Simpson, Astro Boy and
Hello Kitty are all trademarks of the advertising world, yet when we
watch these characters it is easy to forget they are inanimate.

When we relate to the imaginary world of the hyperreal, numer-
ous commentators such as Adorno, Klein, Eco and Baudrillard have
warned us that a more ominous transaction is taking place. In every
purchase there is always a degree of disappointment. Disneyland is
less entertaining than we expected, the Porsche is not comfortable,
the Prada bag is too small. Whatever the promise of the commodity,
it cannot be met. The buoyancy of a consumer society requires every
purchase to disappoint. Indeed, the promises to the consumer must be

eternally withdrawn and every desired object must fail to deliver on expectations. The act of purchase must destroy the very promise that the object offers us.

This difficult relationship between the object and ourselves is a distinctive characteristic of modern subjectivity. We live with the knowledge of a discontinuity between the inside and outside. How we think and feel does not easily correspond to the nature of the external world, yet paradoxically we understand ourselves through contact and continuity with the outside, with others. Friedrich Nietzsche (1844–1900) depicted the modern individual as formulated through these discontinuities between the external world of inanimate objects and our emotional attachments to them. He influenced avant-garde artists of the early twentieth century and the significant thinkers Freud, Sartre, Foucault, Simmel and others. Inherent in the discontinuities between our sentiments and perceptions is the realization that there is always a gap and we are conscious of the disconnection, of there being no outside that corresponds to the inside. Thus the modern individual is shaped by the remarkable opposition of an inside to which no outside, and an outside to which no inside, corresponds. Georg Lukács (1971: 98–9) reiterates the view that the inner self has been hollowed out and made into a subjectivity that becomes an object – to be groomed and improved. He situates this process in the historical moment when bureaucracy began to expand and when individuals became cogs in a corporate machine. It is also the moment when the department store was born.

Subjectivity on Sale

The advent of the department store has played a significant part in promoting the use of possessions to invent and style personal identity. Well before Hollywood, television and the explosive growth of the visual mass media, the department store was conceived and built to change irrevocably our relations to the material world. Emile Zola's realistic

novel, *Au Bonheur des Dames* (1883), describes in detail the mechanics of merchandizing and his nineteenth-century observations remain relevant into the twenty-first century.

The department store was conceived as a technology for self-invention. Its physical layout was designed to engage the shopper on an emotional level. Purchasing goods before the late nineteenth century had been a process largely controlled by the merchant. Shops as such were not generous spaces with goods on display as we now know them. Instead items had to be requested. The merchant could be obliging and bring out a full range of goods or he could evaluate his clients' wealth and decide whether to bother. The department store changed that often fraught relationship. It displayed goods in such a way that customers were enticed to handle them, to become familiar with their touch, as this was thought to pique the desire to possess. Owners of the department store were quick to adopt new technologies that might enhance their business. The department store was one of the first public spaces to adopt electric lighting, and merchants soon had their goods well illuminated. They installed large plate-glass windows opening to the street to increase the visibility of their goods to passers-by, again in an effort to seduce visually.

The interior of the large department store was generally carved up into compartmentalized and independent sections with different themes and motifs that had the effect of creating a narrative around the merchandise. As shoppers wandered through the labyrinth of what had been constructed to resemble an indoor bazaar they were easily disoriented. The technique seemed to prompt shoppers into buying more, as if by initiating a purchase the shopper regained a sense of will over and control. It is a sensation still associated with shopping today (Bowlby, 1985, 2000; Chaney, 1983; Miller, 1981). In the mid-twentieth century, the suburban shopping complex with its multitude of separate shops and businesses has been designed to generate much the same disori-

enting effect as the early department stores. While the mall provides shoppers with convenient and safe spaces in which to wander, it is also a highly engineered environment, densely crowded with advertising and abundant goods designed to assault the sensory processes, to create overload and a disorienting sense of giddiness.

Consumption, advertising, fashion and the display of possessions are inextricably attached to the processes of self-invention. Lisa Jardine in her book *Worldly Goods* (1996: 413–16) recounts how the late fifteenth-century aristocrat Isabella D'Este described herself as 'hungry' for the acquisition of precious antiquities. She would go to extreme and sometimes unscrupulous lengths to secure what she fancied. When she mysteriously acquired a Michelangelo statuette from Cesare Borgia who had in turn obtained it by nefarious means, she refused to hand it back to the original and rightful owner. She was single-minded in her pursuits and not above using her social position to force people to make her gifts of what she desired. Jardine recounts a number of heartless deathbed scenes in which Isabella negotiated deals to gain an objet d'art. While Isabella's conduct may have been extreme, it illustrates usefully that rampant consumption is not only a feature of late capitalism, nor does it begin with industrial or even mercantile capitalism. There are traces of consumerism and the love of surplus that precede the market system. The anthropologist Marshall Sahlins (1972), for instance, has argued that the original affluent society was that of the paleolithic hunters and gatherers who produced more than was needed in material goods and emphasized the importance of leisure and play.

Such varied accounts of consumerism reinforce the view that humans have a long and interesting attachment to objects, whether they are manufactured or found treasures. Aspects of our identity are intimately tied to the material world and examining some of the mechanisms of marketing, the power of visuality and the allure of fashion provides insights into the charms of the object. Against this background

we can ask more pointedly how an ostensibly nonsensical assertion, such as that in the Citroën advertisement linking a car with a kiss, can make sense to the modern consumer.

Rachel Bowlby has provided a cultural history of the chocolate box as a way of understanding the capacity of advertising to shape consciousness. Beginning with the nineteenth century, she describes how the packaging of chocolate initially reflected its exotic status. On the lid of a chocolate box there was commonly pictured a beautiful girl set against a romantic landscape, say, a Pacific island heaven or a sunny field of blooming flowers. The painting was always of a young girl with a head of flowing luxuriant hair and she was frequently dressed in colourful, playful clothes. The image was supposed to suggest carefree happiness. The chocolate box was embellished with the brand name of the manufacturer in decorative script as a further sign of extravagance. Such exotic imagery has now largely vanished from the product. Chocolate is offered in handy industrial wraps using silver foil and heat-resistant paper card. Its packaging, in stark and unfussy designs, evokes a cool sensibility.

The changed aesthetic of chocolate mirrors the change in its status. Chocolate is no longer a luxury but an everyday habit, consumed in vast quantities, and its image has changed accordingly. Bowlby's study of the chocolate box is an illustration of how objects address private sensibilities. We can use chocolate to display our cultural tastes as well as economic wealth. Godiva made chocolate part of the luxe market and Cadbury made it a supermarket basic. It is a versatile product that fits neatly into the transactional and calculated exchanges of modern social life (Bowlby, 2000: 13).

The overlay of goods with a discourse of desire functions as a major narrative of the modern era. Roland Barthes has addressed this in a highly influential dissection of the fashion system. He grapples with the allure of goods as an expression of the mysterious power of desire. He

shows how an object is only desirable within specific circumstances. Goods are not inherently desirable, and they do not remain desirable. Indeed part of their fascination is their limited potency. Desire must be always rekindled. To sustain the individual in a state of longing is the fundamental requirement of the consumer economy and the perpetual challenge of advertising. Advertisers must create a panoramic narrative that surrounds every procurable object.

An advertising campaign for menswear, for example, does not display clothes but instead draws on the depths of high culture. On its huge street billboards there is a quote attributed to Edith Wharton, contemporary of the dapper Henry James and herself a sharp observer of the foibles of the New York elite at the turn of the twentieth century: 'Fashion is an important consideration for those with nothing more important to consider.' Next to the quotation is the image of a young man in Buddy Holly black spectacles, reading a book. The only other reference to fashion is his slight resemblance to a very young Yves Saint Laurent. This style of advertising draws directly from cultural allusion. The billboard promoting menswear uses bold black, red and white – the colours of modern authoritarianism according to the American artist Barbara Kruger (*Black + White*, 1996).

The narrative of the advertisement shifts fashion away from garments and objects to a more abstract plane, to a manner of being in the world. Fashion is no longer about a single or identifiable object – a pair of Blahnik shoes, a suit by Paul Smith, Argyle diamonds, a TAG Heuer watch. The billboard refigures fashion, bridging the divide between high and low cultural forms, and in so doing lends gravitas to consumerism. The statement 'Fashion is an important consideration...' challenges the opinion that fashion is a frivolity. Fashion is serious, it attracts the attention of bespectacled book-readers who occupy space defined by the authoritative colours of black, red and white. Then the phrase '...for those with nothing more important to consider' ranks fashion above

the basic concerns of food, shelter and purposeful work. The advertisement promotes ideas, not objects. It has separated the object from its image and created a hyperreal universe of interesting signifiers. As with Benetton, such advertising has enabled a brand name or label to float freely in the universe without anchorage to actual material goods.

Felix Guattari suggests much of our everyday knowledge comes from such free-floating sources. As a result subjectivity is formulated through social usage. The hyperreal world is a source of entertainment; we tap into it for knowledge about how we feel as if we were receiving a blood transfusion, being drip-fed from history. Subjectivity itself is understood to be a commodity, and as such it is packed with dominant cultural values. Guattari draws on the significance of the Versailles court society as an illustration. It was at Versailles that a huge number of artisans came to work, to produce the gardens, the mirrored hall, silver picture frames and embroidered materials. Versailles was a factory of dreams, a place to realize desire. Guattari asks:

> what was the Court of Versailles, with its minutely detailed administration of flows of power, money, prestige and competence, and its high-precision etiquette, if not a machine deliberately designed to churn out a new and improved aristocratic subjectivity – one far more securely under the yoke of the royal State than the seigniorial aristocracy of the feudal tradition, and entertaining different relations of subjection to the values of the rising bourgeoisie? (1992: 18)

The American talk show *Ricki Lake* dedicated an episode to the attractions of high fashion spending. The programme, entitled 'Get Rid of the Gucci', presented the audience with guests who were high consumers of designer goods. During the interviews with these 'fashion victims' an accountant produced simple calculations that turned their fashion budgets into more rational investments. For instance, a young mother who spent $5000 on designer kids' wear was advised that the

same amount placed in an investment bank account would have yielded her $45,000 after five years. A young unemployed man who had purchased $15,000 of fashion goods using his credit card was warned that he would be paying $250,000 for these items unless he got a job and paid off the debt. The amount of money spent on clothes was equated with a year's tuition at a reputable American university. The moral tone Ricki Lake and the studio audience took toward her guests was to figure them as short-sighted and impulsive, irrational and self-destructive. In defence of their own behaviour, Ricki's guests explained how fashion was an investment. Being well dressed and feeling good translated into social success. But this message did not meet popular approval. The live television audience, placed in the position of moral arbiter, responded to this love of fashion as an unjustifiable personal indulgence that lacked social benefit – it was regarded as a waste. At the same time this judgmental demonstration is a product of the television show itself. Beyond the confines of Ricki Lake's programme members of the television audience enjoy conspicuous consumption.

Popular programmes like *Ricki Lake, Jerry Springer, The Simpsons, Absolutely Fabulous, Seinfeld* and *The Osbournes* are rich with ambiguous examples of how we are variously manipulated by the mass media, advertisements and the consumer imperative. Such programmes also provide counter-narratives of how we successfully resist such influences. In this way popular entertainments traverse the spectrum of opinions and deliver a multiplicity of messages. They are not the effective forms of oppression suggested by Adorno and the Frankfurt School, nor are they the highly influential messages that mobilize vast numbers of individuals to act uncharacteristically such as the Orson Welles episode demonstrated. Yet embedded in the great variety of high-circulation advertisements and entertainments are a few ideas that have greater prominence than others, and one such idea is the emphasis given to the invention of self-identity. With the right contacts, op-

portunities and the appropriate look, the individual can become a self-styled invention. In contemporary society a premium has been placed on the cultural currency of the self and this begs the question, why has self-invention become such a popular preoccupation?

Searching for the Self

Dror Wahrman opens his grand study of the modern self by establishing its idiosyncratic place in the industrial society:

> the modern Western sense of a self or a person 'as a bounded, unique, more or less integrated motivational and cognitive universe, a dynamic center of awareness, emotion, judgment, and action, organized into a distinctive whole and set contrastively against other such wholes' is in truth 'a rather peculiar idea within the context of the world's cultures'. (Wahrman 2004: xi–xii).

He further argues that this unique concept of identity is based on unconvincing assumptions, namely that there is a bedrock or essential core of selfhood characterized by psychological depths and a self-conscious sense of interiority. By interrogating these assumptions Wahrman rightly leads us to consider that this well-defined unique self is a creation of specific social and historical conditions. In turn, this observation directs us to question how such an idea achieved prominence and became naturalized into a universal.

Theories about identity and society take us to the intersection where the *made up* and the *made real* are twinned, and where certain ideas and practices are presented as self-evident, as if this were the way things had always been and will continue to be. Hollywood has played a part in circulating ideas about the nature of identity and society. It has been highly effective in emphasizing physical appearances, the pursuit of romantic love and private ambition, the love of financial wealth and sense of adventure. These have all been promoted as important elements in the making of the modern subject. Although, Hollywood

cannot claim to be the only source of such cultural training, the reach of the commercialized entertainment industries is unrivalled and the prominence of a visual culture, through film and image, has ensured its impact on how we perceive our surrounds.

The inventions of the bicycle, hot-air balloon, roller coaster, automobile and aeroplane also influenced human perception, as have previous regimes in styles of painting and architecture. These inventions in particular have been described as 'vertigo machines'; they fostered dizziness, giddiness, shock and disorientation as well as the pleasures of looking. The first travellers in hot-air balloons described their aerial view of the world as giving a sense of how 'God must see us'. It can also be read as a prescient comment on the future surveillance society. More recently, the fast editing and jump-cutting of pop videos and MTV, and the computer video games that test the speed of our reflexes, are new technologies that have further changed perspectives on the material world. They contribute to a sense of visual clutter that must be cognitively organized so that we can act successfully in the everyday (Mitchell, 1994).

At the same time, in a somewhat contrary vein, as the natural world becomes clearer to us the interior world becomes murkier. Identity and selfhood are depicted as fragile and at risk and new services are available for purchase that promise to make the self more viable and robust. The contradictions of these messages amplify the ambiguity of subjectivity. Why are there frequent reports of escalating rates of self-abuse, suicide, alcoholism and drug use when the cultivation of identity is so central to our culture? Are these practices symptomatic of a fragile subject prone to collapse under the weight of modern living? What are we to make of the realistic portrayals of obsessive and perverse characters that appear in popular cinema and television talk shows? Are they ordinary people? Are they warnings of what we can become or what we really are beneath a veneer that tries to hold in check inherent drives of fear, anger, lust and power?

The growth in modern psychology asserts the ontology of the coherent self. Its provision of professional counselling, intelligence testing and vocational training has become part of the commodification of identity in the consumer age. By the late twentieth century, the 'psy industries' had developed into prominent and lucrative practices. The invention in the 1950s of the psychology laboratory, a viewing room with two-way mirrors and sound recording equipment even suggested a scientific approach to the study of human behaviour, as if in such a space the invisible play of the human psyche with its motives and desires could be accurately observed. The success of psychology in providing the vocabulary and concepts for self-revelation has meant terms such as *motive, attitude, phobia, drive, proclivity* and *emotion* are part of everyday usage (Rose, 1996). The ubiquity of psychological testing and the popularity of such tools as the Myers-Briggs personality test further reflect a desire to have a science of human character. The popular writer Robert Boyle reports that it is not unheard of for companies to require their staff to wear colour-coded name badges that indicate personality type as defined by the Myers-Briggs chart. This categorization of individuals is intended to make communications with others easier as everyone knows how best to behave according to the indicated coding (Boyle, 2003: 219).

Commentaries such as Boyle's are a feature of our cultural landscape and are indicative of the value placed on the widely advertised belief in an authentic core self, and books like Boyle's augment the cultural space carved out by the psy industries to support the imperatives for self-development, self-improvement, self-knowledge and self-assertion. Such ways of thinking about ourselves and the various histories of the self also suggest an intense attention, almost obsession, with it. We are regularly addressed and implored to think about ourselves by advertisers, opinion pollsters and marketers of various products who constantly collect data on how we feel, what we like or dislike, approve

of or not, support or resist. Our reactions to politicians in the media, the launch of a new perfume, the results of a football game and the annual award of Hollywood Oscars all have the effect of emphasizing the importance of our judgments. Gathering such data makes it seem as if someone is watching and taking note; it makes it seem as if our feelings and sentiments are important. As these mapped sentiments are fed back through published vox pop, the inventory of our likes, dislikes, passions, impulses, fears and anxieties become part of the interactional vocabulary of everyday life. It is a discourse about invention, dissemblance, dissection, humiliation and redemption. The continual looping back of information about ourselves intensifies levels of self-absorption. We will be improved by thinking about how to improve; thinking about what we need underscores how much we need it.

The psychological experiments carried out in the mid-twentieth century by Stanley Milgram at Yale University have in retrospect assumed great importance in relation to theories of identity. The results are frequently used to reveal our deficits. They suggest two opposing conclusions: that we need greater guidance from an authority beyond ourselves and, at the same time, we are too easily responsive to authority. Milgram's experiments are invoked to argue we are innately gullible and willing to give up moral responsibility, that we are too ready to accept leadership and the directives of authority.

On the basis that Milgram is right, we need to have precautions in place to protect us from our own nature. Thus the media needs to be controlled, censorship must exist and anarchic ideas must be contained. Even if such safeguards were implemented, the anxiety continues that advertisers, retailers, politicians and so on can recruit us to support their interests if they apply certain techniques of persuasion. Milgram's experiments described in *Obedience to Authority* (1974) are often interpreted as a demonstration of the ease with which we can be manipulated into behaving badly. In these experiments, individuals

were directed to administer to a stranger what would outside the laboratory be a fatal electric shock.

The participants in the experiment were told the project was about learning and memory. Their task was to be the teacher and coerce the learner into remembering lists of words. Whenever a wrong answer was given the teacher was required to deliver an electric shock. Milgram's results have been debated for decades: over 65 per cent of his volunteers were willing to electrocute the learner in the experiment; over 65 per cent of them administered what would have been a fatal shock of 450 volts, and they were prepared to do so because they were instructed by a supervisor. On the basis of these results it seemed possible to direct individuals to do anything asked of them, even to act against their common sense. The European genocide of the Second World War was a haunting backdrop to these ideas. If Milgram's experiments did reveal the truth about human nature, it added to the real possibility that totalitarian social regimes could be brought into existence through brainwashing – a conclusion both alarming and comforting.

Related experiments such as the Stanford Prisoner Project (1971–2) led by Philip Zimbardo involved creating a prison environment and arbitrarily dividing a small group of young men into two categories, either prisoners or guards. The only instructions given to the two groups were to act as if they were guards and prisoners. Very quickly, the acting out of the roles escalated into a brutalizing situation where unnecessary cruelties were imposed on the 'prisoners'. The experiment was designed to be carried out over a two-week period but it was necessary to abandon it much earlier (see *www.prisonexp.org*).

In a similar vein, in 1968 Jane Elliott, a primary school teacher in America's Midwest, commenced a classroom exercise to demonstrate the social inequities created by race. She arbitrarily assigned membership into a category based on eye-colour. In the following hours, each group of students was subject to discrimination and bullying that was

justified by the separation of individuals into the different groups. These experiments have added to the view that we have a base human nature that contains deep-seated human traits such as aggression and hostility, prejudice and malice, gullibility and obedience. Such opinions have spilled into popular culture: *The Manchurian Candidate* (1962, 2004) was a chilling political film recently remade to illustrate again that we can be brainwashed to act in uncharacteristic ways. One year after the original film was released, J.F.K. was assassinated by Lee Harvey Oswald. The film was subsequently banned and taken out of circulation until the late 1980s. Frank Sinatra, one of the actors in the early version, had purchased the film and removed it from public viewing, ostensibly as an act of respect to the Kennedy family.

Directed by John Frankenheimer, the film was prophetically chilling in its depiction of political intrigue, assassination and brainwashing. The narrative revolves around a returned soldier who has been captured by the enemy and programmed to be a deep mole, a sleeper and killer. Frankenheimer has made other films that have anticipated stark, real-world events – *Seven Days in May* (1964) is about a terrorist attack at a sporting event, and the eerie *Seconds* (1966) has Rock Hudson playing a rejuvenated businessman who desires a total makeover. Through nefarious means he purchases a cryonic new life and then finds himself captive to the demands of a consumer culture that provided the second chance.

The Manchurian Candidate (1962) had a pseudo-documentary appearance that made it more realistic. It exposed the heart of the American political machine that relies on spin doctors to rewrite public affairs and manipulate the opinion polls. The opening scene of torturing soldiers now has added value after the recent real-life revelations of events at Abu Ghraib. There is a Freudian inflection in the original film (but not in the 2004 remake) that mirrors the popularity of psychology in the American middle classes of the mid-twentieth

century: it tries to explain the public face of Lee Harvey Oswald by recourse to a submerged, damaged self. When J.F.K. was assassinated a year after the film's release, commentary developed around whether Oswald was indeed a robotic, highly trained and brainwashed assassin as was *The Manchurian Candidate*. The original film emphasized the enigma of the human heart with its capacity to turn a respectable citizen into a dangerous assassin with a simple psychological trigger. The sinister aura about the film has continued: 40 years after the original, the remade version draws on the dark forces of global business to carry the narrative and this can be seen to echo the secret involvement of Halliburton and Bechtel as the hidden interests in the current Iraq war.

Depictions of the modern individual overwhelmed by circumstance and paralyzed into amoral torpor are part of the mid-twentieth-century Zeitgeist. The post-war period begins from Auschwitz and Hiroshima; it is followed by a decade, the 1950s, of American economic efflorescence and the consumer ethic supported by Hollywood and Madison Avenue. From this, in sequence, there follow the decades of 1960s indulgence, 1970s dissipation and 1980s consumerism, and these cumulatively define the second half of the twentieth century as an emotional stocktaking exercise in which the apparently innate weaknesses of human character are rolled out in a continuous stream of critique and spleen by commentators from across the political spectrum. Examples of the mood are found throughout the popular culture of the century and are not confined to post-war America.

In many ways, it is a mood that repeats itself historically after any kind of devastation. The protagonist of Sartre's celebrated novel *Nausea* (1938) is unable to act to improve the human condition. Taking the lead from an earlier work, J.K. Huysmans' *À Rebours* (1884), whose autobiographical character, Des Esseintes, is a languid, sharp-eyed critic without much conviction, Sartre's Antoine Roquentin states (50 years after

Des Esseintes): 'I was just thinking that here we sit, all of us, eating and drinking to preserve our precious existence and really there is nothing, nothing, absolutely no reason for existing' (Sartre 1965 [1938]: 129). In her novel *Tropisms*, a troubling account of urban life, Nathalie Sarraute (1939) depicted people as entirely reactive; they embodied platitudes, they thought in the vocabulary of the mass media, they were only their surface appearances – they lacked depth and individuality.

In Jerzy Kosinski's novel *Being There* (1970), the belief in a noble and estimable self behind the surface performance is revealed as a fiction. The anti-hero of the novel Chance Gardiner (played by Peter Sellars in the film version) is completely baffled by the world about him. Like Werner Herzog's filmic character in *The Enigma of Kaspar Hauser* (1974), he is a blank slate. Events swirl about him and the only way he makes sense of things is through immediate sensory experiences. Yet even as he relies on impressions and sensations, his doubts about reality remain. It is as if he exists but he has no involvement and no identity. To be engaged with the world the individual requires a self but the world is too distant and vague to engage him – silence, inertia and tedium exert a stronger pull. Chance's response is to watch television. Such reactions to an apparently hostile world continue – Sid Vicious responded by promoting self-destruction and Andy Warhol used the aesthetics of the banal to support the attraction of nihilism.

Lives Gone Wrong

Depictions of such fractured and ethically incoherent worlds continue to populate contemporary culture and raise concerns about how we arrived at this moment. Anita Brookner's analysis of nineteenth-century Romanticism suggests a background in which the competing values of ennui and zealotry appear to fuel one other. The late nineteenth-century French popular art movement and Romanticism can be seen to have produced a widespread sense of 'infinite longing' that simultaneously

fails to supply the mechanisms for its satisfaction (Brookner, 2000: 3, 161*ff.*) The French sociologist Emile Durkheim (1907) observed the same disjunctive, moral torpor at the turn of the twentieth century and referred to it as *anomie*. The contemporary worlds of advertising and the entertainment industries can be seen to generate similar contradictions. They have collaboratively produced a passive audience that is willing to defer to experts and authorities (as demonstrated in the experiments by Milgram, Zimbardo and Elliott) who provide instructions on how to live in the world. The modern urbanite, however, like a character from *Seinfeld*, is made into a subject willing to participate in a consumer-driven economy. The effectiveness of popular culture as a source of personal knowledge depicts the individual as transparent to the purveyors of consumer products. Identity is thus commodified and in turn commodities are infused with personality – a phenomenon that seems to make sense to us.

A casual selection of popular novels and films reinforces the position. In Bret Easton Ellis' *American Psycho* (1991), Helen Zahavi's *Dirty Weekend* (1991), Don de Lillo's *Underworld* (1997), Jonathan Franzen's *The Corrections* (2001) and Joyce Carol Oates' *Beasts* (2002), the protagonists live under pressure, they feel subjugated to forces outside themselves, they regard themselves as objects in the plans of others and they do not have the will to act or to be. Such fictional characters show a weakening belief in a coherent identity as well as a sense of surrender to forces beyond their comprehension. They demonstrate how easily a conflation is made between the self and the Zeitgeist. Their characters are individuals struggling with social relations mediated by instrumental values (Goldman, 1992: 7). It is as if the market values of commodity exchange have become dominant and transformed them into 'hollow men'.

These instances of popular culture (and dozens of others) describe the contemporary tension around identity: how can we possess an iden-

tity if it is constantly constituted through transactional exchange and material commodities? It is as if the self and sense of subjectivity are at odds. The self is assumed to be a closed entity located within the individual, not literally in the heart, mind or liver – although the enigmatic pineal gland has been a favoured location. It is metaphorically located in the experience of feeling separate from others, of having an interior that is enclosed within us, making us unique and different from others. Subjectivity, in contrast, refers to a more open or permeable condition between the inner and outer in which thoughts and sentiments are part of a political, economic and historical flow of ideas. The etymology of the word 'subject' gives the impression that the individual is always positioned underneath or below, subject to an overarching authority. Subjectivity depends on pre-existing scripts and, to that extent, we seem to be shaped by circumstances. However, the self-consciousness that accompanies subjectivity also produces a sense of autonomy that again is at odds with a position of subjection. In these ways, the terms subject and subjectivity give a strong sense of identity as a contingency, a state that is variously shaped by social influences, whereas the term 'the self' is a more finished and defined state circumscribed by essential features.

The tensions between the self and subject, between a sense of an innate identity which is often lacking and a manufactured sense of subjectivity that is held in thrall to fashions in psychology and lifestyles, are repeated themes in popular culture. In an essay on the politics of lifestyle, the contemporary social theorist Dick Hebdige draws on the novelist Bret Easton Ellis to illustrate how everyday behaviour is part of a larger cultural landscape in which identity is represented as a site of confusion and disappointment. A growing sense of decline and fatalism about one's circumstances contributes to this viewpoint. Hebdige uses characters from *Less Than Zero* to alert us to these emerging weaknesses in the social fabric (Hebdige, 1993: 77).

Ellis' novel opens with Clay Easton flying into Los Angeles for a summer vacation. Driving away from the airport and entering into the complexity of the Los Angeles road system, Easton's friend Blair has commented that, 'People are afraid to merge on freeways. This is the first thing I hear when I come back to the city'. The comment unsettles Easton:

> Though that sentence shouldn't bother me, it stays in my mind for an uncomfortably long time. Nothing else seems to matter ... to me but those ten words. Not the warm winds, which seem to propel the car down the empty asphalt freeway, or the faded smell of marijuana which still faintly permeates Blair's car. All it comes down to is that I'm a boy coming home for a month and people are afraid to merge. (Ellis, 1985: 9)

This novelistic moment selected by Hebdige illustrates a low-grade anxiety that infuses metro life. It might be a sign of paranoia induced from too many recreational drugs or it could be a sign of the times. A fear of flying or of driving, of merging across freeway lanes, can be seen as a sign that the thresholds of trust and tolerance are weakening. In the context of Ellis's novel and Hebdige's essay, the fear of 'merging on the freeway' is an obvious metaphor signalling that the rules and manners that sustain society are declining in potency.

Hebdige sees the type of postmodern subject emerging from these tensions as an empty vessel. His mordant view is that the economic dominance of late capitalism promotes a misplaced belief in the rational individual. He states that capitalism these days 'has absolutely no stake whatsoever in the idea of individuals being tied to fixed and stable identities'. He describes how the retail and advertising industries promote a belief in a modern individual as a flawed assemblage of contradictions who can be directed to search for private satisfactions and a sense of identity in the consumer economy:

The ideal consumer as deduced from contemporary advertisements is not a 'he' or a 'she' but an 'it'... The ideal consumer is not the ideal productive worker of an earlier epoch – a sexually repressed nobody, alienated from sensual pleasure, subjected to the turgid, life-denying disciplines of the working week and the nuclear family. Instead, the ideal consumer ... is a complete social and psychological mess. The ideal consumer as extrapolated from the barrage of contradictory interpolations from advertising billboards to magazine spreads to TV commercials is a bundle of conflicting drives, desires, fantasies, appetites. What advertising conceived as a system offers is not a sanctuary from conflict and necessity, not a 'magical' refuge from the quotidian grind. It does not address or constitute a subject so much as promise an infinite series of potentially inhabitable (and just as easily relinquished) subject positions.... The subject of advertising is not the rational sovereign subject of Descartes, the subject of 'consumer sovereignty'. ... Rather it is Deleuze and Guattari's 'body without organs' – the absolute decentred subject, the irresponsible, unanchored subject: the psychotic consumer, the schizophrenic consumer. (Hebdige, 1993: 82–3)

This unanchored subject and psychotic consumer is also the focus of Ellis's sensational novel *American Psycho*. The protagonist Patrick Bateman is obsessed with self-invention. Throughout the novel there are constant references to deep personal anxieties that hinge on the problematic nature of identity. The surface story is of a successful Wall Street financier by day and an unapprehended serial killer by night. In the opening section of the novel, Bateman describes his morning routine, which is, in effect, an example of subjectivity produced from the accumulation of detail. His breakfast of neatly assembled portions of kiwi fruit, muesli and herbal tea is a study in compliance with current dietary fashions for self-maintenance. In the shower, he does not wash with soap and water but uses particular cosmetic products that have unique attributes – they are designed to enhance his vitality by preventing premature aging and stimulating his vital appearance. As this detailed routine is performed, a morning television programme plays

in the background – *The Patty Winters Show*. It is showcasing women with multiple personalities:

> 'Well', Patty starts, standing in the middle of the audience, micro-
> phone in hand. 'Who were you last month?'
> 'Last month it seemed to be mostly Polly', the woman says.
> A cut to the audience – a housewife's worried face...
> 'Well', Patty continues, '*now* who are you?'
> 'Well...', the woman begins tiredly, as if she was sick of being asked
> this question, as if she had answered it over and over again and
> still no one believed it. 'Well, this month I'm Lambchop. Mostly ...
> Lambchop.' (Ellis, 1991: 29–30)

Ellis's depiction of the modern individual in this set piece is that of the fractured, commodified postmodern subject. The rash of American talk shows such as those hosted by Oprah Winfrey, Jerry Springer and Ricki Lake, which burst onto the screen in the 1980s, have remained popular 25 years on. In their own way these programmes have rein-forced the fragmented, postmodern identity as they display extreme lives gone strangely and entertainingly wrong. Ellis uses them to show a preternatural concern with identity. In his novelistic example, the schizophrenic woman being interviewed by Patty Winters has become a celebrity puppet figure (Lambchop) from children's television. This is a strange choice for psychological transference and presumably Ellis em-ploys it to underscore his concern about the influence of television on how we think of ourselves. *The Patty Winters Show* itself is a parody of such television entertainments that have become parodies themselves.

A common preoccupation of these programmes is the Foucauld-ian confessional; people admit on television, in front of an audience of strangers, that they have 'sinned', they have been adulterous, dishonest, perverse or worse. These revelations reinforce a view of a convoluted and unstable self that disguises itself at will and embraces every op-portunity for self-promotion. Such an approach to identity implies we

have invisible forces within us that harbour strange but thrilling pos-sibilities. Promulgating such ideas about the depths of identity, as well as the techniques for disciplining them, has become the ambit of much popular entertainment.

Ellis's identification of this trend is echoed by other commentators and theorists who similarly acknowledge the prevailing view that iden-tity is a fragmented and flawed concept. Fredric Jameson (1991) for ex-ample has adopted the revolution in urban architecture as a metaphor of human subjectivity. He took the innovative Bonaventura Hotel built by John Portman in downtown Los Angeles as a site through which to explore the nature of individuals who comfortably fit into such public spaces. The Bonaventura was a new architectural design that invert-ed prevailing assumptions about public space. It did not respect the physical mobility of the individual or provide ease of passage from one point to another, instead it celebrated an aesthetic that dwarfed the in-dividual. At the centre of the hotel is a void, an empty space, in which elevators and escalators move constantly as a type of 'kinetic sculpture'. People are transformed into particles that give colour and movement to this central emptiness.

Jameson recognized in this gesture a discontinuity with the mod-ernist project that used the magnificence of a building to demonstrate the possibilities of a better future. Instead the Bonaventura makes the individual a servant to the surrounds; it gives a dystopic view in which we are reduced to specks within a glitzy machine designed for amuse-ment. The Bonaventura is much like two other popular public spaces, Las Vegas and Disneyland, and Jameson asks of such spaces, what kind of society do they sustain? What effects does this style of architecture have on face-to-face social relations? More specifically, he asks, what difference does it make to the pleasures of dining out, for instance, whether a restaurant is nestled on a sidewalk among bustling metro-politan crowds of people or is perched on a glass roof high above the

street where it provides a panoramic view over the ant-size popula-
tions below?

Embedded in the question is Jameson's concern that the removal of
the individual from human-scale contact with others is a clear sign of
disregard. Individuals are overshadowed by the dazzling architecture;
a sense of personal autonomy is squashed under the physical frame of
looming office stacks and disorienting shopping malls and maze-like
cineplexes. Jameson argues that these alienating physical environments
provoke the individual into impetuous consumption. If we spend mon-
ey and use a credit card we literally produce an identity and put our
tastes and financial resources on display. Herbert Marcuse had previ-
ously derided the practice as an example of consumerist fraud; it makes
identity into a commodity as if it were an object that could be bought
and sold: 'people recognize themselves in their commodities; they
find their soul in their automobile, hi-fi set, split-level home, kitchen
equipment' (Marcuse, 1964: 24). The Bonaventura Hotel, Las Vegas,
Hollywood and Disneyland, along with other hyperreal environments,
appear to Jameson as evidence of the ethically troubling times in which
we live, where human subjectivity has been diminished and, in many
instances, obscured by the spectacle of identity displayed through con-
spicuous consumption.

Looking

Contemporary cinema and twentieth-century art both promote a belief
in an autonomous interior self and, simultaneously, subvert the idea.
For instance, Andy Warhol's *Self-portrait (Strangulation)* (1978) is a
series of six differently coloured images in which he presents himself
being strangled. Apart from the colour, the panels are identical. In the
image, a pair of strong hands encircle his throat, choking him. But the
hands are not Andy's, and this is supposed to be a self-portrait. Thus we
are forced to ask, who is choking him? Warhol is representing himself

as a readily consumable commodity being chocked by a society that transforms everyone into a celebrity and makes them into objects of amusement for others.

With *Screen Tests*, Warhol made numerous four-minute films of a single human subject staring into the camera. Nothing happens; there is no speech, no action, just a long slow gaze. These films can be boring to watch and the subjects themselves appear to get increasingly restless as the minutes go by. During the four minutes in front of the camera each individual appears to withdraw slowly from the event, imperceptibly drifting out of focus as if declining to be engaged with the technology of the film that is making them immortal. Warhol's other works of multiple images using tragic divas such as Elizabeth Taylor, Marilyn Monroe and Jackie Kennedy emphasize again the capacity of popular culture to absorb and devour the subject. In conjunction with Warhol's strangulation self-portrait, we get the strong sense from his art that life is cheap and the individual made for humiliation. Claude Cahun, Man Ray, Diane Arbus, Robert Mapplethorpe, Cindy Sherman, Helmut Newton, Annie Lebowitz and others have each used the captured, frozen photographic image to insist that the material world is not as it seems, that representations always distort and project a particular point of view, and that it is wilful naïveté on the observer's part to watch television, film, media reportage and suchlike without questioning the politics of appearances.

With Hollywood and the media industries, the manufactured image has global exposure on an unprecedented scale and has greatly influenced the ways we think about ourselves. Through this constant confrontation with the image we have become well trained to see ourselves as strangers might; we are reminded of the importance of appearances, of 'the look'. Objects become overlaid with symbolic meanings and the material world becomes aesthetically colonized as we transform objects into sites of private pleasure. Our shoes, for instance, become Blahniks,

Doc Martens and Reeboks, our cars Beetles, Jaguars, Fiats, Statesmen, Coronas and Vectors. Our possessions become tastes and our habits become symbols. This is unproblematic until we see our possessions and tastes multiplied over and over again. How can we continue to think of ourselves as unique when so many others live exactly as we do? This paradox of individuality and typicality is resolved within that remarkable mental process of interpellation that allows us to find aspects of ourselves in television sitcoms, film narratives and consumer goods. It hardly matters that millions of people own a copy of Elton John's musical tribute to the late Princess Diana – that song has its own comfortingly private meaning.

We are regularly addressed by the advertisers of consumer goods, by retailers and pollsters, and urged to think about ourselves and use their products to reveal our habits and meet our interests. Do we watch *Big Brother* and the *Tour de France* on television, in the pub, with friends or not at all? Have we got FlyBuys? Do we drive a car or use public transport? Do we have cable television? Registering this information and conducting mass surveys has the collective effect of making the sentiments of thousands of disaggregated individuals seem to matter.

Members of the Frankfurt School were early critics of the entertainment industries; they claimed that they trivialized the human experience by making ordinary events seem glamorous and interesting. They argued that we were being distracted from a forensic view of reality, and instead we were being given skewed representations that produced a false sense of comfort and self-glory. The entertainment industries, Hollywood films, pop music, jazz and advertising were responsible for plunging us into a vacuum of prattle, an over-involvement in the moment that weakened any interests we may have in more serious concerns such as history and social planning (Adorno, 1991). Reality television, sitcoms and movies may provide escapist identification with attractive

characters but for Adorno this was the irreducible problem of popular culture: it amused and distracted us from the important task of thinking about and policing the divide between reality and fantasy. If we feel unified with Barbara Novak and Catcher Block in *Down with Love*, or Thelma and Louise, Butch and Sundance, Tom Ripley, Harry Potter, Luke Skywalker, Michael Jordon, Tiger Woods, Pelé or Neo from *The Matrix*, if we identify with their cinematic struggles and heroic physical achievements, then the disturbing question for the culture critics is, are we lesser beings because of those moments of transference? Does the appeal of the image, narrative and myth undermine independence of thought?

Debates around such questions can be sterile. Contra-examples are easily assembled. With global communications the reportage of real-world events is much more immediate and unmediated. The use of highly educated, expert commentators makes us increasingly aware of the complexities of world events, but also of how little we really know. In this dense information age, it is easy to feel overwhelmed by remote trends and events. We have come to live at a distance from circumstances that nonetheless affect our lives and our response to this situation ranges from a sense of alienation and disinterest to anxiety and powerlessness. If we report these feelings of oceanic alienation and atomization to the local medical doctor or clergy the diagnosis can be psychological – these are personal signs of incipient depression, they are not political analyses. Thus, can popular culture be both trivializing and distracting, and its opposite, educating and informing? It has the capacity to arouse feelings of compassion and loathing, admiration and disgust. It has the capacity to interpellate and thus locate us at the centre of the world; it can engage us emotionally and intellectually. As Marshall McLuhan punned, the medium is the massage; we are continuously addressed by the mass media and popular culture and brought to attention.

Portraiture, the photographic image and film are about looking at oneself as others might. For those looking at the image, it can be assumed that there is an effort being made to occupy the space of the painter or artist in order to see the particularities of that depicted life. Learning to see the other is part of our cultural training in spectatorial identification. Decoding the conventions of representation involves unpacking conceptual baggage as well as understanding visuality, cognitive perception, cultural semiotics, point of view, optics and the vocabulary of light such as lustre, shine, glimmer, gloss and smoothness.

Mirrors and reflections are instruments that can be used to support a concept of self. Their ubiquity in modern times adds to the layers of debate between reflections and perceptions; am I looking in a mirror to study my physical form or as an act of vanity, a search for self-knowledge? Am I drawn to the cinema to see my imagined self or to find instructional examples? Is Warhol's self-portrait a comment on the times? Is the macabre vision of Diane Arbus an instruction to all of us to be more self-appraising? Is the humour of Cindy Sherman and Yasumasa Morimura a reminder of the fluidity of identity? When Cindy photographs herself as an incoherent assemblage of body parts, and when Yasumasa photographs himself dressed as Vivian Leigh in *Gone With The Wind*, they are telling us to think about the instability of identity and the ease with which it can be represented as foreign. Through such interpellations we see our selves caught between representation and self-assertion, between how we might be seen and how we see ourselves.

The aesthetic realm trains us to read symbols, to think about their context and subtext, to make up stories and find pleasure in looking behind the obvious. The significance of all art forms is not only the emphasis they give to visuality but the influence they have on cultivating our interest in the symbolic and narrative. Through the visual we are trained to engage with the surface image, with what is apparent

at face value, and then to consider how we ourselves can be imaginatively translated into shapes on that surface. Portrait painting in the West, beginning in the early sixteenth century, marked a crucial step in the process of becoming an object of the other's gaze. The increasing popularity and accessibility of the mirror, and then the photographic image in the nineteenth century, captures the idea of mimesis by drawing the viewer into the subject. Furthermore the capacity of the image to achieve a fusion between observer and observed, between these two opposed positions, is often regarded as a moment of intense shared humanity that crosses the temporal divides of time and space.

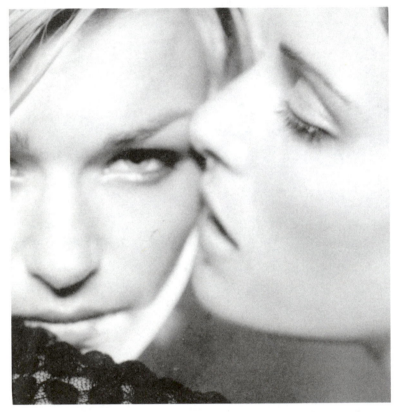

8. *This is Not a Kiss* (magazine advertisement, original ownership unknown).

5. Fashion

The Eye of the Beholder

When the pop singers Madonna and Britney Spears kissed during a public stage performance, the photographed image was instantaneously raced around the global mass media. Metropolitan daily newspapers, better known for front-page pictures of sporting heroes and politicians, prominently positioned these glamorous recent mothers in their passionate exchange. The image had shock-value: commentators asked, is that a real kiss? Is there desire and pleasure in that kiss? Can it be that Britney Spears, fading pop idol celebrated for her strict moral stance on sexual modesty, is really with Madonna, the semi-retired pop queen who had transformed herself from trashy sex icon to aristocratic parvenu over a 20-year period of celebrity?

The heavily coded image with its plethora of visible clues signalled the inauthenticity of the kiss and dulled any frisson suggested by the act. Both women were dressed and positioned to complement one another.

Britney was in white feminine frills; a tight brassiere of laced diaphanous material with a low neckline, short skirt and heavy silver bracelet. Her hair was long, loose and blonde. Madonna, in contrast, was coded as male: she was in black long pants topped with a work singlet, a long silver chain like a nineteenth-century fob-watch dangled from her belt and her hair was pulled back into a tight bun. Her stance was square to the front, her head turned back for the kiss as if it were a fleeting second thought, as if she was momentarily arrested before moving off in another direction, toward another site of male conquest. In contrast, Britney stood directly to her, receiving the kiss as a compliant female. The oppositional costuming, the white and black, the frilly feminine and the unadorned, the loose hair and severe knot, all speak to the conventions of traditional stereotypes of femininity and masculinity. How is it then that an image of two celebrated women iconically captured in an act that could signal a challenge to the hetero-normative regime was yet another restatement of it? The eruptive potential of the transgressive kiss is so controlled by its staging that it becomes innocent of any resistance. These two women, widely known for their heterosexual appetites, were playing at being risqué, and being risqué is what pop stars do.

In addition, the notoriety of this image demonstrated that appearances are ambiguous and easily appropriated, that they can be easily converted from challenges to the status quo into techniques that sustain it. This current image of Britney and Madonna as well as an earlier persona of Madonna parodically dressed in a pinstriped business suit and sporting a monocle show that the reliability of iconic dress and body posture should be questioned. In the documentary film about drag fashion communities in New York, *Paris Is Burning* (directed by Jennie Livingstone, 1990), the haute couture evening gown is paraded in drag and the question arises, are we witnessing the degradation or elevation of the costume? The meaning of a garment is difficult to stabilize as it constantly fluctuates.

Likewise the serious wearer of a pinstriped business suit knows that Madonna has mocked it. Has this affected the pleasures of wearing it? The Campbell's soup can was transformed by Andy Warhol and is now reinserted into our consciousness as a work of art. Does this elevate the aesthetic potential of all mass-produced objects? When the elaborate evening gown is worn by a drag queen in a dramatic demonstration of hyperfemininity, does it have the effect of producing a new discourse on the meaning of the object?

The disaffected fashion photographer Diane Arbus pointed out the ambiguity of style with her unlikely fashion models and inverted aesthetic. Her photographed subjects recast the conventional into the unusual. Arbus portrayed fashion less as a form of body enhancement and more as a disciplinary device. Through Arbus' camera lens fashionable clothes did not fulfil their promise to transport the wearer into the cushioned bourgeois world, instead they showed the fallibility of believing in the values of a materialistic culture. Shloss (1994: 123) gives the example of Arbus' photograph of young triplets dressed identically in a dark, long-sleeved pinafore with a flat white collar. When this conventional, almost prim outfit was worn by a single child, the look was innocent and appropriate, but when the identical triplets were dressed in the same garment, their bodies overshadowed the dress. Their uncanny existence made the costume seem a failure, for although the demure costume tried to marshal them into conventionality, their tripled body prevented any suggestion of normalcy. The point is thus reinforced that to wear a fashionable outfit does not guarantee the wearer will be absorbed into the ideals or conventions it advertises. The intractable body can defy the transformative magic of fashion and in so doing it reinforces the ambiguity of all appearances.

Arbus challenged the conventions of the fashion message. She produced portrait photographs that framed her subjects so that they disrupted and reversed the status quo. She re-figured fashionable objects

like formal dresses, long white gloves, lipstick and face cosmetics to seem strange and ambiguous. She photographed them in unglamorous contexts, such as in a transvestite's backstage dressing room, and in so doing she demonstrated their inability to materialize the happiness and success of the bourgeois values that were supposedly embedded within them. Fashion might suggest that we share the aesthetic values that circulate around desirable objects but, more often than not, these standards elude us. The 'real' body is an obdurate reality that resists the promises of fashion. A recent advertisement campaign by The Body Shop appropriated this position when it claimed that 'there are three billion women who don't look like supermodels and only eight who do' (Boyle, 2003: 36). The point was simple and ingenuous. The Body Shop trades in goods that promise to enhance us. It assumes we want to look like supermodels even when we know we cannot, and it will sell goods that bridge the gap. Arbus used the techniques of fashion photography to emphasize the same point, that most people possess a recalcitrant body that does not meet advertised standards and this, she argued, must be recognized as having its own inherent importance.

The recent teenage fashion style of *kawaii* or 'cute' illustrates how continually fascinating we find the prospect of inventing ourselves in new guises. Being cute was an aesthetic widely adopted by young Japanese females between 1970 and 1990 (Kinsella, 1995). The style had dozens of variations, the most well known being based on the characters Hello Kitty and Astro Boy. 'Cute' individuals spoke in a childish fashion, mispronouncing words and writing in a large, loopy style; they wore pastel-coloured clothes and tried to appear vulnerable and childlike. They used over-sized garments that hung on them to make them seem small. Socks, for instance, were worn slipped down the leg to give the appearance of neglect, in imitation of carefree young school children. They attached tiny furry animals to their carry-bags and stood

pigeon-toed, their hair arranged into ponytails or ringlets, all in an effort to look cute, pitiable, vulnerable and young (Yoshimo, 2000: 217).

Stephen Jay Gould (1981) has referred to a similar phenomenon in his analysis of the cartoon character Mickey Mouse and the way in which Mickey's physical appearance visibly altered in the decades between the 1930s and the 1960s. During that time, Mickey became softer and rounder with larger eyes, a shorter snout and perkier ears. His image was no longer that of the hustling, cunning streetwise mouse but of a cute, cuddly toy. The purpose of the look, according to Gould, followed the biological principle of neoteny, which states that a youthful appearance attracts others. Youthfulness sends out the message that one is energetic, bright and hence more likely to survive. Some analysts attribute J.F.K.'s political success to his youthful good looks. Certainly the physical appearances of politicians have become more important since the advent of mass broadcast television, which has made these individuals instantly recognizable.

The Fashioned Self

There are no definable points of origin for fashion, only moments when certain activities seem more obvious. The Sun King's (Louis XIV's) reign has been widely characterized as indulgent and extravagant, but at the same time it sustained artists and artisans skilled in producing luxury goods. The French court society created new lifestyles dedicated to luxury and, in turn, an industry was produced that could meet the demands (see Sofia Coppola's *Marie Antoinette*, 2006). Versailles can be regarded as a fashion workshop with creative artisans producing new designs for silver and diamond jewellery, mirrors, cabinetry, wines, embroidered fabrics, shoes and hair-styling. At those moments when fashion and commerce, style and luxury intersect and become inextricably linked, the modern idea of fashion can be identified. France has long been regarded as the home of fashion; when Louis XIV

made elegance desirable he also laid the cornerstones for a commercial framework that has endured for three centuries.

The birth of fashion coincides with other changes in society and heralds an era in which individual desires are made into realizable pursuits. The restaurant and coffeehouse (and later the department store) were similarly sites where new styles in social exchange could be cultivated and displayed. In 1675 the coffeehouse was reinvented in Paris and made into an instance of chic. In the previous two decades, coffeehouses had been popular in England and the Netherlands as places where men could meet to drink and smoke. Francesco Procopio took it to a new level; he transported the coffeehouse to Paris, furnished it with marble tables and chandeliers, offered delicate pastries and sorbets to consume and made the Café Procope the forerunner for the modern luxury restaurant (Spang, 2000).

The importance of fashion cannot be underestimated as an influence on the everyday world we inhabit. Towards the end of the 1870s, two Americans in Paris 'anxious to make their mark' were both enjoying some degree of personal celebrity (Hughes, 1997: 252). Virginie Amélie Avegno, a great American beauty recently married into the elegant Parisian establishment, had been carefully educated and cosseted in preparation for such a marriage. She found this with Pierre-Louis Gautreau, twice her age. At 20, Amélie was poised to become a professional beauty, 'La Belle Gautreau' as she would come to be known, whose presence at social functions was reported in the popular press, *La Gazette Rose, Le Figaro* and *L'Evénement* (Davis, 2004: 43). As her celebrity increased, Amélie was a popular choice for portrait painters and she eventually chose to sit for the American John Singer Sargent, the son of a successful Philadelphia doctor and a socially ambitious mother. In 1884, Sargent's painting of Madame Gautreau was exhibited as *Portrait de Mme* *** at the Paris Salon, a huge annual exhibition in which thousands of established and aspiring artists displayed their works to

the general public. The portrait showed a tall, haughty young woman dressed dramatically in a black dress. Her face was turned away from the viewer, her hair held in a chignon had a few wisps trailing down her neck; the only colour in the portrait was the rosy ear and dark red lips. The dark dress was tightly fitted and outlined a heart-shaped full body. There was little display of jewellery or wealth, only a small diamond setting in her hair and then the heavily beaded straps of the dress with one fallen from the shoulder. The painting was soon referred to as *Madame X* and branded by the critics as detestable and monstrous.

Another of Sargent's portraits was also exhibited, coincidentally hanging side by side with *Madame X*. It was of the celebrated society gynaecologist, Samuel Pozzi; he was painted wearing a flaming red dressing gown. The juxtaposition of these two portraits and their proximity seemed to confirm the gossip that the two individuals were indeed romantically entangled. And the slipped shoulder strap on Amélie's dress was seized on by the viewing public as visible proof of moral laxity and notoriety. Mme Gautreau's association with Sargent had also been a matter of gossip in Parisian society and this was enough to ignite a sex scandal that would envelop the two American parvenus.

The annual Paris Salon, where thousands of works of art went on display, was an occasion for social climbing. The hanging of the portrait at the height of the social season was expected to be a mutual triumph, 'Sargent's success would be her success; this would be their shared moment of triumph, when Paris would formally acknowledge his talent and her beauty' (Davis, 2004: 129). Yet the public reaction to the painting was overwhelmingly negative. The small detail of the strapless shoulder suggested vulgarity and the ensuing *succès de scandale* compromised the reputations of both subject and painter. For the next two decades Singer kept the painting in his private collection, even after amending it by painting a restored strap and giving the image a more demure atmosphere. It was exhibited again, two decades later, in 1905

in London, and received enthusiastic reviews. Amélie died in 1915, her life heavily influenced by a painting she never owned, and Singer sold the painting in 1916 to the Metropolitan Museum of Art in New York from where it has become a modern icon. It is now widely exhibited and its image is popular – the Hollywood actress Nicole Kidman imitated the look in a fashion spread for *Vogue*. The puzzle though remains how a gesture as slight as a fallen strap in a painting could produce the moralistic fervour that haunted Singer and Gautreau for decades, and the same could be asked of Jean Shrimpton's first appearance in a miniskirt, or Mick Jagger's revealingly tight pants.

Madame X is part of the history of visual acuity, of using details of the material world to draw metaphysical conclusions. The history of the dandy George Beau Brummell is another episode in this cultural history. Ellen Moers (1978) argues that in the details of Brummell's dress and appearance there could be detected signs of transition from the *ancien régime* to the industrial modern. From the nineteenth century, a language for reading the stranger and estimating their social status was being disseminated through a heightened attention to details of appearance. Styles of clothing and physical demeanour became an important part of the perceptual horizon. Richard Sennett (1976) discusses at length how we became trained to notice the smallest telltale detail and slightest incongruity in dress and how we learnt to treat these as disclosures of a hidden self, a lurking barbarity, that might erupt and destabilize the moment. The assumption at work was that an untrustworthy self was held in check by the rigors of convention and habit:

> people took each other's appearances in the street immensely seriously; they believed they could fathom the character of those they saw ... finding out about a person from how he or she looked, became, therefore, a matter of looking for clues in the details of his costume. (Sennett, 1976: 161)

Being able to read the surface for insights into the interior, and be-coming adept at constructing surface appearances through the control of detail, are processes fundamental to contemporary social relations. Since the late twentieth century fashionability in clothes, cosmetics, body shape and material possessions have all become loquacious as more personal attributes are attached to them. This is achieved largely through modern advertising. Objects are made to represent human sentiments – a diamond ring signifies eternal love, a car freedom, the business suit suggests wealth. The evolution of fashion has also played an important role in privileging the visual and training the eye. Fashion is not merely a frivolous recycling of objects and styles in a cynical at-tempt to pursue profit; while it is fundamentally a commercial enter-prise that sustains industries in manufacture and marketing, it is also a technique that cultivates a specific way of thinking about the world. Fashion is a system of classification that engages the imagination and trains us to recognize the symbolic impact of material goods.

Fashion is also a process that transforms the mundane activities of everyday life into more elaborate and complex aesthetic experiences by altering the emotional investment surrounding the display. When we come to see ourselves through the eyes of others, to evaluate our life-style and possessions in relative terms and in comparison with prevail-ing fashions, then a new level of significance is added to our social expe-riences. We become self-consciously aware of the other's importance in defining our own identity – hence the power of Singer's painted slipped strap to impugn the social reputation of Madame Gautreau. The same attention to detail is applied to celebrities in the modern era who are captured by the paparazzi in unflattering poses and then described as too fat or too thin, possibly pregnant or anorexic, drug-addicted, un-happy, lonely and depressed. Every detail of their presentation comes under close scrutiny that forces a conceptual collapse between identity and appearance. If these usually highly groomed individuals are seen

in uncharacteristic ways then deductions are immediately made about their states of mind and health.

The Mind's Eye

A great deal has been made of the physiognomic association between aspects of character and the shape of the body (Castle, 1986; Sennett, 1976). Wahrman reminds us that physiognomy has had a long and uneven history, with roots in antiquity and the Renaissance. It has circulated through disreputable practices such as fortune-telling and bawdy parlour games before being refashioned in the eighteenth century into a quasi-science of the soul (Wahrman, 2004: 294–9). The idea was especially popular in the eighteenth century, before the advent of professional psychology, and it has remained a common approach (as we saw with Paul Ekman's FACS). The increasing interest in the twenty-first century in cosmetic surgery can also be interpreted as a physiognomic impulse. The willingness to undergo the discomfort of a surgical 'nip and tuck' in order to appear more attractive is presumably driven by a deep belief in the persuasive value of physical appearance.

In the twentieth century, Alison Lurie gives the legacy of physiognomy a new twist by bringing in psychosexual associations and high fashion. She describes, without critical gloss, how the interior secrets of the psyche are expressed directly through the details of dress: 'The woman in the sensible grey wool suit and the frilly pink blouse is a serious, hard-working mouse with a frivolous and feminine soul' (Lurie, 1992: 245). When we encounter one another in the anonymous sphere of the public domain, our clothes become garrulous and disclose desires and the secrets of the heart. Lurie presents appearance as a reliable marker of gender, class, religion and sexual proclivities. Accordingly, in any crowd, she recommends we study appearances to understand who we are mixing with: we can recognize American tourists, for instance,

by their infantilizing swaddling clothes. Their anxieties about travel and leaving their 'comfort zones' are reflected in their soft 'at home' casual attire. The colonial heritage of the British is evident in their choice of inappropriate hats and carryalls which signal an imperialist disregard for the actual physical conditions in which they might find themselves. Muslims, Jews, Hare Krishnas, Catholics and New Agers all make themselves visible with their respective religious insignia. In short, Lurie suggests anonymous strangers send out a plethora of signals inviting us to categorize, rank and stereotype them with the most cursory of glances.

Lurie is not alone in her views. Herbert Blau regards dress as illustrative of human character (Blau, 1999). He considers much of human society to be the expression of libidinal energy emanating from a profound human need to 'look good'. A fashioned appearance is about pleasing oneself but it is also and more importantly designed to seduce and manipulate others. Fashioning ourselves is the result of an ungovernable urge to gaze at others and imagine who they are, and it is about wanting to be looked at in return. Blau considers these eidetic pleasures to be at the core of Western society and he cites literature from Shakespeare to T.S. Eliot to demonstrate their deep penetration into our modern consciousness. He repeats many of the tenets of physiognomy without acknowledging its longstanding and oftentimes disreputable history.

The contemporary popularity of the views of Blau and Lurie are interesting for the emphasis they give to the resilient human urge for self-display. They regard fashion as a language of transaction well suited to a social epoch where it is believed possible to improve and change one's personal circumstances through social acumen. Embedded in the circulation of status and identity are the pleasures of being on display, of being looked at by others, of imagining our own existence inserted into the mind's eye of the other.

Anne Hollander (1980), a historian of clothing, recognizes the importance of visibility but explains it differently from Lurie and Blau. She argues that social circumstances shape the ways we look at others rather than drawing on physiognomic principles. We have learned to see through clothing. Even the naked body, she argues, is understood as a reversal of being dressed, and is imagined always in relation to its clothed mirror image. The smart little black dress with which Coco Chanel captured the Zeitgeist is an example of how clothes make us, and not the reverse. The little black dress became an enduring icon because it emerged at the same time as new definitions of femininity. A woman in a little black dress was suitably attired for any occasion. She could segue from one social role to another without pause. The little black dress was coincident with women stepping out of the home into the public realms of commerce and industry and the new social scene of the cocktail party.

A similar line of reasoning has been applied to menswear. The corporate business suit, which evolved in the twentieth century from the at-home smoking jacket and casual country tweeds, has been adopted by men in response to the daily work demands of corporate capitalism. The suit functions to make all men look alike in their sombre-coloured uniform, which in turn is an outward sign of their reliability and sobriety. The suit depersonalizes the wearer in order to engender trust. The psychoanalytic writer J.C. Flügel has made much of what he referred to as the Great Masculine Renunciation. When men adopted the business suit they renounced their exhibitionist desires in order to gain the material wealth promised by the new economy. As if to balance the gesture, the female body became, he argued, once again fetishized.

Such theories do not fit well with historical explanations that depict fashion as being more about commerce and trade than individual psychology and the libido. Other accounts of the business suit and

gender relations, for instance, rest on different assumptions. Ellen Moers' (1978) account of Beau Brummell's influence on the politics of appearance draws on a different set of assertions. The British Regency of the late eighteenth century created new combinations of political and social groups, thus giving individuals greater licence to more diverse conversation about the pragmatics of government, power, law and commerce. From this emerged a new type of masculinity largely focused on circulating ideas about progress and modern science. The new masculinity represented a different value system and with it came a new mode of appearance, one that was more utilitarian and less excessive (Tytler, 1982; Weschler, 1982). Dress was no longer a symbol of extravagance and excess but of a willingness to be located with a distinctive social group.

The lesson endures. To observe cultural conventions and use them self-consciously is a modern credential that signals 'clubbability' – that 'we' are 'you'. Modern retailers know this law of social life, hence the birth of the fashion clan – the townie, preppy, home boy, Goth, surfer, femme, butch, spunk, hunk, chic, corporate. Club membership, however, is not modern. Lord Chesterfield in the eighteenth century famously instructed his son to understand that while stylish dress may seem foolish and an expensive vanity, it was more foolish to dress unfashionably because in one's adherence to the proper codes of appearance more important declarations of social acceptability were being conveyed (Bell, 1976: 18). This new recognition was foreshadowed in the seventeenth-century fashion of the manteau or mantua (a large overlay, usually dark in colour that made everyone look alike) and the evolution of denim pants from eighteenth-century sailor's dungarees. Both these garments signalled an increasing uniformity of simpler dress codes and signalled the future success of *prêt-à-porter*. The mantua weakened the reliability of class identification by allowing for greater ambiguity and confusion around the visual clues marking social position.

Terry Castle demonstrated how fashion could undermine social conventions in her analysis of the eighteenth-century masquerade. This fashion episode illustrates the use of clothing to display the social value placed on 'perfect freedom'. Masquerade provided an opportunity to escape social strictures and grasp instead the sensation of unencumbered 'psychological liberty' (Castle, 1986: 55). Dress could generate new and complex feelings such as a profound sense of self-alienation based in the separation of mind and body. Masquerade undermined social stability in order to produce a sense of excitement from the unpredictable. The advent of the department store in the mid-nineteenth century was designed to evoke some of the same sensations – disorientation, pleasure in impulsiveness and the materialization of private desires.

Roland Barthes' influential analysis of the fashion system (1983 [1967]) provides us with a handy means for understanding these complex relations with the material world. He suggests that all objects exist on three separate planes at the same time; he refers to these as the 'real', the 'used' and the 'represented'. The real category refers to the design process and manufacture of the object. The 'used' category refers to the place of an object in its cultural context. For instance, when we view a museum display of artefacts, their status is determined by their decontextualization; that is, they have been removed from the environment in which they once presumably had a function. Viewing such objects out of context suggests other ways of living and being in the world that may be radically different from our own habits. However, it is the third category, the 'represented', that holds the greatest interest in terms of the art of self-invention.

The 'represented' refers to the manner in which goods are presented to us, and how we imagine their inherent properties. Goods are 'represented' or put on display in, say, magazines and department stores where they are arranged in order to amplify their attractions.

The 'represented' object evokes desire; we want to own it, but when we do, when we take possession, Barthes explains, there is an immediate sense of disappointment. It does not fulfil the promises of its represented state. It may still deliver pleasure but it is not the same as that which drew our attention when it was still out of reach. The imagined or represented item is part of a visual and textual universe that is elusive. The *mise en scène* in which the object holds its greatest allure, say, the advertisement, cinematic film, retail store or our neighbour's apartment, pervades consumer culture. In practice, we do not encounter the 'real' object as we are always enthralled by and in pursuit of its 'represented' qualities.

If we follow Barthes' reasoning we can see how every purchase carries with it the danger of disappointment. With every purchase we find almost immediately that its allure has faded or failed. In the very next moment we become the focus again of fresh advertising that draws us back into the consumer role, where the idea of possession is again presented as the most likely means for finding the pleasures we seek. Without being as mordant as Theodor Adorno, Barthes returns us to a similar place where we can recognize the folly of searching the material world for abstract pleasures that only reside in the imaginary.

Being Conspicuous

Thorstein Veblen, an early economic sociologist, was fascinated by the social impact of industrial capitalism in late nineteenth-century America, and in particular on the changing personal tastes, living habits and leisure pursuits of the new bourgeoisie. He was intrigued by the impact of new values on a class that was not anchored by strong traditions. As this class grew in size and prominence he expected to see futile exercises of competition with individuals keenly engaged in ostentatious displays of conspicuous consumption, and he was not disappointed. He

noted with some puzzlement that objects regarded as ugly and mundane could be elevated into the fashionable and desirable, and then in a relatively short time discarded as useless. He was intrigued too by the social value placed on useless objects such as the well-manicured lawn that was more highly valued than a field where animals could graze. Women's hats were another puzzle: when they were large and difficult to wear, when they sat precariously on the head, they were held in greater esteem than those practical bonnets that protected the face from the weather.

Veblen was describing, with a detached and bemused eye, what we now take for granted. He wondered why individuals who performed useful tasks were often regarded as inferior to those outside the industrial process who were mostly idle. Men and women who by birth or inherited wealth produced little were members of the upper classes and spent a great deal of their time ensuring their distinction from those below them. He wondered why consumption was at the heart of these distinctions and drew the conclusion that human society was not always progressive or rational. Veblen regarded the desire for status and prestige as a natural feature of all human societies; it could be observed everywhere, even in those relatively egalitarian groupings where it was accepted that some members would be physically superior and better endowed than others: 'no class of society, not even the most abjectly poor, foregoes all customary conspicuous consumption' (Veblen, 1925: 85).

Veblen's late nineteenth-century study of the American bourgeoisie was a precursor to J.K. Galbraith's (1958) analysis, 50 years later, of the so-called 'affluent society'. Conspicuous consumption was a mechanism for gaining prestige and status. It required the continual circulation of goods, which Veblen called 'pecuniary emulation'. Social superiority was also measured by the individual's ability to squander time and use other people's labour to command service from them. He understood that conspicuous consumption was a communication system – hence

cut flowers held more meaning than those growing in the garden because they involved someone's labour, and women of status had to wear elaborate coiffure as well as hats because both required other people's labour. It was also necessary for such women to change clothes three or four times a day, and to host formal dinners where too much food was served. All these activities required extravagant amounts of time and excessive attention.

Veblen was often ironic about these apparent irrationalities; when he described the fashions of those who lived in cold and wet climates he remarked that such individuals frequently 'go ill clad in order to appear well dressed' (Veblen, 1925: 167). He was fascinated by the competitive urge and the development of a subtle hierarchy that made endless distinctions and categories. The glossiness of a silk hat, for instance, was a sign of social superiority whereas the sheen on a coat sleeve was not (Carter, 2003: 47). The glossy hat was gained from purchasing the labour of the servant who cleaned and polished whereas the shiny sleeve was the result of repetitive wear and tear. The difference between 'gloss' and 'sheen' was status.

The desire for status and prestige was not, according to Veblen, a simple function of abundance; there were important differences between wealth and status, and one did not necessarily deliver the other. It was necessary to convert wealth into prestige, and that could be achieved through pecuniary emulation. Veblen described the pleasures of purchase as a form of exhibitionism. Thus wealth was not a triumph over others but a means of attracting attention, of standing out and being seen. It enabled individuals to signal their desire to be like those who were watching them, but slightly better: 'the possession of wealth, which was at the outset valued simply as evidence of efficiency, becomes, in popular apprehension itself a meritorious act. Wealth is now itself intrinsically honourable and confers honour on its possessor' (Veblen, 1925: 29).

There is a derisory inflection in Veblen's views that resonates in current commentary. The contemporary intellectual George Steiner, for example, is equally aware and critical of ostentation. He asserts that a ravenous appetite for material rewards is always dissatisfying; if making money is regarded as the most useful way in which we spend our days and the most interesting social activity to pursue then we inhabit an anti-human and impoverishing society (Steiner, 1980: 77). We are not revealed through possessions; human capacity is not equitable with material comforts, irrespective of their aesthetic complexity. For Steiner this is the danger of material abundance; it becomes confused with the capacities of the imagination. We are greater than our symbols and achievements: the construction of the Brooklyn Bridge may be a monument to human ingenuity but it is still less than the mind that imagined it.

When the styles and practices of the upper classes are imitated, when their fashions 'trickle down' to their 'social inferiors', Veblen argued that these leaders were immediately impelled to redesign and reconstitute themselves. In this way, the upper classes were always inventing new styles to maintain their difference. The trickle-down theory of fashion, however, has been rewritten by twentieth-century street and diffusion fashions that do not follow the rules of social gravity to trickle downwards but work in the reverse to influence those in the upper echelons. Hence the rise in status of denim jeans (once the dungarees of the working labourer) and the athletic shoe (now the expensive Reebok, Fila, Nike, Adidas cross-trainer and stylish casual by Bally).

The highly visible fashion label or brand name first appeared on casual wear and street styles as a form of irony and repudiation. The French haute couture label had always been subtly attached to the garment, most often sewn into the seams. With street style, the label was made a visible part of the design and then parodied. It quickly became a signature that distinguished items from similar competitor goods.

In this way, the brand or label becomes a token of club membership in a universe where goods address us as Nike devotees and Donna Karan fans. The identifying label or brand invests the mundane object with specific qualities that form part of its valued place in the fashion universe.

Judith Butler (1993: 129) has added an important gloss to the personification of objects with her concern over how we derive meaning from particular styles. For example, how do we know whether a style of appearance is confirmatory or subversive? Does the drag queen in the elaborate costumes of hyper-femininity subvert the norms around femininity or re-idealize them? And what do we make of faux fashions that parody dress? When casual and street wear first appeared, smothered in illegible writing and logos, it could be read as a form of mockery of the fashion label. Now that gesture has lost its impact. Did the street stylist bring down the great houses of haute couture or reinvigorate them? As fashion styles proliferate, the fetish of buying symbolic power through the label has grown. The attack on the label by the diffusion stylists has produced an even greater number of labels that in turn function to classify and rank a more diversified range of products – not just shoes, handbags and dresses but now underwear, motor car steering wheels and coffee.

The Depths of Fashion

The linkage of character with physical appearance was significantly strengthened when modern societies eliminated rigid codes of dress and sumptuary laws. This provided opportunities for individuals to construct or fashion themselves using whatever objects they could command. Flexibility in self-representation has been a driving force in the rapid development of the fashion industries and is an acclaimed feature of modernity (Berman, 1983; Gilman, 1998; Harvey, 1990). The

beautiful body has come to be seen as an expression of human virtue, an idea carried through various reformulations of physiognomy since Aristotle.

However, with nineteenth-century medical developments such as anaesthetics and antisepsis, surgical interventions to reshape the body and face have encouraged us to think of flesh as a plastic asset, something that can be engineered and made over to our liking. Late modernity has been described as an era in which the so-called constraints of nature, time, space and matter have been overcome through industrial ingenuity and technological innovation. The modern era is about making the world we want: new breeds of domestic animals, genetically modified foods, cosmetic surgery, synthetic materials and plastics for building, and new fabrics for smart clothes. Modernity is an era of neophilia; the pursuit of novelty in technical, political, social and aesthetic arenas is taken for granted. Douglas Kellner describes fashion as 'a constituent feature of modernity' which is itself

> marked by perpetual innovation, by the destruction of the old and the creation of the new ... Fashion perpetuates a restless, modern personality, always seeking what is new and admired, while avoiding what is old and passé. Fashion and modernity go hand in hand to produce modern personalities. (Kellner, 1994: 161)

The connections of personality and identity with material objects also make us into commodities. Celebrities endorse and embody specific products and lifestyles. Behind the familiar faces and endorsed products are invitations to self-invent. The Hollywood movie star, sports hero and pop idol are advertisements for various material goods as well as abstract personal qualities.

More than three hundred years after the collapse of sumptuary laws, and a hundred years since Veblen (1899), it is much harder to stabilize the value and appeal of certain goods. The capacity of the fashion system to cannibalize styles from every position on the social

and political spectrum has become part of the sartorial cycle, and has sustained a dynamic of constant reinvention. In the 1980s, when Madonna flaunted a huge crucifix as a piece of junk jewellery, she not only started a new street style, she subverted the symbol as a religious sign while at the same time acknowledging a world-wide renewal of religious fundamentalism. Street stylists often gain prominence through shock tactics but their audacious aesthetics are quickly absorbed into mainstream marketing. Such has been the case with the absorption of sadomasochistic fetish wear into haute couture and cross-dressing into international fashion shows. Even the Hugh Hefner playboy aesthetic has had a recent rerun with the American rap singer Pharrell Williams, sycophant of Snoop Dogg and member of the N*E*R*D band, who stages his music videos in a lavish apartment crowded with beautiful people drinking from paper cups and skateboarding on an inside ramp. The ramp is positioned as the literal inversion of Hugh Hefner's sunken, soft-carpeted conversation pit – in its day a sign of decadent pleasure.

It is more difficult in the twenty-first century to trust the links between appearances and character, despite the connection being regularly reiterated. The costumed body neither speaks as a manifesto of rebellion or a mirror to convention. The body has become a surface like a Baudrillardian screen over which flickers endless costumes and changing consumer styles. At an earlier time, Georg Simmel (1950: 409–24) warned that this level of ambiguity and confusion was an unavoidable feature of city life. The city was an assault on the individual; the sheer size of buildings and the press of the thick crowds had an overwhelming effect, making the person feel undistinguished and diminutive. The city itself as a colossal overarching machine could dominate and grind down the individual. Every encounter was with a stranger who could be unexpectedly menacing, he could be Jack the Ripper, Hannibal Lector or Patrick Bateman. In response to these pressures it was necessary to develop another layer of skin, a blasé attitude that gave a sense of

protection through social detachment. Fashionability provided such protection: the well-dressed individual could feel confident and think of themselves as less submerged, more visible in the crowd. A stylish appearance could give a sense of singularity in an otherwise insensitive environment. The noisy, highly stimulating background of the metropolis was intrusive and eroded the individual's sense of singularity. In such an environment, the continuous circulation of goods was one way of controlling and structuring what was otherwise a disorienting milieu.

A century after Simmel, the British award-winning fashion designer Vivienne Westwood responded to the experience of the city in much the same way. She suggested that people use style to secure a sense of identity, and they needed to do so through a form of extreme subjectivism, that is, performing and asserting themselves deliberately in order to recuperate a sense of uniqueness in an environment that was indifferent to them. Westwood suggested that high-flying corporate women may well find some satisfaction in wearing her dishevelled 'city-gent look' into the boardroom. The outfit included an over-sized formal shirt and necktie, complemented with lingerie featuring an appliquéd penis (Wilson and Ash, 1992: 184). Y-front jockeys could also be used. An inverted version was available for men, who could wear slit, silk lingerie concealed under their pinstriped wool suits. Westwood identified such extreme appearances as *couture creation* and its appeal resided in the private repudiation of the conventions of mainstream anonymity.

Such functions for dress have a long heritage; clothes have often been used as billboards for identity politics and declarations by utopian rebels. Indeed, serious social unrest has been advertised through stylized appearances (Luck, 1992; Ribeiro, 1992). Counter-cultural dress, including long hair, a shaven head, stressed denim, tattoos and body piercings, has been a device for publicizing social malaise and political critique (Hebdige, 1988). The armband, soft cap, beret, bloomers,

blue stockings and orange scarf have all been used at various times to flag resistant political values. In many ways, these tactics are an obvious inversion of the conventional dress codes that signify acceptance of the status quo. Even so, knowing when a dress style has an interesting subtextual message or not is difficult to determine. Radical politics are often more varied and subtle than any scarf, cap, T-shirt or dreadlock can acknowledge, and conventionality is more widespread than any uniform can signify.

The basic irony of fashion is that it does not step very far ahead of the mainstream. Indeed, it mostly remains within the limits of prevailing aesthetic values. Yet it does produce an energetic if disjointed discourse much like that produced through the semiotics of advertisements. In both instances, our fluency with these languages embeds us firmly within a prevailing value system. This may well be their important social function; as Herbert Blau has commented, fashion must always be 'linked to living, breathing life, charged with the time of the now' (Blau, 1999: 112). Blau is exclaiming the creativity of fashion, but his words undercut the radical claim. Fashion is always conservative as it is in the moment, not ahead, not behind, but always 'with the time of the now'.

The appeal of fashion often assumes that the psychological is more important than the historical and economic. The psychological tends to emphasize the erotic capacities of the fashionable, thereby encouraging highly specific sexual messages to become attached to fashion forms, and this complements the dominant ideology that appearances are reliable insights into character. Alison Lurie, for example, makes much of this perspective; she argued that women's handbags literally mirror the psycho-sexual characteristics of their owner: a large, open tote bag signifies the owner's casual approach to sex; a hard, closed, shiny compact handbag symbolizes a closely regimented and repressed sexuality (1992: 242). As nonsensical as these assertions sound, they are repeated

in popular forms in the mass media. Steele (1985) has added to such psychoanalytic inflections by describing the sling-back shoe as an echo of décolletage, whilst the low-cut shoe replicates breast cleavage, open-toe shoes reveal a desire to be sexually titillating and the stiletto heel is a request for kinky sex. The Oxford sensible shoe predictably suggests anti-sexuality.

Such interpretations are variously convincing, amusing, irrelevant or misleading. Nonetheless they establish the language of fashion and the discourses around appearances as part of a larger communicative system. Some would argue that fashion is a conspiracy to distract us from the real affairs of society. It confines the fashion lover to an inferior social place, as someone who is a consumer and not a producer (Finch, 1991; Roberts, 1977). Fashion can intensify self-absorption and thus reduce the social, cultural and intellectual horizons of the fashion habitué (Hansen and Reed, 1986; Mort, 1996).

Looking for a psychology of consumption dates from the late nineteenth century when the embryonic therapeutic industries began addressing the self-doubts of the educated bourgeoisie cut loose from the securities of social traditions. These doubts were echoed and even amplified by mass media advertising that promised to answer such anxieties. Urbanization, technological innovation and secularization were and remain colossal social forces that impinge on individual consciousness. Material possessions are often represented as sources of social identity and status in otherwise destabilizing times (Gay, 2001). Simmel's nineteenth-century theory of money contains the same idea: fashion and money work to maintain a classificatory system that ranks and orders individuals along a normative spectrum. Money like fashion has the capacity to give objects a value, it categorizes things. Against the noisy and disorderly background of city life, the capacity of money to bestow value has strong appeal, and is an idea that persists today.

The Ethics of Appearance

Fashion is a disciplinary power in Foucault's sense, insofar as it coerces us to shape our bodies and present ourselves in accord with ever-shifting social expectations. Fashion is collective, systematized and prescriptive. The skills required to be fashionable include making the body docile – being able to diet, wear facial cosmetics, and sit, walk and stand comfortably in constraining items of clothing such as stiff collars and neckties and stiletto-heeled shoes. Foucault's docile body is fashioned by the urbane habits of reading fashion magazines, engaging in body-sculpting makeovers such as gym workouts, cosmetic surgery and periodic internments at health and fat farms. The docile body is a commodity, a site of aesthetic innovation subject to periodic upgrading (Gilman, 1998). City life constantly exposes us to the scrutiny of strangers. The crowded city, where different lifestyles and value systems function in parallel, emphasizes the need to self-monitor and regularly update one's self-performance. In such an environment, fashion seems natural and the emphasis it brings to self-consciousness becomes an ordinary feature of daily life.

On the basis that fashionability displays identity, it follows that the fashion industries are deeply implicated in the manufacture of 'personality'. Fashion provides a short cut by which we adopt an identity and join a subculture that in turn can variously insulate us from others or promote our social stakes. Dick Hebdige (1988: 110) calls fashion goods 'weapons of exclusion'; he is referring to their capacity to function as identity markers. Fashion segments the social world, it localizes social groups by tastes and possessions, it transforms identity into a material commodity. Jean Baudrillard (1993) extends Hebdige's point; he views fashion as economic in origin but aesthetic in effect. Like Barthes, he acknowledges there is a poignant discontinuity between the urge to consume and the disappointment of possession. Even when fashion

styles have been used in explicit moral campaigns, for example as with bloomers or the green T-shirt, the end result is that social conditions do not change enough. After all, the green T-shirt has not halted the exploitation of natural resources, nor has the discarded corset changed the status of women. Gilles Lipovetsky makes the same point: the pleasure of fashion 'coexists with the arms race, with lack of personal security in daily life, with the economic crisis and the subjective crisis' (1994: 132). Fashion may be a way to limit the boredom of everyday living – urban and suburban life after all can be grindingly monotonous without such diversions. But to expect fashion and appearances to increase liberalism in the world is a political mistake.

Another Marxist theorist of consumption, W.F. Haug (1986: 41–2), is more optimistic about the fashion system. He portrays it as deeply implicated in the production of political opportunities that offer a utopian future. He describes fashion as a form of 'aesthetic innovation'. While it sustains the rapid circulation of goods with the marketing technique of 'out with the old, in with the new', it is also cultivating expressions of human ingenuity through constant innovation. In this way fashion makes the consumer ethic morally acceptable as it defines a site where clever inventions gain reward. The creation of fashion then is a 'natural' dynamic; it is a force for change. Aesthetic innovation is not about change for its own sake, but it can be about change that brings improvement. Thus fashion, when it fosters aesthetic innovation, argues Haug, is a form of progress that highlights evolutionary improvement.

These intellectual skirmishes about the sociological influence of fashion, however, provide more entertainment than reassurance. Dressing the body each day is an ordinary event. The historian Leslie Rabine regards this act as deeply implicated in the formulation of identity. Clothes are 'erotically charged' and handling them often, constantly grooming oneself and styling an appearance is a way of intensifying

the sensual. Dressing is a way of producing ourselves; it is a symbolic replay of the birth of subjectivity – 'the pleasures of fashion include the symbolic replay of this profoundly productive moment when subjectivity emerges' (Rabine, 1994: 64). Defining the body through clothes moves it away from its biological qualities and emphasizes instead the aesthetic and abstract. Gilles Lipovetsky (1994: 79) reinforces the viewpoint in his description of how 'the psychologizing of appearance is accompanied by the narcissistic pleasure of transforming oneself in one's own eyes and those of others, of "changing one's skin", feeling like – and becoming – someone else, by changing the way one dresses'.

Such views of the physical body and its appearance have had the effect of elevating the importance of material goods not only as a source of physical comfort but as a source of entertainment. Definitions of selfhood or personal identity can be moved away from abstract attributes of morality and character towards a more material inventory of what objects an individual can own and command. In such a schema, we are identified and judged in large part by our material resources. Fashion is not just about the circulation of luxuries and superfluities in a consumer age. It is not just a hedonistic pursuit of private desires. Looking at fashion is more than observing the predominance of highly promoted luxury goods, extravagant patterns of consumption and celebrity endorsements of leisure activities and lifestyles. Fashion is a classificatory system. Fashion operates in the fields of clothing and decoration as well as in commercial, domestic, political and intellectual spheres where it influences the objects on view in art galleries and museums, the cars we buy, the animals we live with as companions, the names we give our children and the foodstuffs we consume.

The visible prominence of global products functions, at one level, to cultivate our visual acuity. In this way, we learn to see more in the symbolic image. The idea underscores the value of advertising as being more than the promotion of specific consumer items, it is a training

system through which we acquire an improved visual language. The ubiquity of fashion photography thus trains huge numbers of people (especially women) who look at magazines and advertisements to gain pleasure from identification with such images. Individual identity can be constituted through such associations, as the fleeting parade of fashioned images provides us with a 'look' we can adopt. The image, however, is not always obedient and cannot be relied upon to sustain the encoded messages.

Some images are ironic and parodic, challenging the conventional, especially the hetero-normative. Fuss (1996) has made the observation that when a heterosexual woman gazes at magazine images of her imagined and better self, she is being simultaneously trained to look at other women with a 'homospectorial look'. Fashion photography, like mainstream cinema, commonly assumes a heterosexual viewer yet the eroticization of images of the female body cannot always be contained and directed only at men. Fashion advertising and photography encourage women to gaze at other women with desire. Valerie Steele (1985), the psychoanalytical historian of fashion, has always connected the fashion image with the erotic. Fashion products and images deliberately manipulate the gaze to stimulate the pleasure of looking and infuse goods with a sexual charge. The eroticization of the gaze is especially evident with those products that might be construed as enslaving or constraining, such as women's corsets and stiletto-heeled shoes. This allows women to use such objects for their own personal benefit.

As fashion eroticizes aspects of the everyday, it can also make us slavishly attentive to details and thus anxious about appearance. The twentieth-century popularity of trousers, shirts and different styles in shoes have given women much more physical freedom and choice in self-representation. The pleasures of voyeurism and exhibitionism have become firmly attached to the visible body making the displays of gender and status a playful part of its repertoire. Fashion can ameliorate the

tensions between the masculine and feminine as well as those created by status inequalities and social privilege by creating ambiguous styles. The fashion industries endorse a modernist assumption that societies are progressive and self-renewing; they provide sites for expressions of human rationality and creativity.

There have always been debates about the function of fashion, whether it has increased social progress through mass production of goods, whether it is a natural extension of Calvinist virtues of parsimony and austerity, or whether it poses a moral threat to society because it endorses material plenitude (Weber, 1930; Williams 1983). Consumerism can be defended if levels of consumption are tempered by reasoned desire and not driven by the tricks and coercion of scurrilous techniques such as subliminal advertising. Consumerism can also be condemned because of the blatant inequalities that the pursuit of goods encourages. The debates about the social relations engendered by consumerism are more fully developed through wider perspectives that place our relations with the material world in the context of globalized economies and new technologies for the manufacture and distribution of goods. If fashion is extended beyond the elitist spheres of haute couture and located within popular culture and everyday life then it is easily recognized as a vehicle for expressing individual agency and social aspirations. Fashion is a discourse that gathers together a variety of codes and stylistic registers through which we communicate, and as such it works to provide a plurality of opportunities to represent ourselves and project images of subjectivity.

We are not passive victims of fashion, as is often thought, nor are we entirely in control of the meanings attached to material goods. The category of the fashionable incorporates from one extreme the materially utilitarian to the opposite, the aesthetically decorative; it is a loose concept brought into action for multiple purposes. It eludes being defined and applied in any stable manner, yet its value as a signpost re-

mains. It materializes social relations and provides a subtle symbolism of identity. As Anne Hollander rightly reminds us, beauty is famous for being fleeting, although with the possibility of continual makeovers and various industries supplying the means for rejuvenation this threat of it being fleeting and soon passed over could be curbed. We need only purchase another facelift, new outfit or head of hair to be once again restored to the front of the social stage.

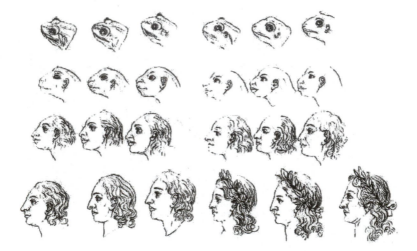

9. *Successive Stages From Frog to Apollo* (as used by J.C. Lavater, *c.* 1795, original ownership unknown).

Afterword

This book begins with a reference to a painting by René Magritte depicting two identical masked apples. The mask and the Janus-like double identity of the apples works well as a metaphor for thinking about self-invention, as the identical apples, each wearing the same party mask, bring attention to the function of appearances. In the painting, the masks themselves are quite small, covering only the eyes, and they are inadequate as a disguise, yet they effectively point to the confident way we use possessions to present aspects of ourselves to the world at large. Magritte's image poses but does not answer the question, what exactly is being concealed behind the mask and what is revealed? Do we see this particular paradoxical image as a warning not to trust appearances or as the opposite, an endorsement to read the obvious and trust what is apparent? By contemplating the mask and its relatives – the fashionable suit, striking haircut, cosmetic and extreme makeover – we are shunted down the path of thinking about the density of traffic that surrounds the presentation of identity in everyday life.

Visual Culture

We live in an era of dense visuality; the technological sophistication of new media has been smoothly absorbed into everyday life. The ubiq-

uitous camera shows us what is important, and we have learned to accept its viewpoint and rely on the visual to explain the connections between the observed and the real, between what we see and understand to be true. As the visual image has proliferated and become increasingly powerful, it has added to the techniques for better crafting the presentation of the self. Fashioning identity has been promoted by global industries that market the tools for such practices. The huge commercial success of many Hollywood films rests on their exciting visuality: the action shot, jump-cut, wide panorama and close-up are all camera techniques that have helped spread pleasure in the visual. In this way, Hollywood films have prepared audiences for the exuberance of consumer advertising; they have encouraged materialist and instrumentalist values that undergird conspicuous consumption and have come to dominate mainstream Western culture since the mid-twentieth century. The celebration of vision as a reliable source of knowledge has defined much of popular culture and sustained the opinion that vision is the most discriminating and trustworthy of the senses (Jay, 1989: 50).

At the same time, however, that the scopic regime has gained in value, it has also been vigorously challenged, principally by the creation of visual products that have no referents in the real world. The René Magritte painting of the two masked apples is a case in point. The Impressionist, Cubist and Abstract artists were highly successful at separating the image from the world, by creating objects and visions that exceeded reality and, in doing so, they demonstrated a need for some caution. What we see is not always real. Hollywood products and the advertising industries have done the same; they too have created hyperrealities and presented visual universes without material referents. Yet there is a difference between the ambitions of the avant-garde artist and the commercial machinery of Hollywood and Madison Avenue; where the former alerts us to the complexity of perception in order to

heighten our visual acuity, the latter lacks inherent caution and promotes instead a misleading elision of the image with the real.

A cultural emphasis on the visual can suggest that what we see is a mirror reflection of the external reality, that the surface view is a reliable record and appearances are indeed real. Yet seeing the obvious is not always easy. The transfer between what is presented and what we perceive, between what is intended and what we derive, is contested. Ideas and images energetically circulate and we accept such information as an authoritative reference yet at the same time we know it is a particular viewpoint and narrative on how to see the world. Films like *Mr and Mrs Smith*, *True Lies*, *Pillow Talk* and *Mrs Doubtfire* present dissemblance as a source of amusement and pleasure. They suggest that if we act convincingly then our social experiences will be enhanced. In such films we are shown how characters transform themselves by donning a pair of spectacles, changing clothes, self-consciously affecting a manner of speaking and exaggerating good manners. Such displays specifically show how a transitory subject position becomes a great source of amusement. They reinforce the idea that self-fashioning and styling a repertoire of identity positions goes hand-in-hand with social success.

With the growth of the mass market and the consumer ethic in the West, identity has become a potent social force in the realization of contemporary ideals. Identity functions as a link between human relationships and social structure. There are numerous histories that explore varieties of self-identity and these have been central to the cultural development of the West. The Cartesian dictum stated that the process of thinking about identity actually produced a substantial self; I think therefore I am. In 1694, John Locke conceptualized the self as an unstable entity and wondered how it endured through time. He asked if he was the same person today as yesterday. He wondered about the guarantees that would ensure he was the same person tomorrow.

These concerns have not been answered and they continue to reappear in various contexts. How I think about myself changes periodically; it is interrupted by sleep, intense activity, even lapses in memory and consciousness. In what sense then can anyone be confident that I am the same person today as yesterday and tomorrow? Could I not, for instance, have several identities as Locke describes – a day and a night person? The idea resonates in numerous forms; *Dr Jekyll and Mr Hyde* (Stevenson, 1886) for instance plays out the possibility of harbouring opposed desires within the same body. Such preoccupations are not idle; we do regularly speak of ourselves as having multiple facets, some more dominant than others. Am I the same person when I am drunk, tired, stressed, in love or threatened? Stanley Milgram's celebrated psychological experiments reveal the ease with which individuals can be directed to act 'out of character'.

Self-Invention

The same considerations reverberate through contemporary fashions in popular reality television programmes in which individuals test themselves in uncommon situations and find they are capable of acting in uncharacteristic ways. Take for example reality television programmes like *The Amazing Race*, where contestants have to move around the world under pressure of time and with limited resources, and they find themselves taking risks that ordinarily they might avoid. This is the idea explored by Patricia Highsmith in the Tom Ripley novels. Jonathan Trevanny is a mild-mannered, retiring young man who is transformed into a pre-meditated murderer, and who surprises himself by enjoying the excitement. Bret Easton Ellis explored the same territory in *American Psycho* where the Wall Street financier, Patrick Bateman, transformed himself after office hours into a serial killer.

John Locke's questions about identity bring us to consider a fundamental issue, the exercise of trust. It is only with a foundation of

trust that a society can exist. We must be able to walk down the street without fear of a stranger rushing at us with murderous intent; we must be able to sleep peacefully without fear that a neighbour will invade our property and damage our assets; we must believe in the stability of currency to provide the monetary means for transacting daily business. Without trusting in the stability of certain practices and patterns of conduct it is impossible to invest in the future. Thus, Locke remarks, we only know each other and recognize one another because we trust in the idea of identity being preserved across time and circumstances. We must trust in the identity of the other and in our own memory to recognize the person as the individual we know.

Bishop Berkeley's early eighteenth-century writings on identity (see Luce and Jessop, 1948–57) suggest we can be two or more people, thinking and acting differently in whatever guise we assume. David Hume, also writing in the eighteenth century, asserts we are little more than concatenations of different perceptions (see Millican, 2002). Identity then is a fiction insofar as it does not exist as a stable category but is better thought of as a manner of thinking. We are actors, good actors, and we learn how to convince others of specific interpretations. Identity is a performance, a mask and role that can be executed with self-conscious purpose. It is not the case that the mask conceals a true identity within. Rather, all social activities involve us in the production of an identity that fits the occasion. We are constantly writing identities and such preoccupations have long been used by popular forms as a point of observation, commentary, entertainment and amusement.

Wahrman (2004: 194–5) reports on the 1740 memoirs of Martin Scriblerus as an instance of this. In the first half of the eighteenth century the Scriblerus Club, which included Jonathan Swift and Alexander Pope, produced a satirical document recounting the misfortunes of the fictional hero Martin Scriblerus. He was in love with one half of a pair of Siamese twins conjoined at the sex organs. As the romance developed

and love became marriage, Martin found himself subsequently charged with rape and incest by the other half of the pair. The question generated by this situation concerns identity: is his new wife one person or two?

During the court trial, it is revealed that the twinned sisters are of deeply opposed personalities; where one is kind the other is not, one is calm the other angry, and so on. The legal presentation of the case involved the exploration of a range of confounding concerns; for instance, if the romance with the Siamese twins had been conducted on a desert island with no witnesses or audience, would there be a case to answer? Is Martin married to one person with two bodies (in part) or two different people encased in one unusual body? In which case, where is the seat of identity? The ensuing debates contributed to the formulation of identity as an assumed status. A point of the fiction was to show how the individual comes to occupy an identity through specific social relations with others, and through acquired attributes, memories and obligations. Identity then is better thought of as fluid and unstable, always in need of being located within a set of cultural practices. In this instance, if it was decided that Martin was married to only one part of a twin, then he was indeed guilty as charged.

Two hundred years later a film like *Pillow Talk* implicitly functions to sustain these philosophical questions. During the reign of the Hollywood film, identity was repeatedly presented as both a fluid state of mind as well as a stable essence of reliable qualities. There were myriad narratives of perverted, inverted, converted and diverted identities; the innocent are corrupted, the innocent are not innocent; the respectable are not as they appear – they are spies, embezzlers, soldiers of fortune, con-artists and worse. Popular culture reinforces the view that appearances are hieroglyphics that need to be deciphered and Hollywood, in particular, has cultivated an emphasis on appearances, on the visual, and provided lessons on how to read the obvious. It has used art to imitate the spectator and offer explanations of human nature; it has been

a technology for grooming the social actor. Woody Allen rephrased the mission more sardonically, 'Life does not imitate art; it only imitates bad television' (*Husbands and Wives*, 1992).

The historian Fernand Braudel has alerted us to the problem of starting in one place only to arrive at another (Braudel, 1980). Accordingly, a focus on self-invention leads to other considerations such as whether the emergence of professional psychology invested itself in promoting certain fictions about selfhood, whether it deliberately cultivated a belief in a knowable inner self in order to access it through the tools of psychological experimentation. The emphasis on performance may also be seen as influential in popularizing cosmetic surgery and extreme physical makeovers that reshape the body to align more closely with current fashions in appearance.

Kant observed, 'the more civilized men become, the more they become actors' (Hundert, 1997: 81). Developing this double consciousness is the primary step towards recognizing that daily life is largely constituted from the management of the fluctuating tensions and ambiguities that combine and recombine the various elements in play-acting, deception and invention. Much of popular culture is focused on situations created by these intersecting tensions. Our pleasure derives largely from seeing the paradoxical on display and being both engaged and distanced from it. Being an actor involves understanding the techniques of switching between the background and foreground, between authoring the self and being a product of the other. From these activities we learn how the self can be an art form, an imaginative bridge between multiple levels of impermanent reality. At the same time, learning about the role of identity in social life involves, in effect, a study of how society itself is sustained.

Underlying these efforts to fit our selves into current styles is an acceptance that identity and what we understand as the self are better thought of as interlocking patterns of behaviour that circulate through

well-recognized and conventional social settings. By the mid-twenti-eth century, after two world wars, nuclear explosions and holocaust, when 'all that is solid has melted into air', we are familiar with the view that the human self is divided, fragmented and unstable. The stream of consciousness literature of the modernist writers and the philosophical works of Bergson, Schutz, Merleau-Ponty, Deleuze and Guattari made the idea of a fixed personality based on a stable unconscious increas-ingly untenable.

The counter-idea of identity or subjectivity as a contingent synthe-sis, influenced by circumstance, has gained acceptance. Thus we are tacitly drawn to the viewpoint that every society uses the body as the site where abstract power arrangements are played out. Public cere-monies of extreme cruelty, which we see daily on *The Jerry Springer Show*, *Extreme Makeover*, *The Apprentice* or *Big Brother*, are sites where identity is dramatized and defined as a capacity to calculate, improvise, perform, dissemble and delude. At the same time, these are sites where the desire for a coherent, authentic and reliable character at the core of our being is also played out. Living with these contrary claims is thus presented as the passport to a civilized life and not the opposite, a reason for paralysis.

These comments bring Goffman's work back into focus. His ironic manner of writing and direct address to the 'phoneyness' of much so-cial life was immediately engaging to the socially mobile members of an economically expanding society. When he stated, *en passant*, in the early sections of *The Presentation of Self in Everyday Life*, 'the world is, indeed, a wedding' (1959: 53), he used the conventional act of a wed-ding to emphasize how much of everyday life is performative, scripted and necessarily witnessed by an audience. Like a wedding, everyday life is structured around the taken-for-granted narratives that value ap-pearances. His use of the wedding as a synecdoche gave prominence to the many staged and patterned events in daily life.

Along with Goffman's success, there were other cultural products traversing similar territory. The film by Billy Wilder *Some Like It Hot* (1959) was received by audiences at the time as a madcap zany comedy, but its narrative subtext was a study of dissemblance and identity construction. The film recounts the problems of two young men who disguise themselves as women in order to flee a dangerous situation. However, their appearances create other tensions as their disguises as women hinder their pursuit of romantic love and true happiness.

The film can be read in many ways. Following the Second World War, women who had worked in factories manufacturing the nation's economy had to be reoriented back to the family. Clear gender roles dividing the lives of men and women were thus asserted and on this basis suburban America with its shopping malls, cars and fast foods was brought into existence. By the mid-1950s, high levels of material consumption had been set in place, largely through the success of the nuclear family. Against this background, *Some Like It Hot* was an incisive analysis of gender, romantic love and self-invention that may not have been immediately obvious at the time. The end note of the film resonates with postmodern inflections that destabilize hetero-normative regimes: will Jack Lemmon as the cross-dressing Daphne accept the proffered love of the very rich bachelor playboy Osgood Fielding III? Osgood is not bothered that Daphne is a man; he is in love and that is all that matters. At the end of the film, the audience is left with the question, will their union take place?

Some Like It Hot demonstrated the plasticity of gender and questioned the value of love as a reliable emotion. The film was prescient; in the following two decades romantic love would be constantly promoted through popular culture and thoroughly interrogated by the 'sexual revolution' of the 1960s and 1970s. The various influences, from Tamla Motown music, Elvis Presley, Mary McCarthy's *The Group* (1963), the censorship of D.H. Lawrence's *Lady Chatterley's Lover* (1929), and

Betty Friedan's *The Feminine Mystique* (1963), all contributed to a Zeit-geist in which love, sex and happiness were being scrutinized.

The more recent and popular *M. Butterfly* by David Henry Hwang (1988) was well received by audiences who had had a decade or more to warm to the same idea that gender was not a reliable category and the pursuit of true love was not without its destabilizing consequenc-es. The narrative recounted the trial of the French diplomat Bernard Boursicot, charged with treason after it was revealed his Chinese opera-singer lover of 20 years was a man and a spy. Boursicot did re-ceive some sympathy as a victim of love, but he was also ridiculed for finding love where he did. The subtexts of such products seem to be that for all our longing to follow the impulses of the heart, believing as we do that these are authentic and healthy, we are still rule-bound, we are merely conduits of culture and circumstance, and our identity is shaped accordingly. David Riesman had described in *The Lonely Crowd* (1950) the same preoccupations that drew Goffman's attention, namely, the growing influence of the other's anonymous regulating gaze. In the next decades a series of best-sellers would propel these ideas further, making self-invention an apparent matter of fact (Covey, 1989; Frankl, 1962; Lasch, 1979; Luciani, 2004; Slater, 1970; Wolfe, 1980).

The rise of the professional society in the latter half of the twentieth century has aided and abetted a new psychology around self-invention. With the 'fall of public man', to use Richard Sennett's phrase, the pro-cess of finding a place for oneself in the world has become increasingly contested and arbitrary. We are now located by contingency and situ-ation (Heller, 1999), and our status is a matter of ambition and oppor-tunity. We learn to balance the discontinuities between the realities of an obdurate external world and our sentimental attachments. We may know there is no outside world that corresponds to the inner world of desire, nonetheless, we manage daily to bridge the gap. We produce a subjectivity that seems to have an objective facticity, it has a surface we

can style and groom. At the same time that we cultivate this singularity we also know that anonymity haunts every one of us and this underlying notion in turn appears to frame the modern preoccupation with self-invention.

Bibliography

Abagnale, Frank William (2001) *The Art of the Steal*, New York: Broadway.

Adorno, Theodor (1991) *The Culture Industry*, London: Routledge.

—— (1981) 'Notes on Kafka', in *Prisms: Studies in Contemporary German Social Thought*, Cambridge, MA: MIT Press.

Ang, Ien (ed.) (1997) *Planet Diana: Cultural Studies and Global Mourning*, Kingswood, NSW: Research Centre for Intercommunal Studies.

Aristotle (1943 [4th c.BCE]) 'Generation of animals', trans. by A.L. Peck, London: Heinemann.

—— (14th c.) *Philosophi Phisnomia*, London: British Library, MS 3469.

Auerbach, Erich (1957) *Mimesis*, New York: Doubleday.

Austen, Jane (1962 [1813]) *Pride and Prejudice*, London: Collins.

Banville, John (1997) *The Untouchable*, London: Picador.

Barthes, Roland (1983 [1967]) *The Fashion System*, New York: Hill and Wang.

—— (1981) *Camera Lucida: Reflections on Photography*, New York: Hill and Wang.

Baudrillard, Jean (1993) *Symbolic Exchange and Death*, London: Sage.

Bell, Quentin (1976) *On Human Finery*, London: Hogarth.

Bellah, Robert, with Richard Madsen, William M. Sullivan, Ann Swidler and Steve M. Tipton (1985) *Habits of the Heart: Individualism and Commitment in American Life*, Berkeley, CA: University of California Press.

Benstock, Shari, and Suzanne Ferriss (eds) (1994) *On Fashion*, New Brunswick, NJ: Rutgers University Press.

Berger, John (1972) *Ways of Seeing*, London, Penguin.

Berlin, Isaiah (1990 [1959]) *The Crooked Timber of Humanity*, London: John Murray.

Berman, Marshall (1983) *All That is Solid Melts into Air: The Experience of Modernity*, London: Verso.

Blau, Herbert (1999) *Nothing in Itself: Complexions of Fashion* (Bloomington, IN: Indiana University Press.

'Bogus aristocrat gets 21 months inside' (2005) *Australian*, 9 November, p. 10.

Bolk, Louis (1929) 'Origin of racial characteristics in man,' *American Journal of Physical Anthropology*, 13, pp. 1-28

Bond, Anthony, and Joanna Woodall (2005) *Self Portrait: Renaissance to Contemporary*, London: National Portrait Gallery.

Boorstin, Daniel (1961) *The Image: A Guide to Pseudo-Events in America*, Harmondsworth: Penguin.

Bourdieu, Pierre (ed.) (1999) *The Weight of the World: Social Suffering in Contemporary Society*, Oxford: Polity.

—— (1977) *Outline of a Theory of Practice*, New York: Cambridge University Press.

Bowlby, Rachel (2000) *Carried Away: The Invention of Modern Shopping*, London: Faber.

—— (1985) *Just Looking: Consumer Culture in Dreiser, Gissing and Zola*, London, Methuen.

Boyle, David (2003) *Authenticity: Brands, Fakes, Spin and the Lust for Real Life*, London: Flamingo.

Braiker, Brian (2004) 'The politics of denial: A political psychologist explains the roles denial, emotion and childhood punishment play in politics,' *Newsweek*, 13 May.

Braudel, Fernand (1980) *On History*, Chicago: University of Chicago Press.

Brewer, John, and Roy Porter (eds) (1993) *Consumption and the World of Goods*, London: Routledge.

Brookes, Rosetta (1992) 'Fashion photography,' in Juliet Ash and Elizabeth Wilson (eds) (1992) *Chic Thrills*, Berkeley: University of California Press, pp. 17–24.

Brookner, Anita (2000) *Romanticism and its Discontents*, New York: Farrar, Straus and Giroux.

—— (1993) *Fraud*, London: Penguin.

Brown, Bill (ed.) (2004) *Things*, Chicago: University of Chicago Press.

Bryson, Anna (1998) *From Courtesy to Civility: Changing Codes of Conduct in Early Modern England*, Oxford: Clarendon Press.

Burke, Peter (1995) *The Fortunes of the Courtier. The European Reception of Castiglione's Cortegiano*, Oxford: Polity.

—— (1981) *Montaigne*, Oxford: Oxford University Press.

—— (1978) *Popular Culture in Early Modern Europe*, New York: New York University Press.

Butler, Judith (2004a) *Precarious Life: The Powers of Mourning and Violence*, London: Verso.

—— (2004b) *Undoing Gender*, London: Routledge.

—— (1993) *Bodies That Matter: On the Discursive Limits of 'Sex'*, London: Routledge.

—— (1990) *Gender Trouble: Feminism and the Subversion of Identity*, London: Routledge.

Capote, Truman (1965) *In Cold Blood*, New York: Penguin.

Carter, Michael (2003) *Fashion Classics: From Carlyle to Barthes*, New York: Berg.

Carter, Miranda (2002) *Anthony Blunt: His Lives*, New York: Farrar, Straus and Giroux.

Castiglione, Baldassare (1994 [1528]) *The Book of the Courtier*, 'Introduction', edited by Virginia Cox, London: Everyman.

Castle, Terry (1986) *Masquerade and Civilization*, Palo Alto, CA: Stanford University Press.

Chaney, David (1983) 'The department store as a cultural form', *Theory, Culture and Society*, 1 (3), pp. 22–31.

Cleland, John (1963 [1748–9]) *Fanny Hill: Memoirs of a Woman of Pleasure*, New York: Penguin.

Covey, Stephen (1989) *The 7 Habits of Highly Effective People*, New York: Free Press.

Coward, Rosalind (1984) *Female Desire*, London: Paladin.

Craib, Ian (1994) *The Importance of Disappointment*, New York: Routledge.

'Crime report' (2003) *Marie Claire*, 100 (December), pp. 112–18.

Davis, Deborah (2004) *Strapless: John Singer Sargent and the Fall of Madame X*, Gloucestershire: Sutton.

Davis, Natalie Zemon (1983) *The Return of Martin Guerre*, Cambridge, MA: Harvard University Press.

DeJean, Joan (2005) *The Essence of Style*, New York: Free Press.

DeLibero, Linda (1994) 'This year's girl: a personal/critical history of Twiggy', in Shari Benstock and Suzanne Ferriss (eds) *On Fashion*, New Brunswick, NJ: Rutgers University Press, pp. 41–58.

DeLibero, Linda (1986) *White Noise*, New York: Penguin.

Denzin, N.K. (1995) *The Cinematic Society: The Voyeur's Gaze*, London: Sage.

Dickens, Charles (1966) *Oliver Twist*, Harmondsworth: Penguin.

Doniger, Wendy (2000) *The Bedtrick: Tales of Sex and Masquerade*, Chicago: University of Chicago Press.

Douglas, Mary, and Baron Isherwood (1979) *The World of Goods: Towards an Anthropology of Consumption*, London: Allen Lane.

Doy, Gen (2005), *Picturing the Self*, London: I.B.Tauris.

Durkheim, Emile (1997 [1897]) *Suicide*, New York: Free Press.

Dyer, Richard (1998) *Stars*, London: British Film Institute.

—— (1993) *The Matter of Images*, London: Routledge.

—— (1992) *Only Entertainment*, London: Routledge.

Eagleton, Terry (2005) *The English Novel*, Oxford: Blackwell.

Eco, Umberto (1976) *Faith in Fakes*, London: Secker and Warburg.

Ekman, Paul, and Wallace Friesen (1975) *Unmasking the Face*, Englewood Cliffs, NJ: Prentice Hall.

Elias, Norbert (1978) *The Civilizing Process*, New York: Urizen.

Elliott, Jane (1987) *A Class Divided: Blue Eyes Black Eyes*, Boston: PBS Frontline.

Ellis, Bret Easton (2005) *Lunar Park*, New York: Knopf.

—— (1999) *Glamorama*, New York: Knopf.

—— (1991) *American Psycho*, London: Picador.

—— (1987) *Rules of Attraction*, New York: Simon and Schuster.

—— (1985) *Less Than Zero*, New York: Simon and Schuster.

Engels, Frederick (1952 [1891]) *The Condition of the Working Class in England in 1844*, trans. by W.O. Henderson and W.H. Chaloner, London: Allen and Unwin.

Eugenides, Jeffrey (1994) *The Virgin Suicides*, London: Abacus.

Ferris, Lesley (ed.) (1993), *Crossing the Stage: Controversies on Cross-Dressing*, London: Routledge.

Finch, Casey (1991) '"Hooked and buttoned together": Victorian underwear and representations of the female form', *Victorian Studies*, 34 (3), pp. 337–63.

Finkelstein, Joanne (1991) *The Fashioned Self*, Oxford: Polity.

Flügel, J.C. (1950) *The Psychology of Clothes*, London: Hogarth.

Frankl, Viktor (1962) *Man's Search for Meaning*, New York: Simon and Schuster.

Franzen, Jonathan (2001) *The Corrections*, London, Fourth Estate.

Freud, Sigmund (1985) *The Complete Letters of Sigmund Freud to Wilhelm Fliess, 1887–1904*, edited and trans. by J.M. Masson, Cambridge, MA: Harvard University Press.

Friedan, Betty (1963) *The Feminine Mystique*, New York: Dell.

Fromm, Erich (1956) *The Sane Society*, London: Routledge and Kegan Paul.

Fuss, Diana (ed.) (1996) *Human, All Too Human*, New York: Routledge.

—— (1995) *Identification Papers*, New York: Routledge.

Gaines, Jane, and Charlotte Herzog (eds) (1990) *Fabrications: Costume and the Female Body*, London: Routledge.

Galbraith, J.K. (1958) *The Affluent Society*, Harmondsworth: Penguin.

Gambetta, Diego (ed.) (1988) *Trust: Making and Breaking Cooperative Relations*, New York: Blackwell.

Garber, Marjorie (1995) *Vice Versa*, New York: Simon and Schuster.

—— (1992) *Vested Interests: Cross-Dressing and Cultural Anxiety*, London: Penguin.

Garfinkel, Harold (1967) *Studies in Ethnomethodology*, Englewood Cliffs: NJ: Prentice Hall.

Garton, Stephen (2004) *Histories of Sexuality*, London: Equinox.

Gay, Peter (2001) *Schnitzler's Century: The Making of Middle-Class Culture*, New York: Norton.

George, Elizabeth (1997) *Deception on His Mind*, London: Hodder and Stoughton.

Gilman, Sander (1998) *Creating Beauty to Cure the Soul*, Durham, NC: Duke University Press.

—— (1991) *The Jew's Body*, New York: Routledge, 1991.

Gladwell, Malcolm (2002) 'The naked face', *New Yorker*, 5 August, p. 38.

Goffman, Erving (1976) *Gender Advertisements*, London: Macmillan.

—— (1970) *Strategic Interaction*, Philadelphia: University of Pennsylvania Press.

—— (1967) *Interaction Ritual: Essays in Face-to-Face Behavior*, New York: Anchor.

—— (1963) *Stigma: Notes on the Management of Spoiled Identity*, Harmondsworth: Penguin.

—— (1959) *The Presentation of Self in Everyday Life*, New York: Anchor.

Goldman, Robert (1992) *Reading Ads Socially*, London: Routledge.

Goldmann, Lucien (1975) *Towards a Sociology of the Novel*, trans. by Alan Sheridan, London: Tavistock.

Gombrich, Ernst Hans (1960) *Art and Illusion: A Study in the Psychology of Pictorial Representation*, Oxford: Phaidon.

Good, David (1988) 'Individuals, interpersonal relations, and trust' in Diego Gambetta (ed.) *Trust: Making and Breaking Cooperative Relations*, Oxford: Blackwell, pp. 31–48.

Gould, Stephen Jay (1981) *The Mismeasure of Man*, New York: Norton.

Greenblatt, Stephen (2004) *Will in the World: How Shakespeare Became Shakespeare*, London: Norton.

—— (1980) *Renaissance Self-Fashioning: From More to Shakespeare*, Chicago: University of Chicago Press.

Guattari, Félix (1992) 'Regimes, pathways, subjects' in Jonathan Crary and Sanford Kwinter, (eds) *Incorporations*, New York: Zone, pp. 16–37.

Hansen, Joseph, and Evelyn Reed (1986) *Cosmetics, Fashion and the Exploitation of Women*, New York: Pathfinder Press.

Harré, Rom, and Grant Gillett (1994) *The Discursive Mind*, London: Sage.

Harvey, David (1990) *The Condition of Postmodernity: An Enquiry into the Origins of Cultural Change*, Oxford: Blackwell.

Haug, Wolfgang F. (1986) *Critique of Commodity Aesthetics, Appearance, Sexuality and Advertising in a Capitalist Society*, trans. by Robert Bock, Oxford: Polity.

Hebdige, Dick (1993) 'A report from the Western front: postmodernism and the "politics" of style,' in Chris Jenks (ed.) *Cultural Reproduction*, London: Routledge, pp. 69–103.

—— (1988) *Hiding in the Light: On Images and Things*, London: Routledge.

Heller, Agnes (1999) *A Theory of Modernity*, Cambridge, MA: Blackwell.

Highsmith, Patricia (1974) *Ripley's Game*, London: Penguin.

—— (1955) *The Talented Mr Ripley*, London: Vintage.

Hilberg, Raul (1985) *The Destruction of the European Jews*, vols 1–3, New York: Holmes and Meier.

Hobbes, Thomas (1947 [1660]), *Leviathan*, London: John Dent.

Hobsbawm, Eric, and Terence Ranger (eds) (1983) *The Invention of Tradition*, Cambridge: Cambridge University Press.

Hollander, Anne (1980) *Seeing Through Clothes*, New York: Avon.

Hollinghurst, Alan (2004) *The Line of Beauty*, London: Picador.

Hughes, Robert (1997) *American Visions: The Epic History of Art in America*, New York: Knopf.

Hundert, E.J. (1997) 'The European Enlightenment and the history of the self,' in Roy Porter (ed.) *Rewriting the Self*, London: Routledge, pp. 72–83.

Huxley, Aldous (1984 [1932]) *Brave New World*, New York: Penguin.

Huysmans, J.K. (1959 [1884]) *A Rebours*, Harmondsworth: Penguin.

Hwang, David Henry (1989) *M. Butterfly*, New York: Penguin.

Illouz, Eva (1997) *Consuming the Romantic Utopia: Love and the Cultural Contradictions of Capitalism*, Berkeley, CA: University of California Press.

James, Henry (1922) *The Turn of the Screw: The Aspern Papers*, London: Macmillan.

Jameson, Fredric (1991) *Postmodernism, or the Cultural Logic of Late Capitalism*, Durham, NC: Duke University Press.

Jardine, Lisa (1996) *Worldly Goods*, London: Macmillan.

Jay, Martin (1993) *Downcast Eyes: The Denigration of Vision in Twentieth-Century French Thought*, Berkeley, CA: University of California Press.

—— (1989) 'In the empire of the gaze', in Lisa Appignanesi (ed.) *Postmodernism: ICA Documents*, London: Free Association Books, pp. 49–74.

Kellner, Douglas (1994) 'Madonna, fashion, identity', in Shari Benstock and Suzanne Ferriss, (eds) *On Fashion*, New Brunswick, NJ: Rutgers University Press, pp. 161–3.

Kinsella, Sharon (2002) 'What's behind the fetishism of schoolgirls' uniforms in Japan?', *Fashion Theory*, 6 (2), pp. 91–110.

—— (1995) 'Cuties in Japan', in Brian Moeran and Lise Skov (eds) *Women, Media and Consumption in Japan*, Honolulu: University of Hawaii Press, pp. 220–54.

Klapp, Orrin Edgar (1969) *Collective Search for Identity*, New York: Holt, Rinehart and Winston.

—— (1962) *Heroes, Villains and Fools*, Englewood Cliffs, NJ: Prentice Hall.

Klein, Naomi (2000) *No Logo, No Space, No Choice, No Jobs*, London: Picador.

Koestenbaum, Wayne (2001) *Andy Warhol*, New York: Penguin.

Kosinski, Jerzy (1970) *Being There*, London: Bodley Head.

Kruger, Barbara (1996) *Black + White* magazine, Sydney.

—— (1994) *Remote Control: Power, Culture and the World of Appearances*, Cambridge, MA: MIT Press.

Lasch, Christopher (1979) *The Culture of Narcissism*, New York: Norton.

Lavater, Johann Caspar (1885) *Essays on Physiognomy*, London: Ward, Lock and Bowden.

Lawrence, D.H. (1959 [1929]) *Lady Chatterley's Lover*, New York: Grove Press.

Lillo, Don de (1997) *Underworld*, New York: Scribner.

Lipovetsky, Gilles (1994) *The Empire of Fashion*, Princeton, NJ: Princeton University Press.

Luce, Arthur Aston, and Thomas Edmund, Jessop (eds) (1948–57) *The Works of George Berkeley, Bishop of Cloyne*, 9 volumes, London: Nelson.

Luciani, Joseph (2004) *The Power of Self-Coaching*, New York: John Wiley.

Luck, Kate (1992) 'Trouble in Eden, trouble with Eve', in Juliet Ash and Elizabeth Wilson (eds) *Chic Thrills*, London: Pandora, pp. 200–12.

Lukács, Georg (1980) *Essays on Realism*, edited by Rodney Livingston, trans. by David Fernbach, London: Lawrence and Wishart.

—— (1971) 'Consciousness of the proletariat', in *History and Class Consciousness*, trans. Rodney Livingstone, London: Merlin, pp. 46–82.

Lurie, Alison (1992) *The Language of Clothes*, London: Bloomsbury.

Machiavelli, Niccoli (1981 [1513]) *The Prince*, trans. by George Bull, London: Penguin.

Malouf, David (1978) *An Imaginary Life: A Novel*, London: Chatto and Windus.

Marar, Ziyad (2003) *The Happiness Paradox*, London: Reaktion.

Marcuse, Herbert (1964) *One Dimensional Man*, London: Heinemann.

Martin, Judith (1991) *Miss Manners' Guide to Excruciatingly Correct Behavior*, New York: Galahad.

Mauss, Marcel (1985 [1928]) 'A category of the human mind: the notion of person; the notion of self', trans. by W.D. Halls, in Michael Carrithers, Steven Collins and Steven Lukes (eds) *The Category of the Person: Anthropology, Philosophy, History*, Cambridge: Cambridge University Press, pp. 1–25.

—— (1979) *Sociology and Psychology: Essays*, trans. by Ben Brewster, London: Routledge and Kegan Paul.

McCarthy, Mary (1963) *The Group*, London: Weidenfeld and Nicolson.

McClelland, David C. (1961) *The Achieving Society*, New York: Free Press.

McInerney, Jay (1996) *The Last of the Savages*, New York: Knopf.

McKendrick, Neil, John Brewer and J.H. Plumb, (1982) *The Birth of a Consumer Society: The Commercialisation of Eighteenth-Century England*, London: Hutchinson.

McLuhan, Marshall (1967) *The Mechanical Bride: Folklore of Industrial Man*, London: Routledge and Kegan Paul.

Milgram, Stanley (1974) *Obedience to Authority: An Experimental View*, London: Tavistock.

Miller, Michael, B. (1981) *The Bon Marché: Bourgeois Culture and the Department Store, 1869–1920*, Princeton, NJ: Princeton University Press.

Millican, Peter (ed.) (2002) *Reading Hume on Human Understanding*, New York: Oxford University Press.

Mills, C.W. (1946) 'The competitive personality', *Partisan Review*, 13, p. 433.

Mintz, Sidney W. (1986) *Sweetness and Power: The Place of Sugar in Modern History*, New York: Viking.

Mirzoeff, Nicholas (1999) *An Introduction to Visual Culture*, London: Routledge.

Mitchell, W.J.T. (1994) *Picture Theory: Essays on Verbal and Visual Representation*, Chicago: University of Chicago Press.

Moers, Ellen (1978) *The Dandy*, Lincoln: University of Nebraska Press.

Montaigne, Michel de (1958 [1595]) *Essais*, trans. by Donald Frame, Palo Alto, CA: Stanford University Press.

Morris, Jan (1974) *Conundrum*, London: Faber.

Mort, Frank (1996) *Cultures of Consumption: Masculinities and Social Space in Late Twentieth Century Britain*, London: Routledge.

Mulvey, Laura (1975) 'Visual pleasure and narrative cinema', *Screen* 16 (3), pp. 6–18.

Nicolson, Harold (1955) *Good Behaviour*, London: Hogarth.

Oates, Joyce Carol (2002) *Beasts*, New York: Carroll and Graf.

O'Sickey, Ingeborg (1994) 'Barbie magazine and the aesthetic commodification of girls' bodies', in Shari Benstock and Suzanne Ferriss (eds) *On Fashion*, New Brunswick, NJ: Rutgers University Press, pp. 21–40.

Packard, Vance (1957) *The Hidden Persuaders*, New York: Penguin.

Perrault, Charles (1697) *Little Red Riding Hood* (originally under the general title *Tales of Mother Goose*, Paris).

Porter, Roy (2003) *Flesh in the Age of Reason*, London: Allen Lane.

—— (ed.) (1997) *Rewriting the Self: Histories from the Renaissance to the Present*, London: Routledge.

Postle, Martin (ed.) (2005) *Joshua Reynolds: The Creation of Celebrity*, London: Tate.

Proust, Marcel (1982 [1913–27]) *Remembrance of Things Past*, vol. 5, ch. 2, trans. by C.K. Scott Moncrief, New York: Vintage.

—— (1957 [1923]) *The Captive*, trans. by C.K. Scott Moncrief, London: Chatto and Windus.

Rabine, Leslie (1994) 'A woman's two bodies: fashion magazines, consumerism and feminism', in Shari Benstock and Suzanne Ferriss (eds) *On Fashion*, New Brunswick, NJ: Rutgers University Press, pp. 59–75.

Rebhorn, Wayne (1995) *The Emperor of Men's Minds: Literature and the Renaissance Discourse of Rhetoric*, Ithaca and London: Cornell University Press.

—— (1978) *Courtly Performances: Masking and Festivity in Castiglione's Book of the Courtier*, Detroit, MI: Wayne State University.

Ribeiro, Aileen (1992) 'Utopian dress', in Juliet Ash and Elizabeth Wilson (eds) *Chic Thrills*, Berkeley: University of California Press, pp. 225–37.

—— (1986) *Dress and Morality*, London: Batsford.

Richardson, Samuel (1932 [1747–8]) *Clarissa*, London: Dent.

—— (1914 [1740]) *Pamela*, London: Dent.

Riesman, David, with Reuel Denney and Nathan Glazer (1950) *The Lonely Crowd: A Study of the Changing American Character*, New Haven, CT: Yale University Press.

Rintoul, Stuart (2004) 'The great pretender', *Weekend Australian*, 10–11 April, pp. 22–5.

Roberts, Helen, 'The exquisite slave: the role of clothes in the making of the Victorian woman', *Signs*, 2 (3) 1977, pp. 554–69.

Robertson, Pamela (1996) *Guilty Pleasures: Feminist Camp from Mae West to Madonna*, London: I.B.Tauris.

Rorty, Richard (1989) *Contingency, Irony and Solidarity*, Cambridge: Cambridge University Press.

Rose, Nikolas (1996) *Inventing Our Selves: Psychology, Power and Personhood*, Cambridge: Cambridge University Press.

—— (1990) *Governing the Soul: The Shaping of the Private Self*, London: Routledge.

Sahlins, Marshall (1972) *Stone Age Economics*, Chicago: Aldine-Atherton.

Sarraute, Nathalie (1967 [1939]) *Tropisms, and the Age of Suspicion*, trans. by Maria Jolas, London: Calder and Boyars.

Sartre, Jean Paul (1965 [1938]) *Nausea*, trans. by Robert Baldick, Harmondsworth: Penguin.

Schama, Simon (2004) *Hang Ups: Collection of Essays on Art*, London: BBC Books.

Schwartz, Hillel (1996) *The Culture of the Copy: Striking Likenesses, Unreasonable Facsimiles*, New York: Zone.

Sedgwick, Eva Kosofsky (1990) *The Epistemology of the Closet*, Harmondsworth: Penguin.

Sennett, Richard (1976) *The Fall of Public Man*, Cambridge: Cambridge University Press.

Shaftsbury, Anthony Ashley Cooper (1999 [1714]) *Characteristicks of Men, Manners, Opinions, Times*, Oxford: Clarendon.

Shakespeare, William (2003) *The Complete Works*, New York: Longman.

Shelley, Mary (1969 [1831]) *Frankenstein*, London: Oxford University Press.

Sheridan, Richard (1995 [1777]) *School for Scandal*, New York: Norton.

Shloss, Carol (1994) 'Off the (w)rack: fashion and pain in the work of Diane Arbus', in Shari Benstock and Suzanne Ferriss (eds) *On Fashion*, New Brunswick, NJ: Rutgers University Press, pp. 111–24.

Silverman, Kaja (1996) *The Threshold of the Visible World*, New York: Routledge.

Simmel, Georg (1950) *The Sociology of Georg Simmel*, New York: Free Press.

Slater, Philip (1970) *The Pursuit of Loneliness*, Boston: Beacon.

Smith-Rosenberg, Carroll (1985) *Disorderly Conduct*, New York: Knopf.

Sontag, Susan (2004) 'Regarding the pain of others', *New York Times*, 23 May.

Spacks, Patricia Meyer (1976) *Imagining a Self*, Cambridge, MA: Harvard University Press.

Spang, Rebecca (2000) *The History of the Restaurant*, Cambridge, MA: Harvard University Press.

Stearns, Peter N. (2001) *Consumerism in World History*, London: Routledge.

Steele, Valerie (1985) *Fashion and Eroticism: Ideals of Feminine Beauty from the Victorian era to the Jazz Age*, New York: Oxford University Press.

Stein, Gertrude (1941) *Ida: A Novel*, New York: Random House.

Steiner, George (1980) 'The archives of Eden', *Salmagundi*, 50–1, pp. 57–89.

Sterne, Laurence (1967 [1759]) *The Life and Opinions of Tristram Shandy, Gentleman: With a Life of the Author Written by Himself*, Harmondsworth: Penguin.

Stevenson, Robert Louis (1886) *Dr Jekyll and Mr Hyde*, New York: Charles Scribner's and Sons.

Thompson, Hunter (1971) *Fear and Loathing in Las Vegas*, New York: Warner Books.

Treviño, Javier, and Charles Lemert (eds) (2003) *Goffman's Legacy*, Lanham, MD: Rowman and Littlefield.

Trilling, Lionel (1972) *Sincerity and Authenticity*, London: Oxford University Press.

Turnbull, Sarah (2002) *Almost French: A New Life in Paris*, London: Bantam.

Turner, G. (1641) 'A Collection taken out of many Authors for my owne private use not onely of Astronomie but allso of Natureall and Artificiall Astrologie with other verie good rules and observations', London: British Library, MS 3570.

Tytler, Graeme (1982) *Physiognomy in the European Novel: Faces and Fortunes*, Princeton: NJ: Princeton University Press.

Vanneman, Alan (1999) 'Tony and Rock go down on Doris in *Pillow Talk*', *Bright Lights Film Journal* 24 (April), available at *www.brightlightsfilm.com*.

Veblen, Thorstein (1925 [1899]) *A Theory of the Leisure Class: An Economic Study of Institutions*, New York: Viking.

Voltaire, François-Marie Arouet de (1999 [1759]) *Candide*, trans. by Daniel Gordon, Boston: St Martin's.

Wahrman, Dror (2004) *The Making of the Modern Self: Identity and Culture in Eighteenth-Century England*, New Haven: Yale University Press.

Walter, Tony (ed.) (1999) *The Mourning for Diana*, Oxford: Berg.

Warner, Marina (1994) *From the Beast to the Blond: On Fairy Tales and Their Tellers*, London: Chatto and Windus.

Weber, Max (1930) *The Protestant Ethic and the Spirit of Capitalism*, London: Harper Collins.

Weschler, Judith (1982) *A Human Comedy: Physiognomy and Caricature in Nineteenth Century Paris*, London: Thames and Hudson.

West, Nathanael (1961 [1933]) *Miss Lonelyhearts, and a Cool Million*, Harmondsworth: Penguin.

White, Patricia (1999) *Uninvited: Classical Hollywood Cinema and Lesbian Representability*, Bloomington: Indiana University Press.

Wilde, Oscar (1983 [1895]) *The Importance of Being Earnest*, Harlow: Longman.

—— (1973 [1890]) *The Picture of Dorian Gray*, London: Faber and Faber.

Williams, Raymond (1983) *Culture and Society 1780–1950*, Harmondsworth: Penguin.

—— (1980) *Problems in Materialism and Culture*, London: Verso.

—— (1961) *The Long Revolution*, London: Chatto and Windus.

Wilson, Elizabeth, and Juliet Ash (eds) (1992) *Chic Thrills*, Berkeley: University of California Press.

Wise, David (2002) *Spy: The Inside Story of How the FBI's Robert Hanssen Betrayed America*, New York: Random House.

Wolfe, Tom (1980) *Mauve Gloves, Clutter and Vine*, New York: Bantam.

Woolf, Virginia (1967) 'Mr Bennett and Mrs Brown', in *Collected Essays*, vol. 1, London: Hogarth.

—— (1942) *A Room of One's Own*, London: Penguin.

—— (1928) *Orlando: A Biography*, London: Hogarth.

Yoshimo, Shunya (2000) 'Consuming "America": from symbol to system', in Chua Beng Huat (ed.) *Consumption in Asia*, London: Routledge.

Zahavi, Helen (1991) *Dirty Weekend*, London: Flamingo.

Zimbardo, Philip (1972) *The Psychology of Imprisonment*, Palo Alto, CA: Stanford University Press.

Zola, Emile (1957 [1883]) *Ladies Delight [Au Bonheur des Dames]*, London: Penguin.

Cited films and television programmes

Film (title, director, year)

8½, Federico Fellini (1963)

American Beauty, Sam Mendes (1999)

Arrival of a Train in the Station, Lumière Brothers (1895)

Babe, Chris Noonan (1995)

Bad Seed, The, Mervyn LeRoy (1956)

Being There, Hal Ashby (1970)

Blue, Derek Jarman (1993)

Blue Angel, The, Josef von Sternberg (1930)

Bourne Identity, The, Doug Liman (2002)

Breach, Billy Ray (2007)

Bus Stop, Joshua Logan (1956)

Catch Me If You Can, Steven Spielberg (2002)

Clueless, Amy Heckerling (1995)

Color Me Kubrick, Brian W. Cook (2005)

Da Vinci Code, The, Ron Howard (2006)

Dirty Pretty Things, Stephen Frears (2002)

Down with Love, Peyton Reed (2003)

Dressed to Kill, Brian de Palma (1980)

Enigma of Kaspar Hauser, The, Werner Herzog (1974)

Erin Brockovich, Steven Soderbergh (2000)

Gone with the Wind, Victor Fleming (1939)

Great Impostor, The, Robert Mulligan (1961)

Grifters, The, Stephen Frears (1990)

Hud, Martin Ritt (1963)

Husbands and Wives, Woody Allen (1992)

Legally Blonde, Robert Luketic (2001)

Libertine, The, Laurence Dunmore (2004)

Little Miss Sunshine, Jonathan Dayton (2006)

Love Actually, Richard Curtis (2003)

Lover Come Back, Delbert Mann (1961)

Manchurian Candidate, The, John Frankenheimer (1962); Jonathan Demme (2004)

Marie Antoinette, Sofia Coppola (2006)

Matrix, The, Andy Wachowski, Larry Wachowski (1999)

Memento, Christopher Nolan (2000)

Mission Impossible, Brian de Palma (1996)

Move Over Darling, Michael Gordon (1963)

Mr and Mrs Smith, Doug Liman (2005)

Mrs Doubtfire, Chris Columbus (1993)

My Beautiful Laundrette, Stephen Frears (1985)

My Fair Lady, George Cukor (1964)

On the Waterfront, Elia Kazan (1954)

Parent Trap, The, David Swift (1961); Nancy Meyers (1998)

Paris is Burning, Jennie Livingstone (1990)

Pillow Talk, Michael Gordon (1959)

Pretty Woman, Garry Marshall (1990)

Prizzi's Honor, John Huston (1985)

Psycho, Alfred Hitchcock (1960)

Queen, The, Stephen Frears (2006)

Ripley's Game, Liliana Cavini (2002)

Saturday Night Fever, John Badham (1977)

Screen Test #1–#4, Andy Warhol (1965–6)

Seconds, John Frankenheimer (1966)

Send Me No Flowers, Norman Jewison (1964)

Seven Days in May, John Frankenheimer (1964)

Shrek, Andrew Adamson and Vicky Jenson (2001)

Some Like It Hot, Billy Wilder (1959)

Sommersby, Jon Amiel (1993)

Spellbound, Alfred Hitchcock (1945)

Superman, Richard Donner (1978)

Talented Mr Ripley, The, Anthony Minghella (1999)

Terminator, The, James Cameron (1984)
That Touch of Mink, Delbert Mann (1962)
Thelma and Louise, Ridley Scott (1991)
Thrill of It All, The, Norman Jewison (1963)
Tootsie, Sydney Pollack (1982)
Torn Curtain, Alfred Hitchcock (1966)
Tristram Shandy: A Cock and Bull Story, Michael Winterbottom (2005)
True Lies, James Cameron (1994)
Truman Show, The, Peter Weir (1998)
Vanishing, The, George Sluizer (1988)
Victor Victoria, Blake Edwards (1982)
Virgin Suicides, The, Sofia Coppola (1999)
Wag the Dog, Barry Levinson (1997)
War of the Roses, Danny DeVito (1985)

Television programmes

Ab Fab [Absolutely Fabulous] (1992–)
Agony Aunt (2006)
Amazing Race, The (2001–)
Apprentice, The (2004–2007)
Big Brother (1999–)
Biggest Loser, The (2004–)
Buffy (1997–2003)
Extreme Makeover (2002–04)
Friends (1994–2004)
Home and Away (1988–)
Inspector Rex (1994–2004)
Jerry Springer Show, The (1991–)
Kath and Kim (2002–07)
Nip/Tuck (2003–)
Osbournes, The (2002–05)
Queer Eye for the Straight Guy (2003–)
Ricki Lake (1993–2004)
Saint, The (1962–9)
Seinfeld (1990–98)
Sex in the City (1998–2004)
Simpsons, The (1989–)
Survivor (1992–2002)
West Wing, The (1999–2006)

Index